The perpetual ideal is astonishment.

— Derek Walcott, *White Egrets*

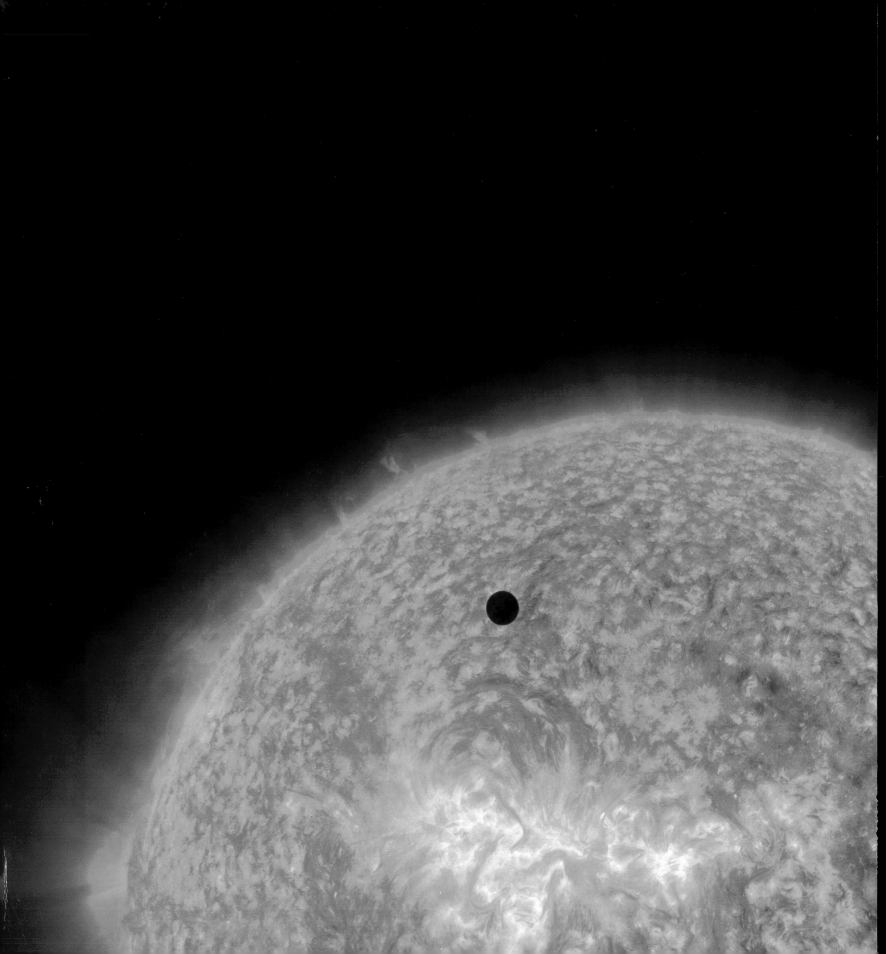

OTHERWORLDS

VISIONS OF OUR SOLAR SYSTEM

MICHAEL BENSON

Abrams, New York

title page

Venus Passing in Front of the Sun

Venus is the small black dot in
the upper left. Because the solar
observatory that took this picture
was orbiting our planet, the true
size of Venus in relation to the
Sun is apparent. The Sun contains
99.86% of the mass of the Solar
System, and Venus is almost
exactly the size of Earth.

Composite ultraviolet photograph.
Solar Dynamics Observatory,
5 June, 2012

Library of Congress Control Number: 2016949534

ISBN: 978-1-4197-2445-9

© The Trustees of the Natural History Museum
Text and images © Michael Benson/Kinetikon Picture
Foreword © The Trustees of the Natural History Museum

First published by the Natural History Museum
Cromwell Road, London SW7 5BD

Image processing, optimization and sequencing by Michael Benson
Designed by Human1st, Slovenia, and Kinetikon Pictures

Printed and bound in Slovenia
10 9 8 7 6 5 4 3 2 1

Abrams books are available at special discounts when purchased
in quantity for premiums and promotions as well as fundraising
or educational use. Special editions can also be created to
specification. For details, contact specialsales@abramsbooks.com
or the address below.

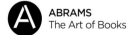

ABRAMS
The Art of Books

115 West 18th Street
New York, NY 10011
abramsbooks.com

MIX
Paper from
responsible sources
FSC® C057358

Table of Contents

Foreword

Dr. Joseph Michalski

So much depends on perspective. In photography, it's inescapable; the two-dimensional depiction of our three-dimensional reality results in complex geometrical relationships that, fascinatingly, communicate size, depth and distance in a unique way to each viewer. While the word 'perspective' (latin *perspectivus*) originally related only to the literal meaning of optics and sight, the word eventually has come to equally signify the figurative concept, referring essentially to how we see our world.

Michael Benson's work, *Otherworlds: Visions of Our Solar System*, emphasizes the notion of perspective. The planetary landscapes photographically depicted here include size, scale and distance relationships that are nearly unfathomable; the photographic perspective on immense, distant alien planets and moons toys with the human mind. But more importantly, these spacecraft data allow us to look back at our home planet from above and to understand our Earth in the context of our cosmic neighbourhood. In this way, this photographic journey through our Solar System is a perspective-changing experience.

For millennia, Earth is all we have known. Yes, astronomy is one of the oldest sciences – humans have always looked to the cosmos in an attempt to understand the harmony of nature, to gain perspective on the meaning of our experiences. But our imaginations have always been shaped by our limited terrestrial confines. The cosmic dance of celestial objects overhead, the systematic movements of the Sun, on which we depend, and the planets – they have always been but points of light, like fires in the sky. Until the space age. After thousands of years of two-dimensional life on the surface of planet Earth, humans, in less than 100 years, first took to the skies and, shortly thereafter, left the gravitational grasp of our planet.

In so doing, we have launched yet another renaissance – a truly transcendent moment in human history. For the first time, we have created machines that will outlive us. The Voyager spacecraft (plus a couple of others) are leaving our Solar System. They will still exist when, in four to five billion years from now, our Sun expands and dies, roasting the Earth and anything on it. But our avatars will still be flying through interplanetary space, carrying with them a coded, probably incomprehensible message from their creators.

But exploration is not just about legacy – it is about answers. While the scientific revolution, and telescopic observations in particular, transmuted mythological systematic phenomena observed in the night sky into comprehensible, systematic workings of nature, these objects were still largely just points of light. Since the space age came into full-force with the launch of Sputnik in 1957, humans have had the audacity to visit our former gods.

Michael Benson's work takes us on a voyage from planet Earth into the ether. We begin in low Earth orbit, seeing our planet as it is – a precious blue orb floating in the darkest emptiness one can imagine. Suddenly, our simple two-dimensional lives expanded immeasurably. For example, that rain you felt on the coast of Mexico, that was a moment in time within a dynamic

storm larger than the entire country. This synoptic view of our planet demonstrates that it is a complex geosystem, of which we are but a single part. Yes, this amazing planet is indifferent. It and the processes that occur within it are much bigger than us. Seeing the Earth from space de-emphasizes our anthropocentric perspective.

We next visited the Moon. We found that our natural satellite, which can accurately be considered a double planet with our own, may not be a deity dancing in the sky, but is in fact a literal remnant of our own creation. Lunar exploration has shown that the Moon was likely created through a catastrophic collision between the early Earth and a large proto-planet. The debris from that collision coalesced to form the Moon. This calamity speaks to the chaotic and violent nature of our earliest Solar System history, our origin. Ironically, the cratered surface of the ancient lunar crust is also a clear reminder of how meteor impacts have shaped the extinction and evolution of life on Earth, and could be part of our future.

As we evolved as a space-faring species, we visited our planetary neighbours, Mars and Venus, and then went on to explore Mercury, the Sun and the gas giants of the outer Solar System: Jupiter, Saturn, Uranus and Neptune.

We know the least about our nearest neighbour, the cloud-shrouded Venus. But perhaps this planet has taught us the most in certain ways. The most Earth-like planet in the sense that it is nearest to us and approximately the same size, same mass and therefore the same gravity, it possesses an amazingly hellish landscape beyond imagination. Pervasive volcanoes shape the surface, and temperatures in excess of 450° Celsius (850° Fahrenheit) liquefy rocks. The weight of the dense CO_2 atmosphere would crush a human's bones in less than a second. Venus stands out as the best possible example of a natural run-away greenhouse. If Venus is a god of love, she sure has a strange way of showing it.

Mercury displays a volcanic, impact-cratered landscape not unlike that of our own Moon. Dangling perilously close to the Sun's plasma flares, Mercury is still a world of contradiction. Without an atmosphere, the day-night temperature contrast on Mercury is astounding. It bakes to over 400° Celsius (750° Fahrenheit) in the sunlight and falls to lower than -170° Celsius (-270° Fahrenheit) at night. Mercury, named after the 'messenger' god because he changes position in the sky so quickly, completes an orbit around the Sun in just 88 Earth days. But, a day on Mercury lasts 58 Earth days. Amazingly, this means a year on Mercury is about 1.3 Mercurian days. Perspective matters.

While not literally the closest planet to Earth, Mars probably is the most Earth-like. Though smaller than Earth, this solid planet has a surface area roughly equal to the land area of our world. Landscapes bearing sand dunes, volcanoes, glaciers and dried river channels and lake beds are all reminiscent of Earth's geology. Originally considered the god of war for its red colour, Mars has been revealed as a frozen benign desert. The red colour is the result of an oxidized, iron-bearing surface. An amazing thing we've learned about Mars is that it might contain a time capsule of geological information critical for understanding the origin of life. While our planet has been continuously active for billions of years, Mars is different. Mars was very active early on, like Earth. But that activity greatly slowed down about 3.5 billion years ago and therefore secrets to processes characteristic of the early Solar System – and so early Earth – are locked into the pristine rock record on the Martian surface. Ares might one day reveal secrets to the origin of life.

In the outer Solar System, we have observed gaseous giants that are so enormous and powerful that our minds can barely comprehend the scale and power of these objects. Jupiter has had a storm that is three times the size of Earth raging for hundreds of years. Neptune has a similar storm with winds nearly twice the speed of sound. Saturn exhibits wispy rings more than 100,000 kilometres across and only tens of metres

thick. These might be the remnants of an ancient moon torn apart by gravity. Imagine. Moons captured by gravity. Moons that exist for a while and then are destroyed by gravity to create truly magnificent rings which themselves are just a passing phenomenon.

The Solar System is dynamic. No two moments will be the same. These images of our star system are unique because they have captured nature as it is, or rather as it was at the time of the photo. This book and exhibition demonstrate incredible photographic beauty and perspective. They also take us on a voyage of discovery. We see our home in a different context. Earth is so special, so unusual, we cannot help but appreciate its beauty. And likewise, vistas from other planets take our breath away. But, most importantly, this grand voyage into the cosmos has taught us about our context in nature.

Welcome to Michael Benson's vision. We children of Earth – literally made of stardust – have achieved adolescence. This journey describes a species attempting to understand its place in the universe.

Introduction

Michael Benson

Each epoch produces its monuments. They may be literal, as in the pyramids or Acropolis, or figurative, as in *The Odyssey* or Fra Angelico's *Annunciation*. The Great Wall, the Baghava Ghita, the haikai of Yosa Buson; all seem to embody their period of human history in the same way a fine wine can contain the essence of the hillside on which its source grapes grew, and the record of that year's seasons.

The events of the last century, to say nothing of the last five or six decades, have been so exponentially overstuffed with kaleidoscopic inventivity, so replete with architectural innovations and cultural landmarks, that it's hard to tease out those that may ultimately signify. It's even hard to characterize it as a single period. While a comparatively short span, historically speaking, it has been filled with so many chapters, so many evolutionary and revolutionary developments, that future historians will be busy for generations trying to figure it all out. What was more important, the arrival of TV in the 1950s, or the rise of the Net? Who will win out in the end, Gehry or Serra? Will anybody remember Damian Hirst or Jeff Koons in a hundred years, let alone a thousand? Will future citizens still listen to Eno's *Another Green World*, or read Gaston Bachelard, at least occasionally? It's impossible to say.

The show of photographic prints *Otherworlds: Visions of Our Solar System* presents the case that the visual legacy of planetary exploration is an artifact of our times that may prove to have lasting significance. Although clearly the result of a sustained scientific-technical effort, *Otherworlds* positions that legacy as belonging to

culture – to the arts and, specifically, to photography. (And with still more particularity, the works contained in *Otherworlds* belong to that seemingly outmoded genre, the landscape. Which raises the question, could the landscape be considered marginal at least in part because we've run out of terrestrial frontiers?)

As of this writing we're just shy of six decades since that now-evaporated country, the Soviet Union, lofted a tumbling, bewhiskered satellite into Earth orbit. Although Sputnik, Russian for 'fellow-traveller,' an 83 kilogram (183 pound) magnesium-titanium-aluminum sphere, carried no scientific instruments let alone camera systems, it did transmit a radio beacon, which in turn provided information about the ionosphere. And the speed of its orbital decay spoke volumes about the density of the upper atmosphere. While the satellite triggered what became known as the Space Race, a short-lived period during which the USSR and the United States effectively raced each other to the Moon (news flash: the US circumnavigated with a manned spacecraft, Apollo 8, in 1968 and landed the next year), it also for the first time sampled the nearest shore of an exceedingly vast expanse of space and time – one so staggeringly immense that it could only be called a 'new ocean,' as John F. Kennedy did, at the risk of sounding hopelessly, provincially Earth-bound.

These events in turn inaugurated a new genre of achievement: unmanned exploration. Woefully underfunded compared to the expensive crewed missions, a succession of increasingly sophisticated robotic spacecraft nevertheless conducted the true exploration of

the Solar System. After millennia of speculation about the nature of those mobile points of light that the Ancient Greeks called *planētēs*, or wanderers, much of the Solar System has now been opened to human eyes for the first time. In the last six decades we've seen, in great detail, the largest canyons and highest mountains within the domain of the Sun, on the fourth planet, Mars; a vast anticyclonic storm three times the size of Earth, raging on the face of Jupiter, called the Great Red Spot; and geysers of liquid water venting into space from Saturn's moon Enceladus, a kind of endless upwards waterfall feeding into and sustaining the planet's nebulous outer E-ring. We've also made the staggering discovery of a vast global salt water ocean under the grape-skin ice crust of Jupiter's moon Europa – one that may contain several times as much liquid salt water as in all the oceans of Earth combined.

Apart from their physical locations many billions of miles away, most of these revelatory visions have been conducted at the farthest peripheries of our rather self-absorbed view of things. They're the domain of specialists and a small tribe of science and space geeks. We Earthlings, it has to be said, are largely myopic creatures – woefully preoccupied by our provincial squabbles, our tedious internecine power grabs, our pop cultural events and manufactured scandals. It's at the expense of a more capacious view. Only occasionally, when a particularly stupendous interplanetary achievement unfolds – for example, the extraordinarily virtuosic sky-crane descent of NASA's compact-car-sized Curiosity Rover in 2012, a kind of hyperkinetic extraterrestrial conjuring act that served to underline yet again the truth of Arthur C. Clarke's famous dictum, 'Any sufficiently advanced technology is indistinguishable from magic' – only very occasionally does the collective human gaze rise above the terrestrial to the celestial. (Enough to ensure the widespread popularity of these efforts, however – something verified by polling.)

And yet there are many reasons why the ongoing story of robotic space exploration merits our keen attention. Among other things, it's one place where Vernor Vinge's concept of a 'technological singularity' may incrementally be coming true. (Best known from Ray Kurzweil's 2005 book *The Singularity Is Near: When Humans Transcend Biology*, the idea posits that humanity will be supplanted by a superhuman artificial intelligence). Those small squadrons of automated explorers, each more sophisticated than the last, have served as our remote sensing organs. Doesn't it make sense, given the frailty and limited shelf-life of mortal men and women, that as technology progresses a way might eventually be found to in effect transplant our intelligence and curiosity directly into our spacefaring machines? A particularly creepy, unsettling kind of sense...

And then there's the visual legacy of the activity – the subject, of course, of *Otherworlds*. We've effectively vaulted right through the Sistine Chapel ceiling, after all, and are well into witnessing the real thing. It's a central premise of *Otherworlds* that whatever its undoubted significance within the annals of scientific inquiry, the visual legacy of solar system exploration constitutes an audacious, utterly consequential chapter in the history of photography – and indeed of all graphic visual representation, starting with the caves at Chauvet and Lascaux. While these spacecraft didn't necessarily go to the planets with the intention of being the most far-flung landscape photographers in history, that doesn't mean that if their data is properly re-evaluated and repurposed – to say nothing of reprocessed and edited – they can't play exactly that role.

In fact the excavation of raw image data, which usually can be found in the archives of these missions as fairly low resolution individual black and white frames, and the processing of it to make colour composites, and the further tiling of those colour frames together to make panoramic mosaic views – all of this is one way that the true achievement of these expeditions can be seen, evaluated and properly understood. Our superbly engineered avatars have been scoping out the border between the known and unknown. They've

been witnessing alien landscapes so eerily strange, or for that matter hauntingly familiar, that they've forced us to re-evaluate our own experience. They've provided occasion, in other words, to reformulate and expand on our native context, here on our gloriously beautiful, but ultimately circumscribed, planet Earth.

Where the science motivating these trajectories can sometimes seem arcane, the view through the portholes punched into space and time along the way can be a revelatory, even a life-changing experience – one open to non-specialists. In some ways it's a populist activity, enabled by powerful digital image processing tools, a set of keys unlocking 60 years of frontier visions from their slumber in the archives.

There's an element of the old Situationist and Letterist strategy of *détournement* in this repurposing, as well, though here not at the service of political pranksterism – even if it does have an ethical, even a political dimension. (*Détournement*, literally translated, means 'rerouting,' though it has also carried the connotation of hijacking.) *Otherworlds* also contains certain links to the mystical Russian philosophy of Cosmism, with its insistence, via Konstantin Tsiolkovsky, that 'Earth is the cradle of the mind, but humanity can't remain in its cradle forever.' As with science, the production of these photographs from multiple elements that have been transmitted, in a chain of zeros and ones, across the solar system, is about discovery. But it's a very different order of discovery than the kind sought by pure research. Still, the links between those two modes of inquiry, science and art, are everywhere evident in these photographs. And ultimately, *Otherworlds* simply confronts its viewers with what amounts to a series of 'Behold!' moments. Yes, these places really exist. And yes, they really look like that – on a good day.

I got to know Arthur C. Clarke during the last decade of his life, and remember one quite moving discussion with him. We'd been talking, in the Sri Lankan heat, about the predictions of Tsiolkovsky and of Clarke himself, concerning the ultimate expansion of the species into the Solar System. Both of these Space Age architects had held out the tantalizing prospect of our transformation into a truly multi-planet civilization. But things didn't seem to be unfolding in that way.

It was 2001 – a year not without its significance in Clarke's story – and I had just finished reading his 550-page compendium of essays, *Greetings Carbon Based Bipeds*. Organized by decade, the book takes its readers through the evolution in the great futurist's thinking about humanity's destiny in the cosmos – from a quasi-utopian belief in our future among the stars, to a more rueful millennial realization that things may not turn out quite according to his projections. The concluding thoughts call to mind Bachelard's observation, in *The Psychoanalysis of Fire*, that 'Science is formed rather on reverie than on experiment, and it takes a good many experiments to dispel the mists of the dream.' Clarke admits that he and his fellow travellers may have been a bit too optimistic about the colonization of the planets – or at least, about the time (and form) it might take.

When I mentioned that I had found this admission quite affecting, particularly given the space-faring future so vividly realized in his fictions, Clarke considered the thought for a minute. Then he suddenly flashed one of those wicked crocodilian grins of his. 'Yes, but there's really no reason to be disappointed,' he said. 'Actually we've been lucky to live in the greatest age of exploration the world has ever known. And it's all because of our robotic spacecraft. I wish some of my long-gone colleagues in the British Interplanetary Society could see these pictures!' He shook his head in astonishment. 'I mean, gosh! It's absolutely extraordinary what has been achieved!'

Earth and Moon

In the beginning, the Heavens and the Earth floated side by side within the same astounding sentence. A kind of hierarchy was evoked, but still, an equivalence was implied. It was as though the hulking Earth (with its restless oceans, staggered mountain ranges, bone-dry deserts and teeming jungles) and the immense dome of Heaven (with its wandering lights, its belt of smoke and its spangle of pinpoint fires) were somehow equal. There was little sense, in other words, that the second was within the first, let alone that one constituted everything, and was apparently infinite, and the other was a very specific singular something, and very finite.

Despite this little oversight, both Heaven and Earth were so-named, with the latter set afloat upon the equalizing black papyrus of the former, and if anyone, or anything, eventually looked closely enough down on the face of the waters, that entity — that he, or she, or it — might have noticed the faintest microscopic stirring of self-replicating molecules. This was the force that through the green fuse would eventually drive the flowers. One day it would power the radical thought that the Earth is but a cradle for a civilization destined eventually to expand beyond it.

Our unnamed observer would also have noted the presence of a large satellite, whose cool light and proximity to the Earth might serve as a first extraterrestrial destination, should intelligence ever arise in the sea or land below. Scientific number-crunching has revealed that without this luminous object to stabilize the Earth's seasonal spin, terrestrial temperature shifts would be so extreme as to render the probability of higher forms of life evolving here extremely doubtful. The Earth-Moon system, in other words, is a compound with real implications. The complexity of life forms on the larger requires the gravitational stability provided by its lifeless, ash-grey smaller component. The Moon, you could say, is an outrigger to human development, and its tidal pull can be thanked not just for luring the species off the Earth, but also for helping provide the conditions allowing our development in the first place.

And if our hypothetical observer had waited for about five billion years and then sent a small mechanized investigative tool — a specific kind of device sometimes known as a robotic spacecraft — whipping past this particular blue-white marble? What would he (or she, or it) be able to deduce?

Actually, we're in a good position to say. When the Galileo Jupiter spacecraft went through its complicated

facing page

Earth and Moon

Taken above the Pacific Ocean, this geostationary satellite image captures Earth and the Moon in a single frame. In the mid-Pacific, high clouds near the planet's day-night terminator line glow red with sunrise.

Composite photograph. GOES West, 25 May, 2015

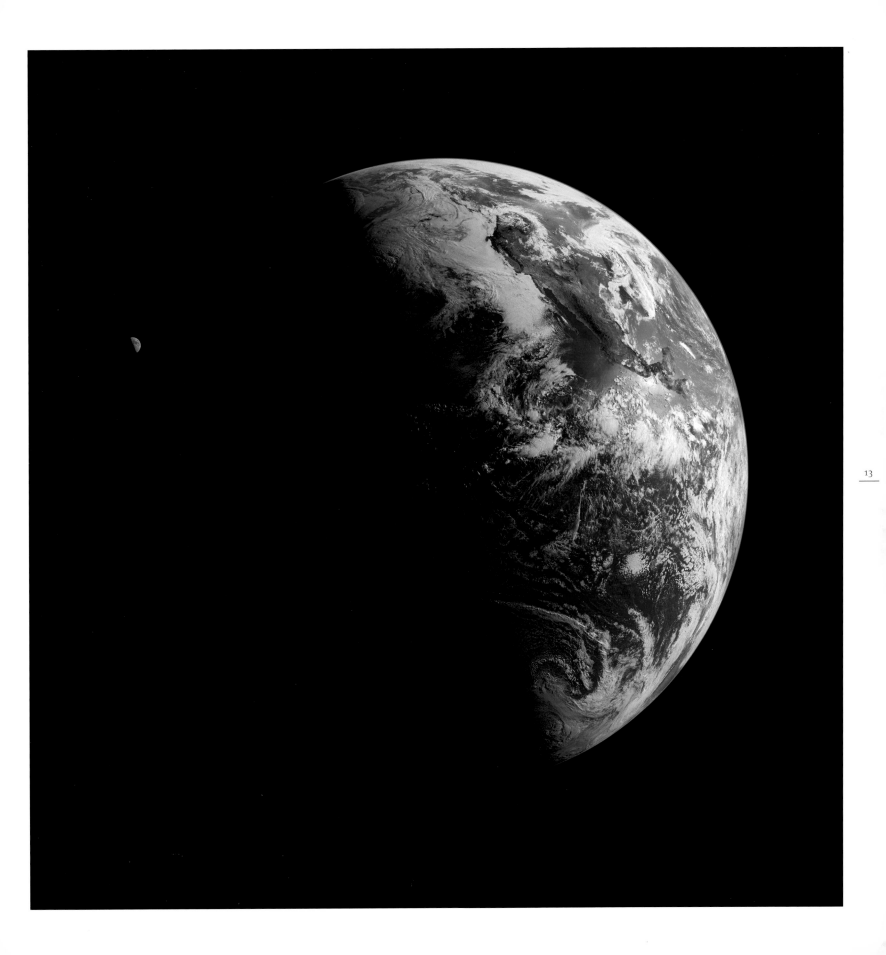

gestation in the late 1970s and early 1980s, among its slate of other problems was the seemingly confounding fact that the only upper rocket stage then available wasn't quite powerful enough to send the robot on its way to the Solar System's largest planet. All wired up and ready to go, this sophisticated device was as stuck on Earth as the metal ores that it had been crafted from — until a certain trajectory specialist named Roger Diehl spent some time grappling with the problem. It was a hard one. The maths was uncompromising; there simply wasn't enough thrust. Late one night, however, Diehl suddenly sat bolt upright in bed. The solution had arrived in the form of a message from the interstices of his subconscious mind. In the morning he punched it into his computer and confirmed that Galileo could get to Jupiter with the existing upper stage. First, however, it would have to go inwards to Venus, and then return to pass the Earth again not once but twice, in order to pick up enough momentum to sling-shot towards the huge outer planet. The flight would take three years longer than originally planned, and the spacecraft would now have to be shielded from the harsh sun near Venus. But it would work.

Apart from suddenly making Galileo's Jupiter mission possible, Diehl's brainstorm meant that for the first time, planetary scientists could use an interplanetary space probe on a classic fly-by trajectory to study the mysterious third sphere from the Sun, a.k.a. Earth. And when another restless scientific mind, this one owned by the astronomer, planetary scientist and best-selling author Carl Sagan, contemplated this fact, it occurred to him that it might be worthwhile to see if the most sophisticated space probe yet built could discover life *on Earth*. And assuming that, what about intelligent life? An appropriate enough project for a robot named after the astronomer who'd first observed that those wandering specks of lights called 'planets' were worlds in their own right.

While the results of this experiment are detailed in Sagan's 1994 book *Pale Blue Dot*, the short version is that Galileo's Earth fly-by data revealed that although this planet probably has life of some sort — an extraordinary enough finding in itself, of course — no unambiguous signs of intelligence could be found. And if this may have an uncomfortable ring of truth to it, and in any case is worthy of some serious debate, it has to be said that this finding came from only Galileo's first pass of the planet. Less well known is the fact that during its second fly-by of the Earth, exactly two years later, another planetary scientist, Dr. Paul Geissler (a man later responsible for providing colour data for several of the pictures in this book) spotted something very strange and provocative in the rugged Western Australian desert. Stark, ruler-straight and hard to dispute, there it was: a hard-edged line demarking the boundary between what appeared to be irrigated green land — and the orange outback.

In the end it was Paul Geissler who discovered that intelligent life almost certainly exists in the Solar System, its tiny sign inscribed on a continent in the southern hemisphere of Planet Earth.

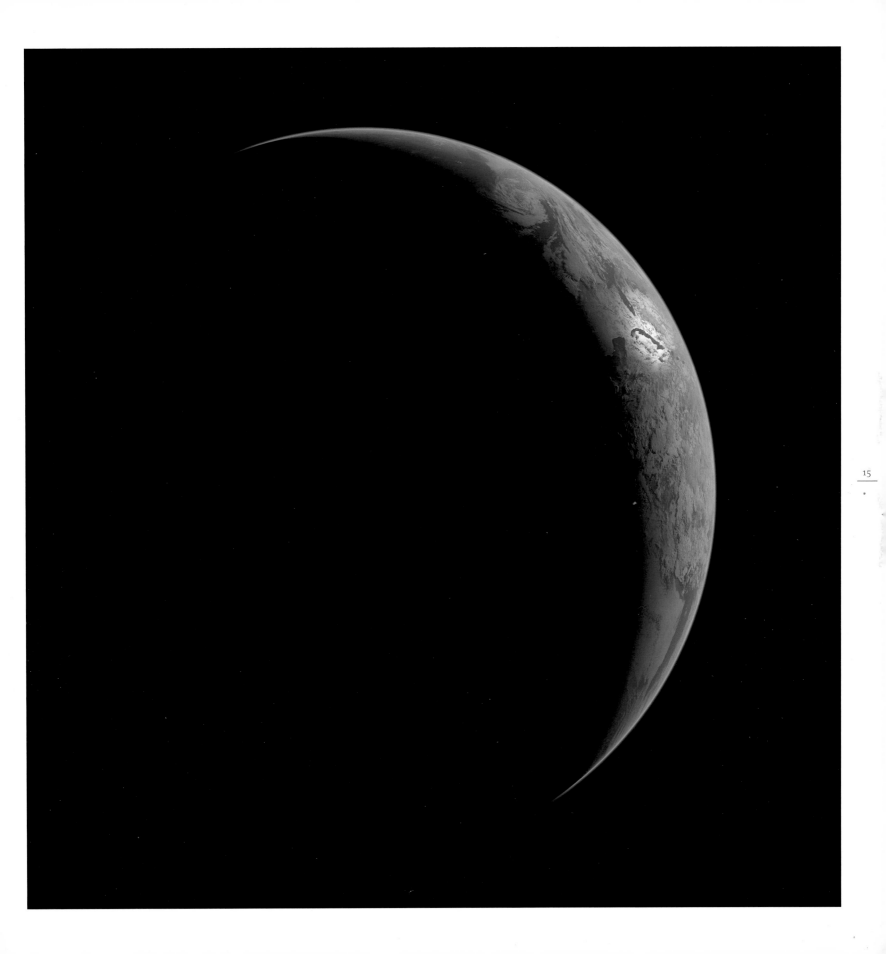

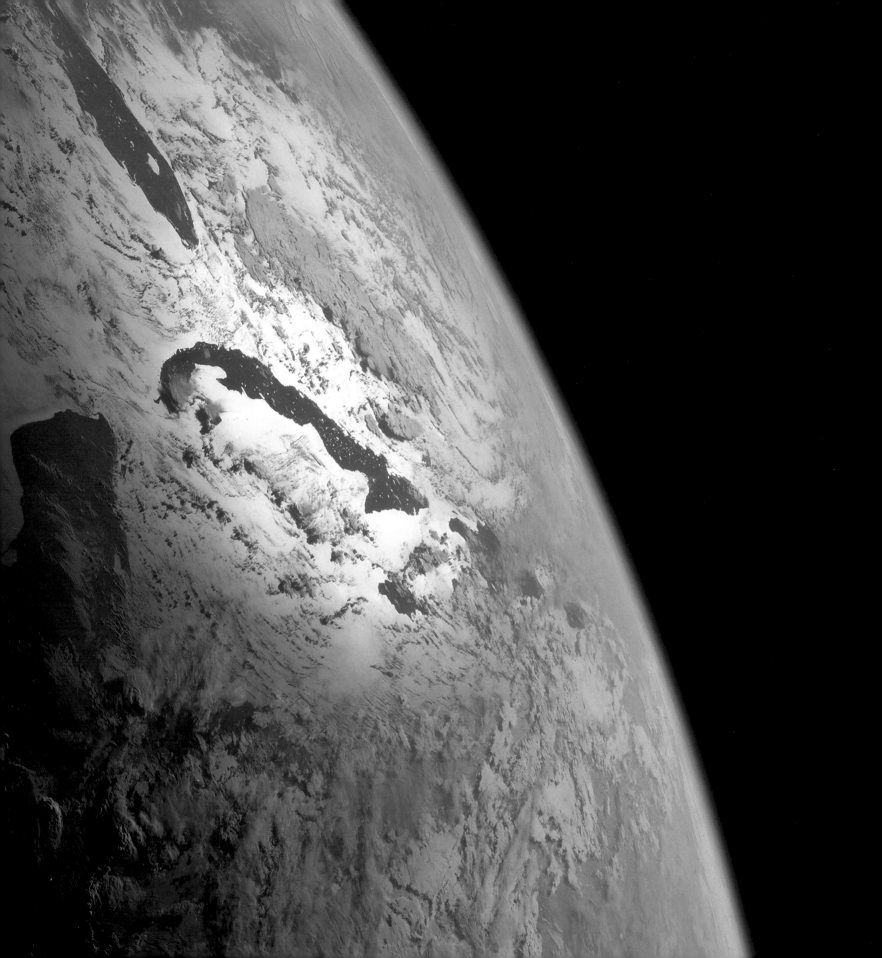

facing page

**Earth, with Hurricane
and Sahara Dust**

This near-full Earth view, taken
shortly before the northern hemi-
sphere summer solstice, shows an
extraordinary variety of phenom-
ena. A vast wall of airborne sand
sweeps across the Atlantic from
the Sahara Desert, ice retreats
from Canada's Hudson Bay and
the perfect spiral of Hurricane
Carlos pirouettes off southern
Mexico's Pacific coast.

*Composite photograph.
GOES East, 13 June, 2015*

overleaf

Detail View

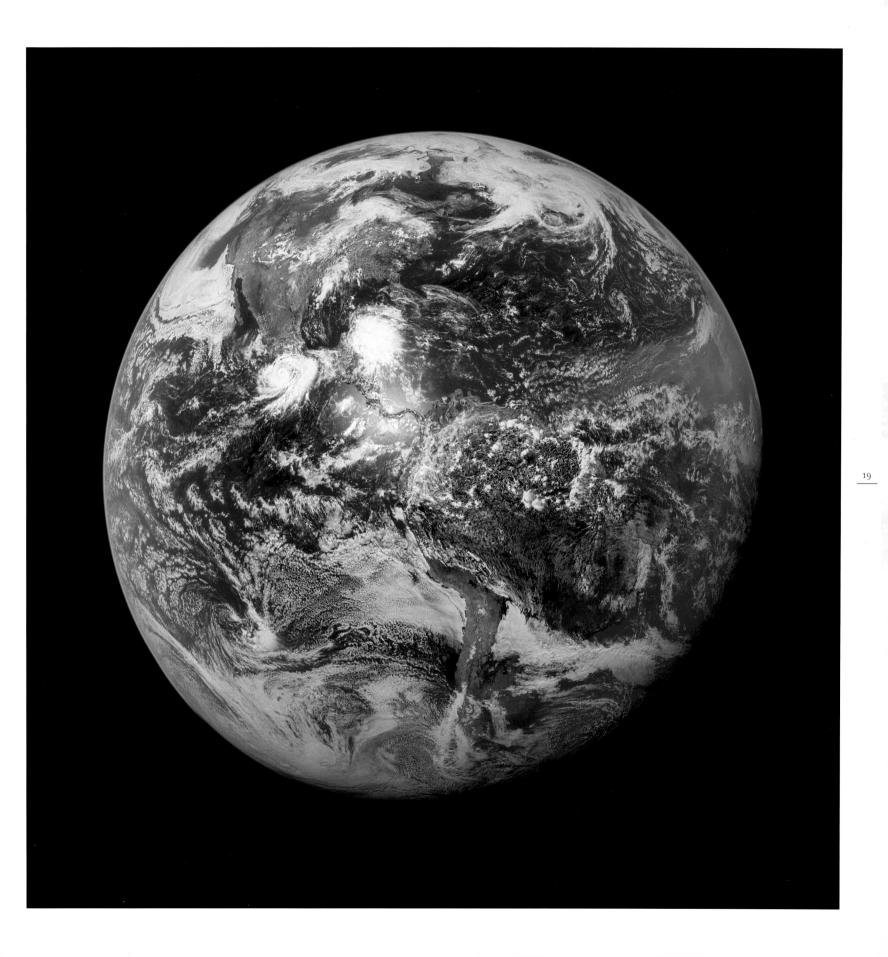

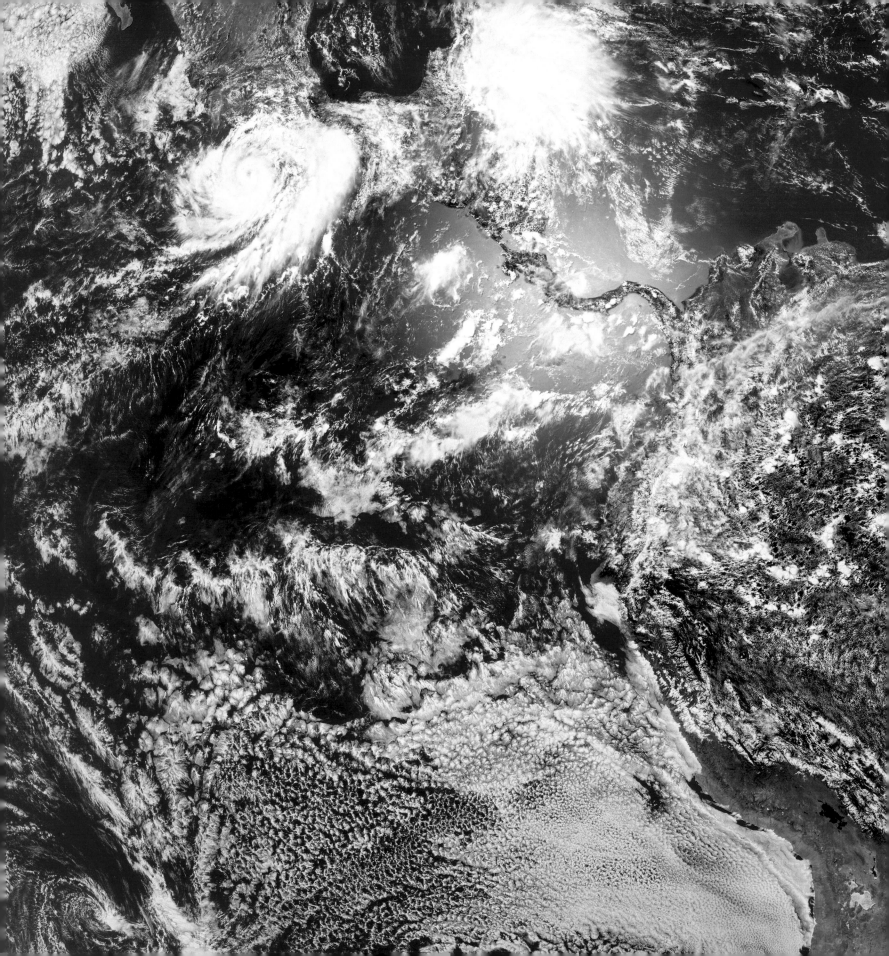

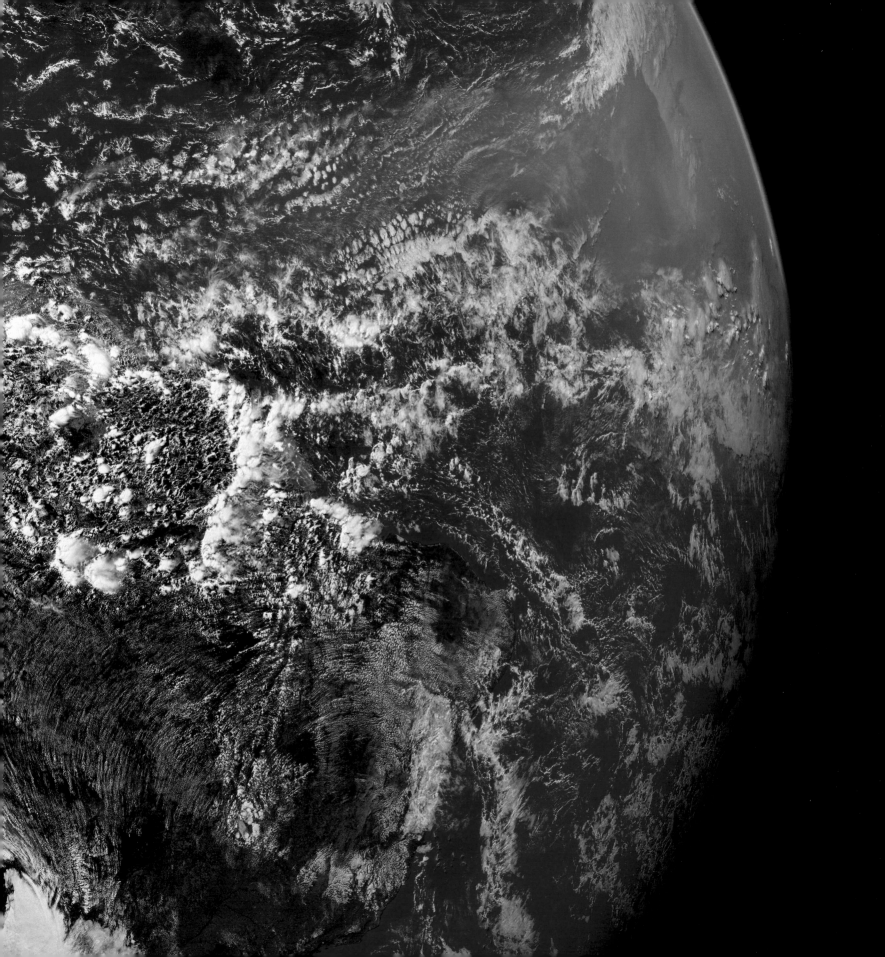

facing page

Sahara Sandstorm

A vast wall of wind-borne sand
sweeps across the western Sahara
before extending out across the
Atlantic and impacting the Canary
Islands. Like most terrestrial
deserts, the Sahara is expanding
at an alarming rate. The amount
of dust in the air has doubled in
the last hundred years.

Acqua, 3 March, 2004

overleaf, left and right

Yucatán Burning

Signs of human intervention
can be seen even from very high
orbits. Here, fires from slash-and-
burn deforestation rage across
Mexico's Yucatán peninsula and
neighbouring Guatemala in April
2003, sending dense plumes of
smoke across the Gulf of Mexico.

Aqua, 19 and 26 April, 2003

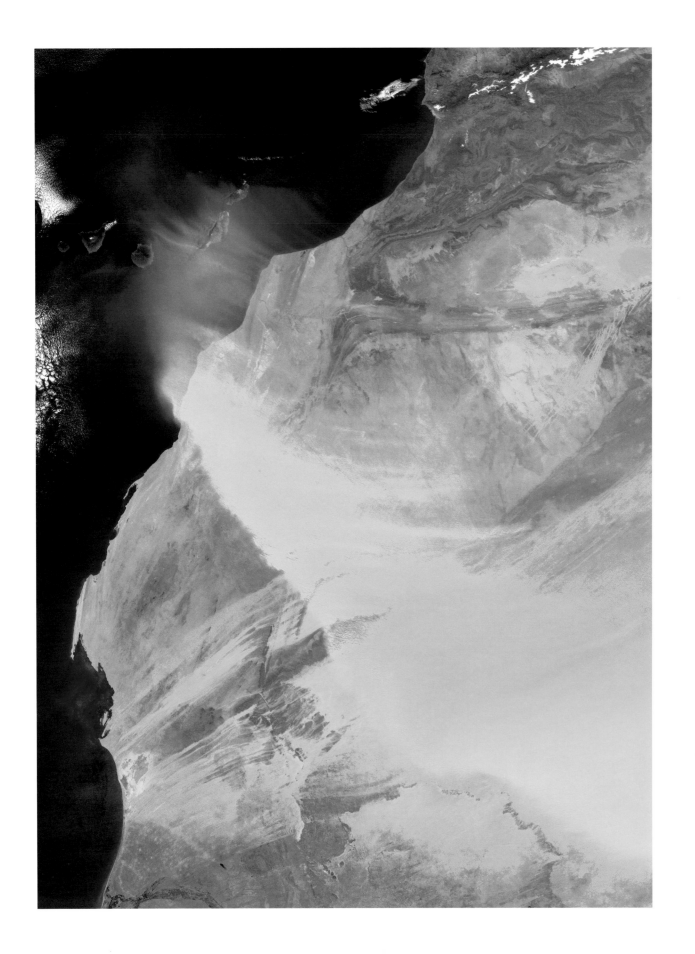

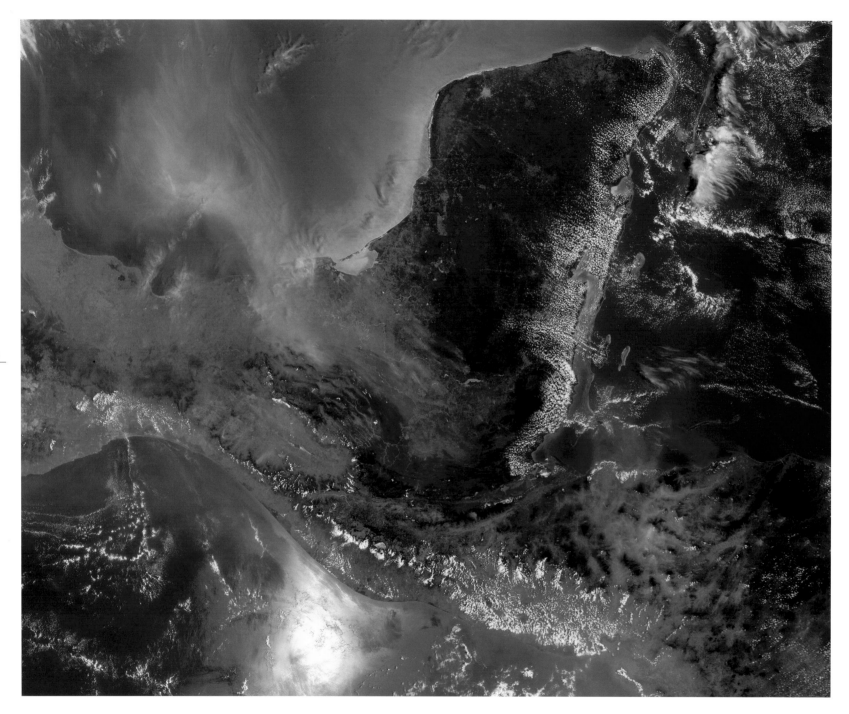

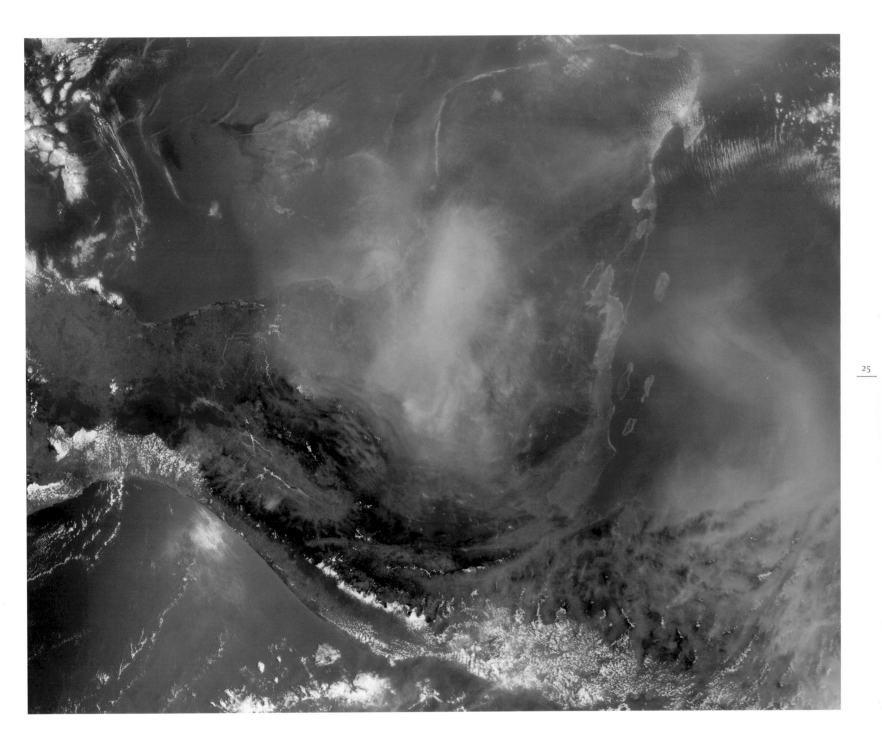

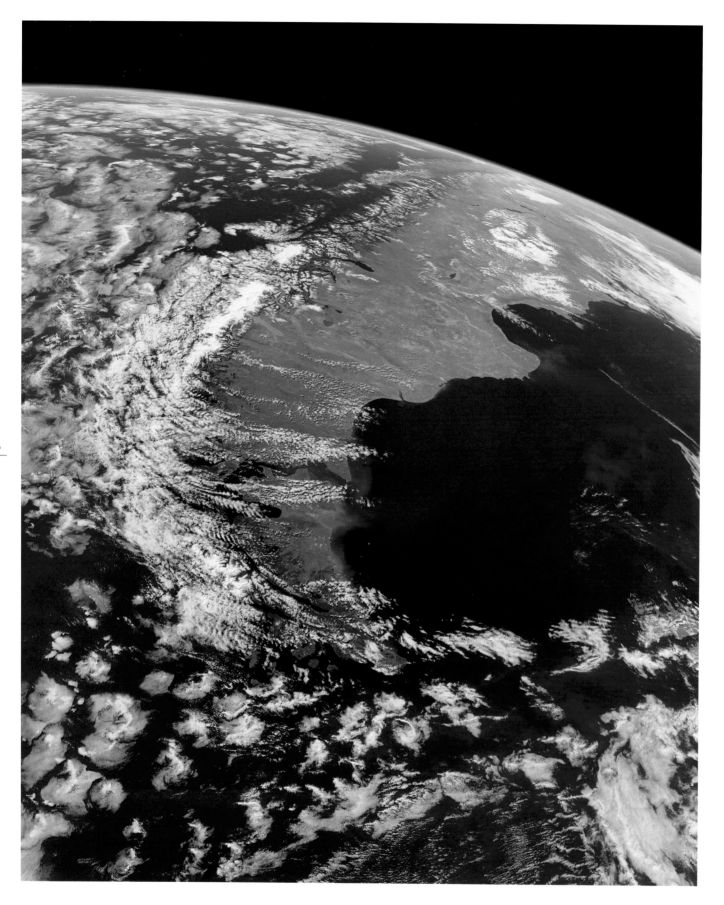

**Southern Tip of
South America**

Tierra del Fuego and the
southern tip of the South
American mainland under
sparse cloud cover. The
southern tip of the conti-
nent curves to the right,
pointing across to the
Falkland Islands, which
are just visible under the
clouds on the far right.
To the West, the Andes
Mountains partially dam
Pacific clouds.

*Orthographic Projection.
Aqua, 12 November, 2010*

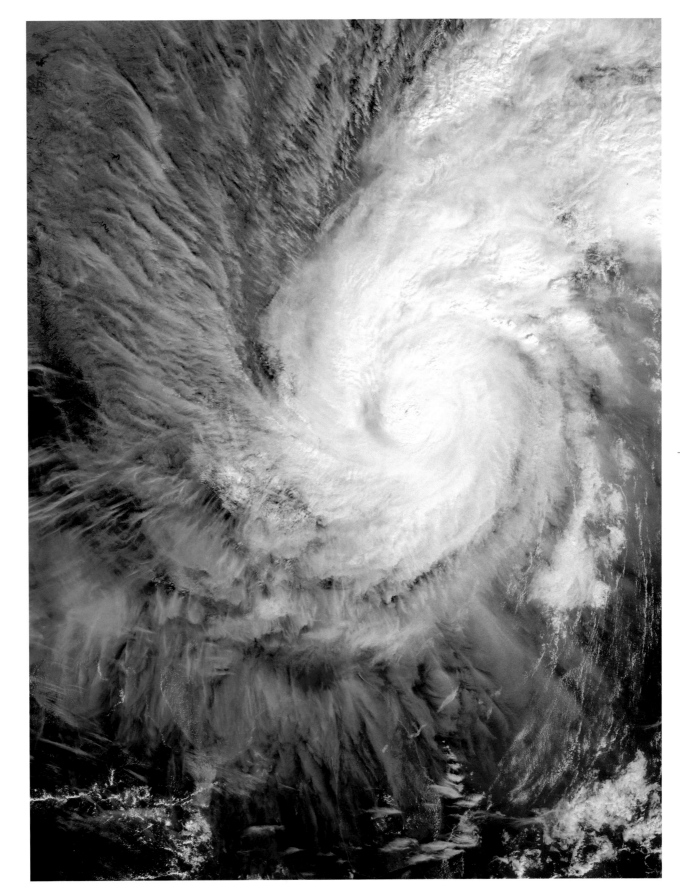

right

**Typhoon over
Bay of Bengal**

The immense vortex
of tropical Cyclone 03B
slams into India's east
coast with wind speeds
approaching 75 miles (120
kilometres) an hour. Be-
low, the teardrop-shaped
island of Sri Lanka is
relatively cloud free.

Terra, 15 December, 2003

Sun on the Pacific

Sun glints off the Pacific Ocean as seen from the International Space Station at an altitude of over 250 miles (400 kilometres). A towering cumulonimbus cloud can be seen to the left, formed by water vapour carried high by air currents. Its flat top marks the boundary of the stratosphere.

ISS 007 crew, 21 July, 2003

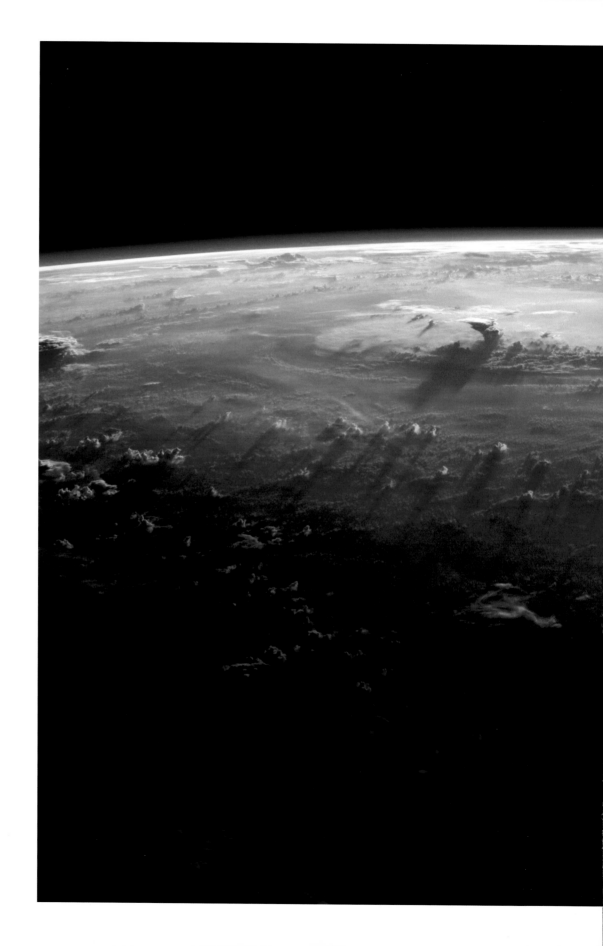

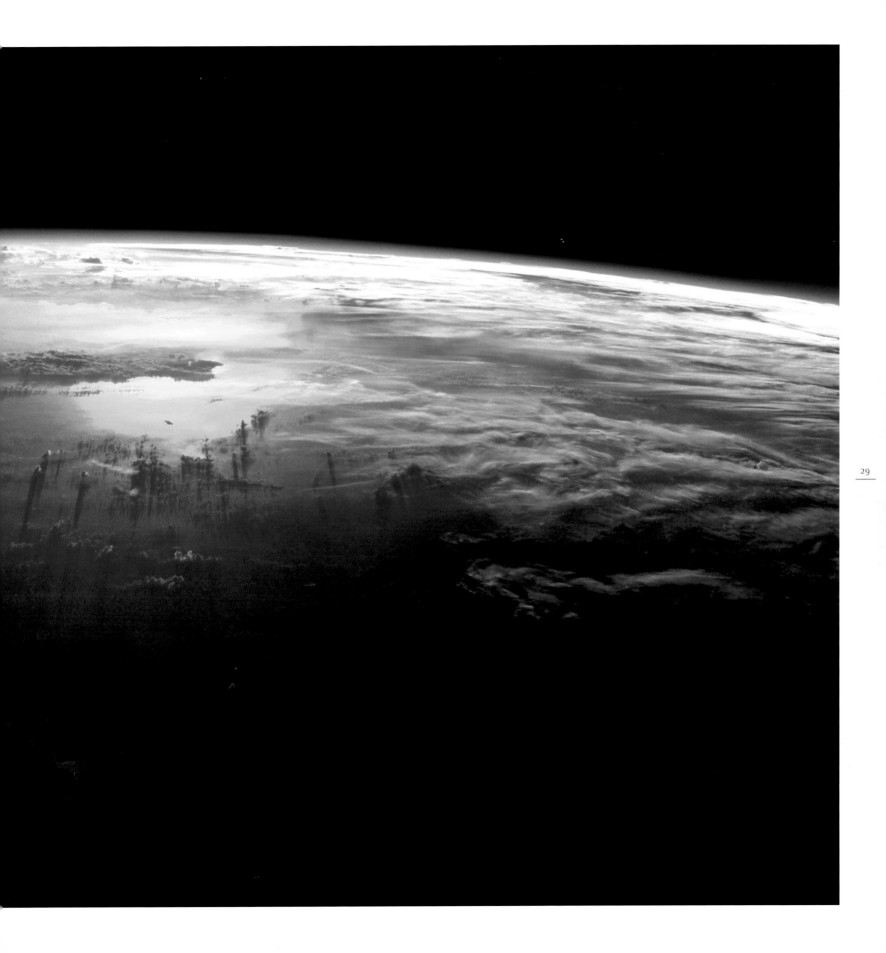

facing page

Eclipse Shadow on Earth

A vast travelling shadow cast by
a lunar eclipse blankets eastern
India and the Bay of Bengal. In the
upper left corner, the snow-
covered Himalayas mark India's
northern frontier. The vast, brown
Tibetan plateau, sometimes called
'the roof of the world,' is above.

Orthographic projection.
Aqua, 15 January, 2010

overleaf

Moonlight on the Adriatic

In this luminous view of southern
Europe, the Adriatic Sea with its
many islands gleams in reflected
moonlight. In the centre, the
Italian peninsula extends into the
Mediterranean Sea. To the lower
right, Milan's road network blazes.
South is up.

Mosaic photograph.
ISS 023 crew, 29 April, 2010

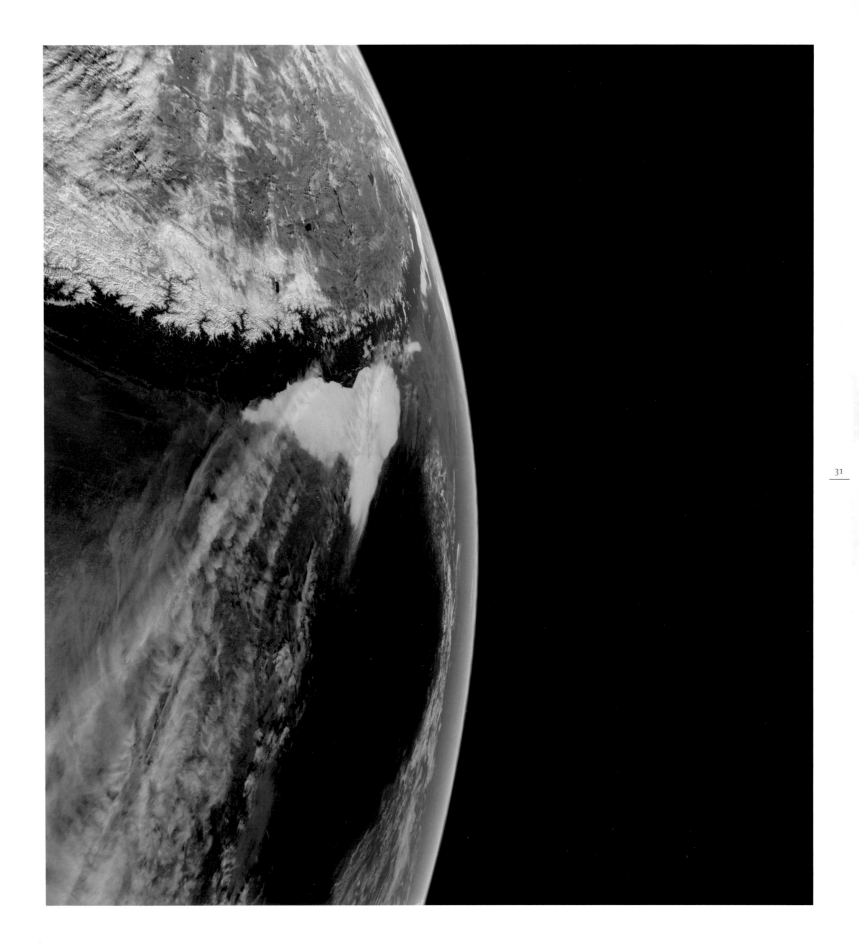

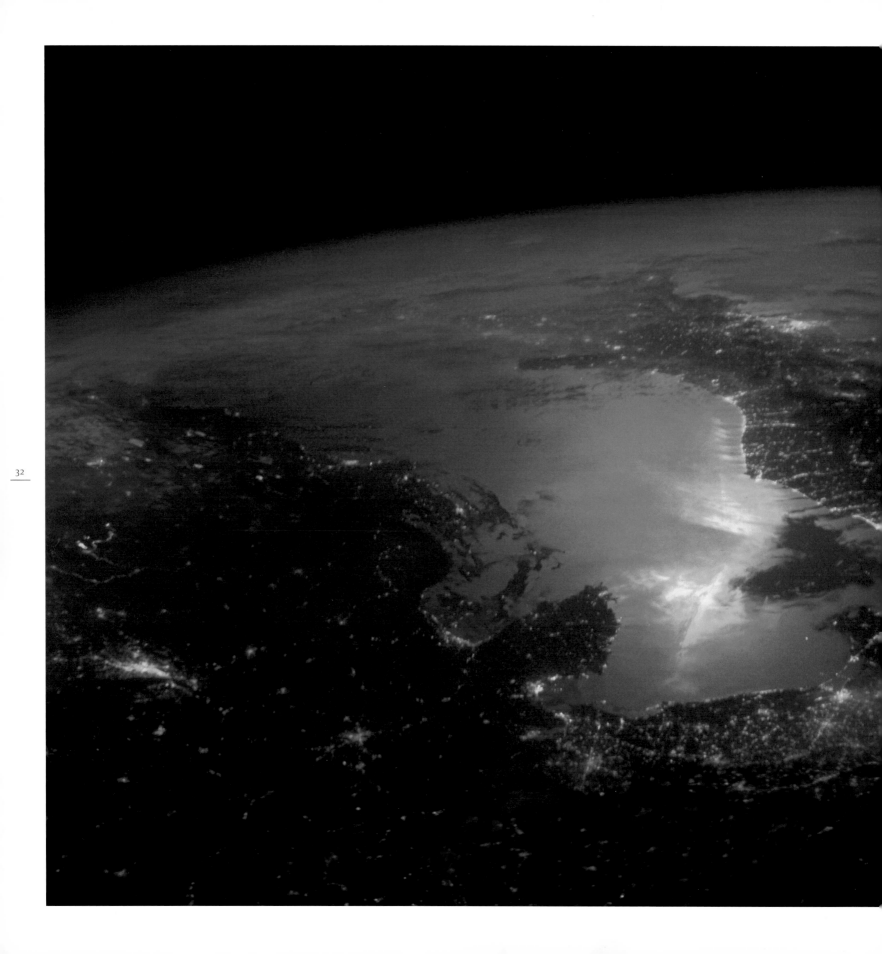

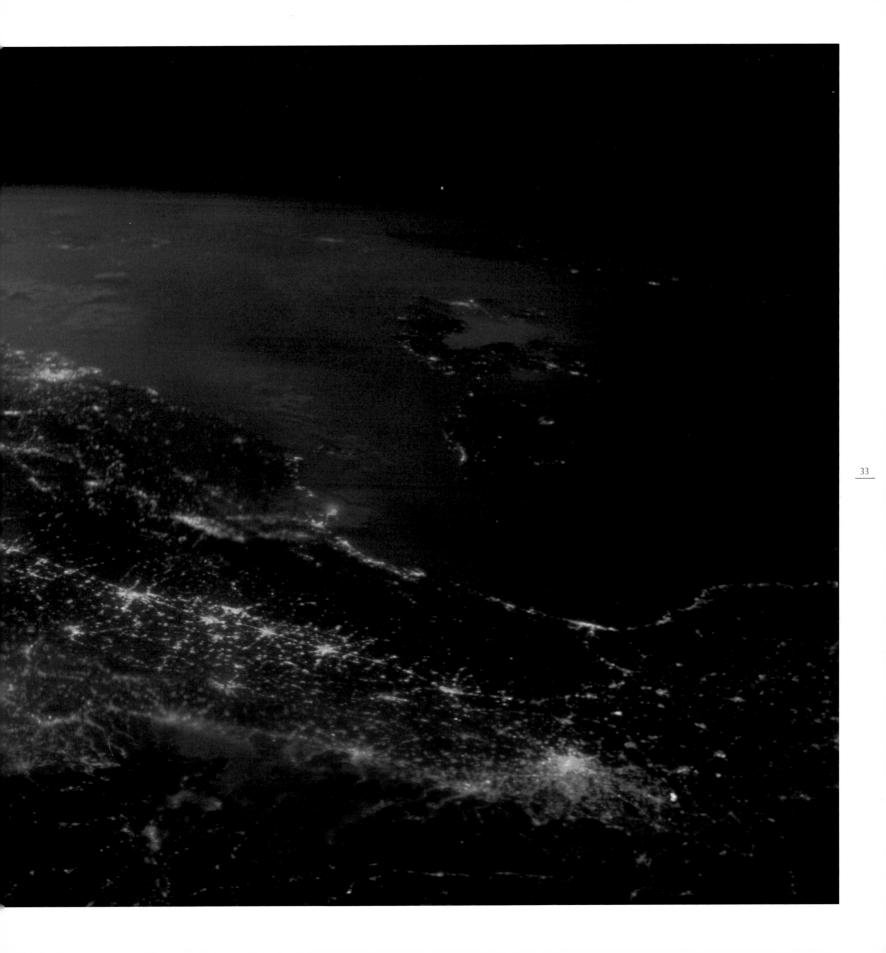

facing page

Crescents Moon and Earth

In this historic image, both the
Moon and Earth are seen for
the first time as paired crescent
worlds, with the western half of
the Moon's far side visible. This
photograph was taken 18 months
before human beings saw earth-
rise over the Moon for the first
time, during the Apollo-8 mission.

Lunar Orbiter 4, 19 May, 1967

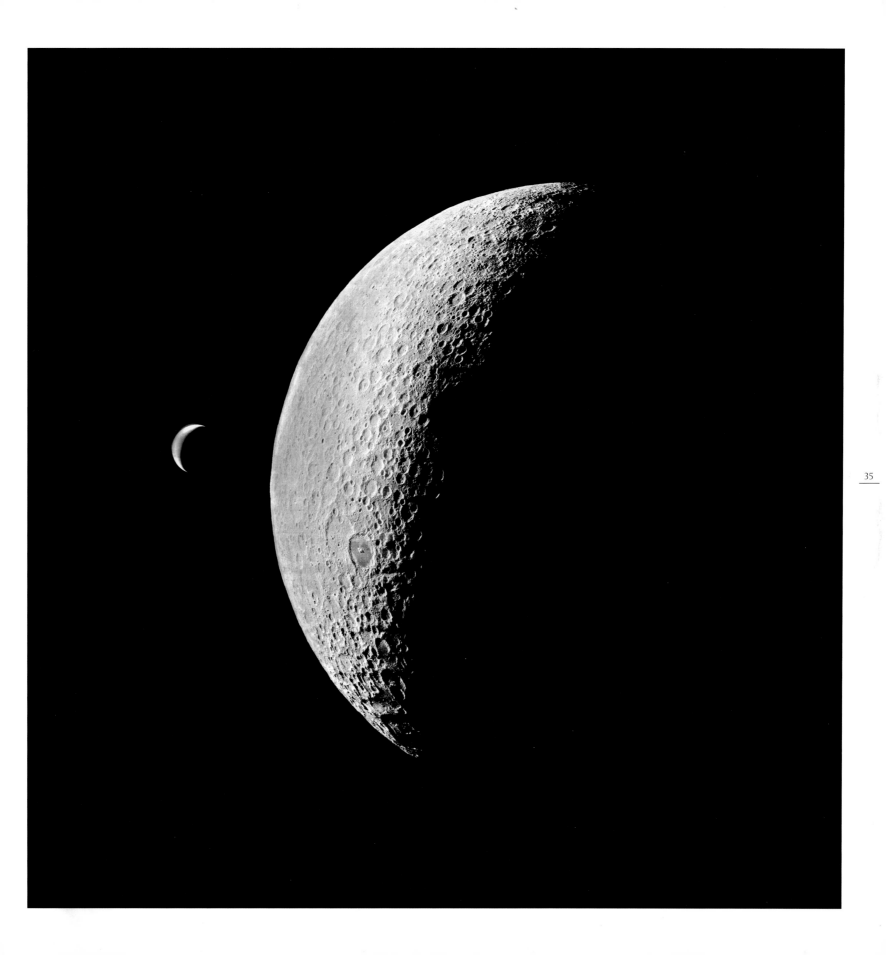

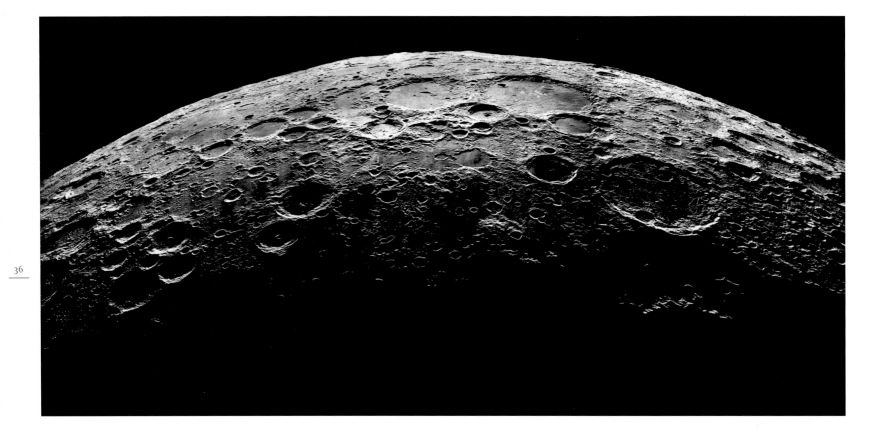

Lunar Limb

In this view of the lunar horizon, among other prominent craters, Von Karman, Leibniz and Oppenheimer can be seen.

Lunar Orbiter 4, 19 May, 1967

Mare Orientale

The Moon's Mare Orientale impact crater is 200 miles (320 kilometres) wide, one of the largest in the Solar System. The outermost circle of the crater is the Montes Cordillera scarp. At 560 miles (900 kilometres) wide and three and a half miles (five and a half kilometres) high in places, these are the highest mountains on the Moon.

Lunar Orbiter 5, 18 August, 1967

Antoniadi Crater Near the Lunar South Pole

A distinctive far-side crater, 89-mile-wide (143 kilometres) Antoniadi has an uplifted central peak, visible to the left, and a well-preserved rim two miles (three kilometres) high. Antoniadi lies within the Aitken Basin, the deepest basin on the Moon. As a result, the floor of the smaller crater, visible just below centre, has the lowest elevation on the Moon.

Lunar Reconnaissance Orbiter, 2 February, 2014

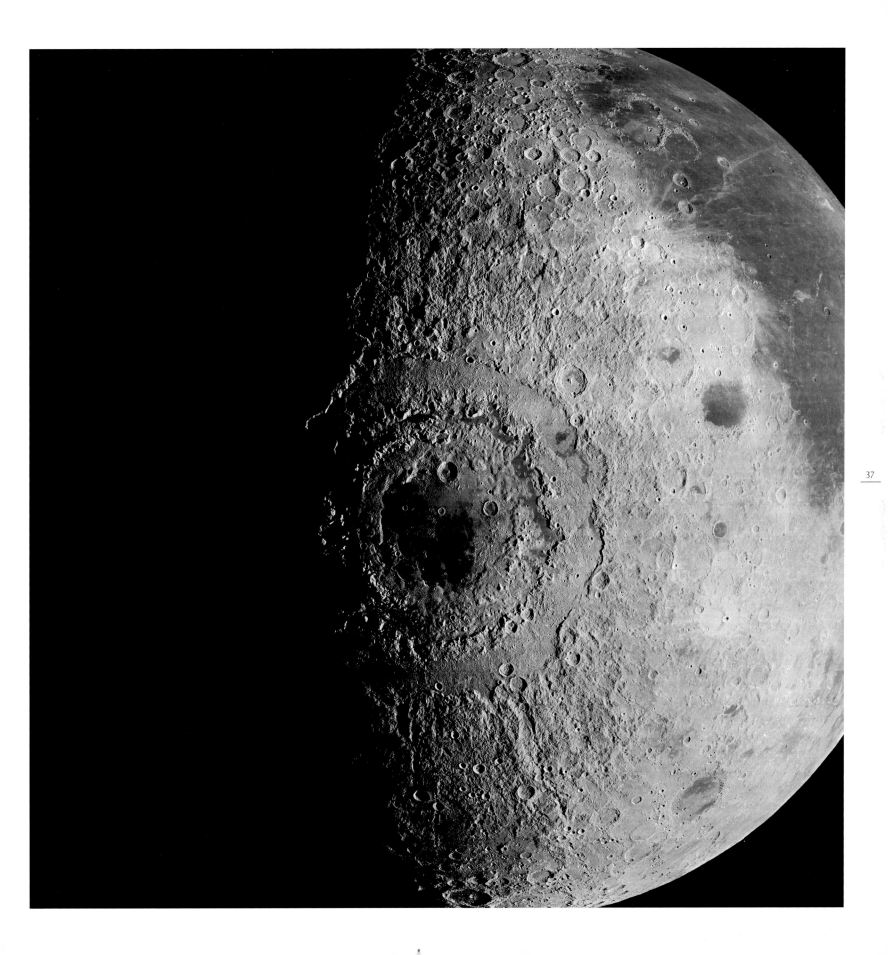

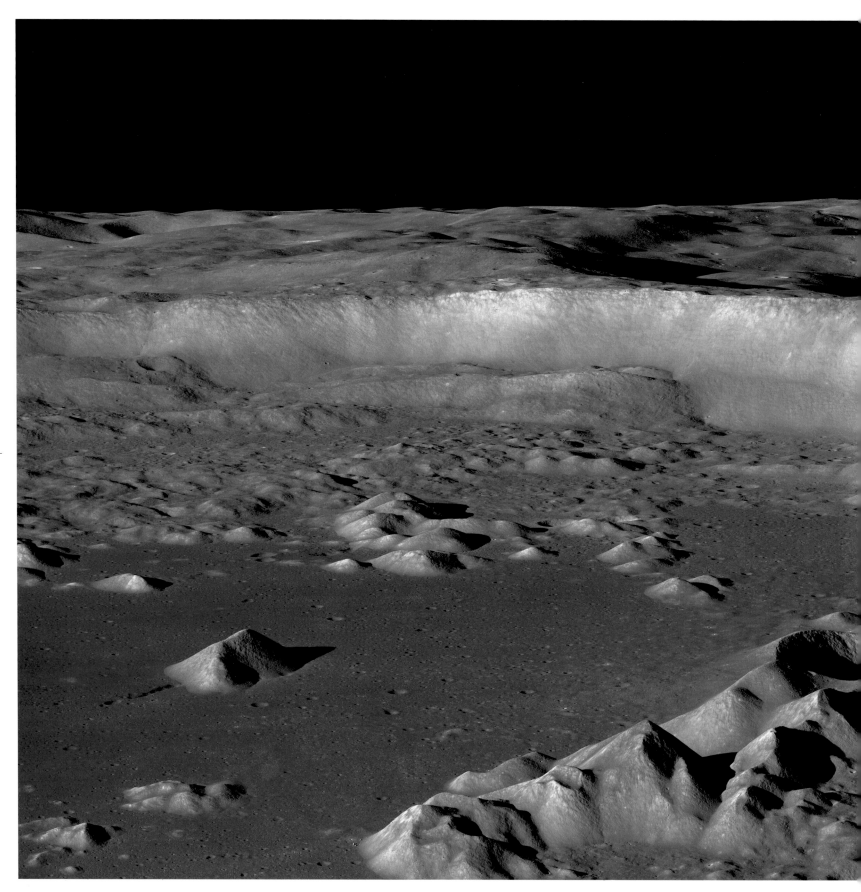

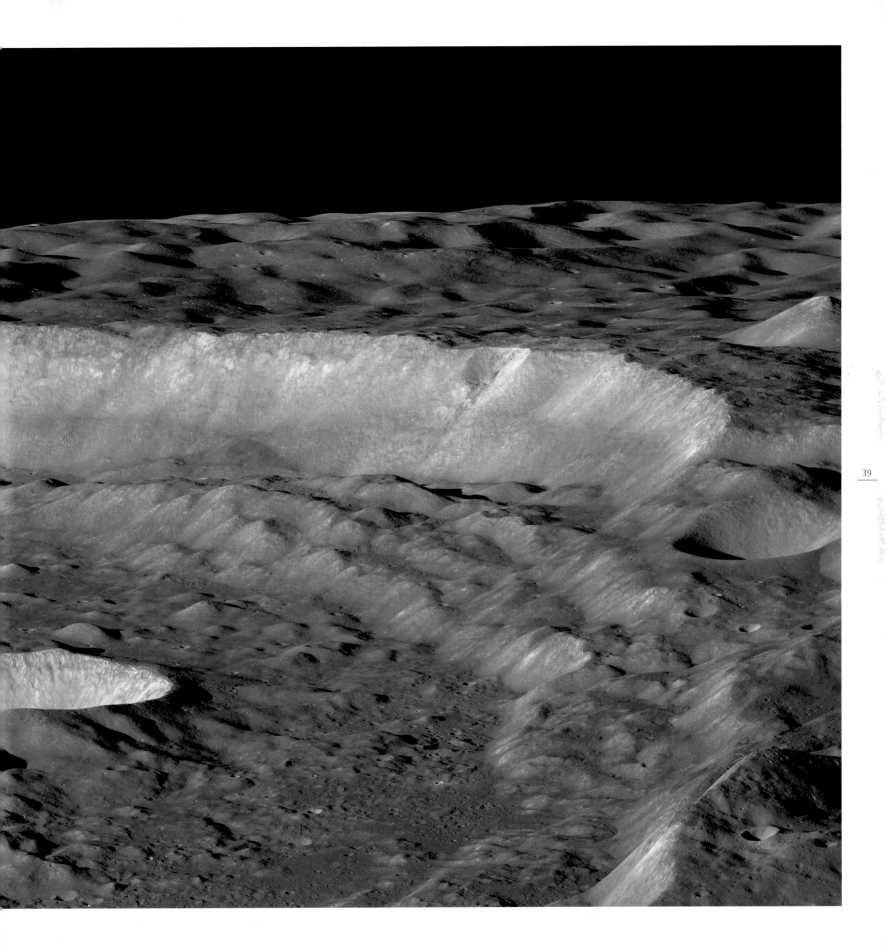

Far Side Lunar Landscape

Lunar hills and craters in raking
light. From an altitude of only 34
miles (55 kilometres), this view
is of the northern hemisphere
west of Mare Orientale, not far
from Rowland Crater. The image
documents the Moon's terminator
line, or day-night boundary, from
an oblique angle.

Lunar Reconnaissance Orbiter
23 June, 2011

overleaf, detail view on right

Earth over the Lunar Horizon

In this image, among the high-
est-resolution pictures ever taken
of our planet from its natural sat-
ellite, Earth appears to hang over
the horizon of the Moon. Because
part of the lunar horizon is in
shadow, a dark band can be seen
between the lit parts of the lunar
surface and the bright clouds
over Antarctica. The Moon always
presents the same face to Earth,
so Earth would never appear to
rise or set from its surface.

Mosaic composite photograph,
Lunar Reconnaissance Orbiter,
12 October, 2015

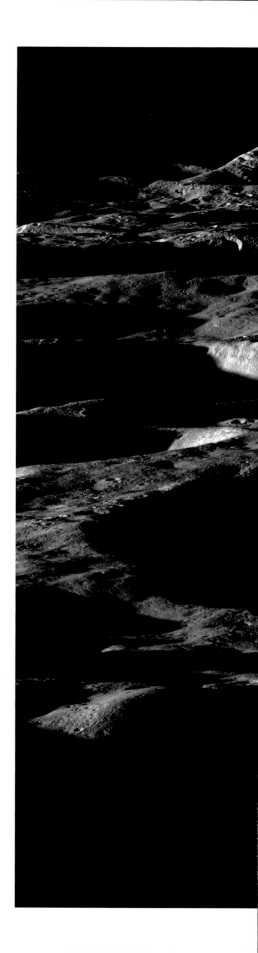

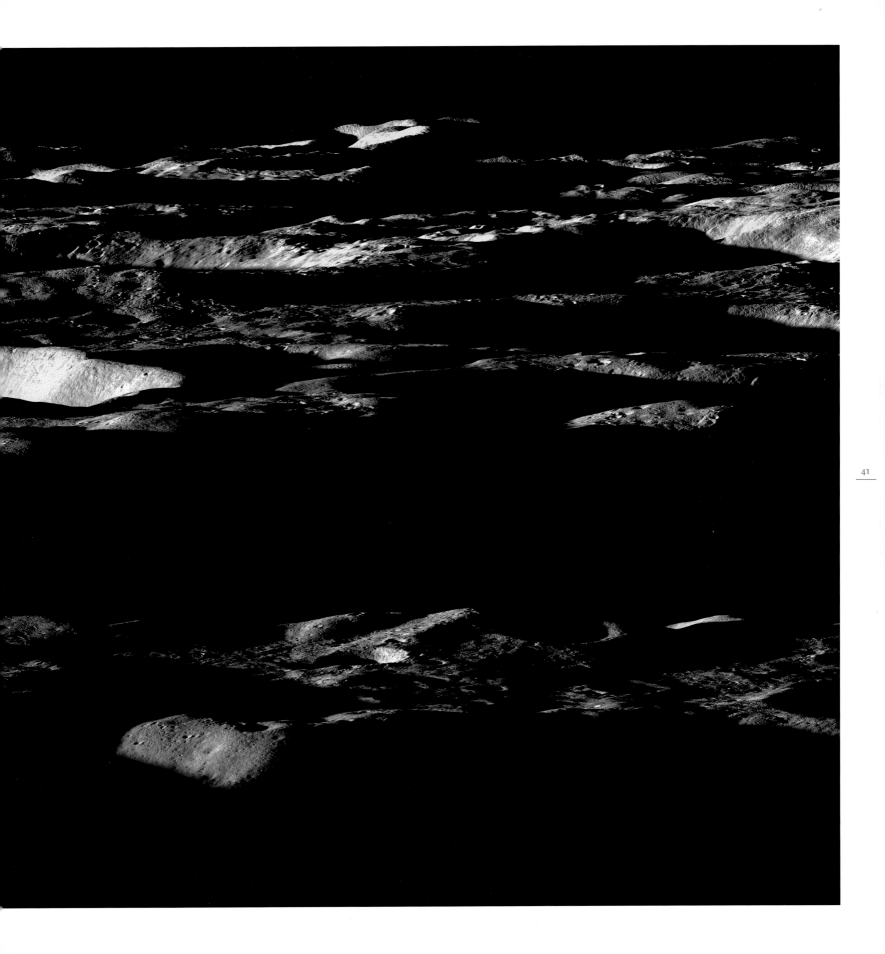

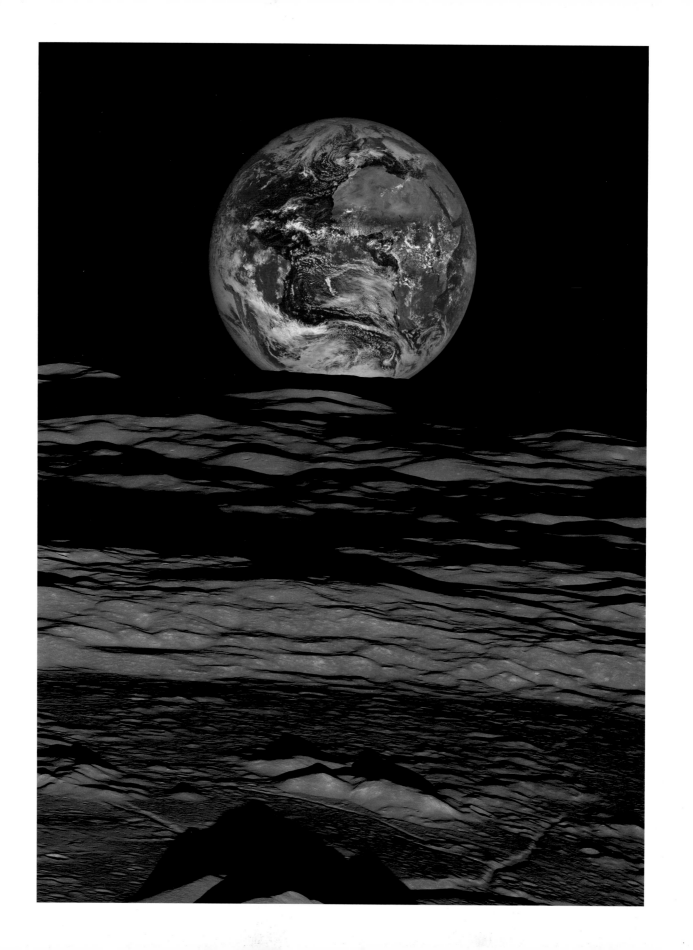

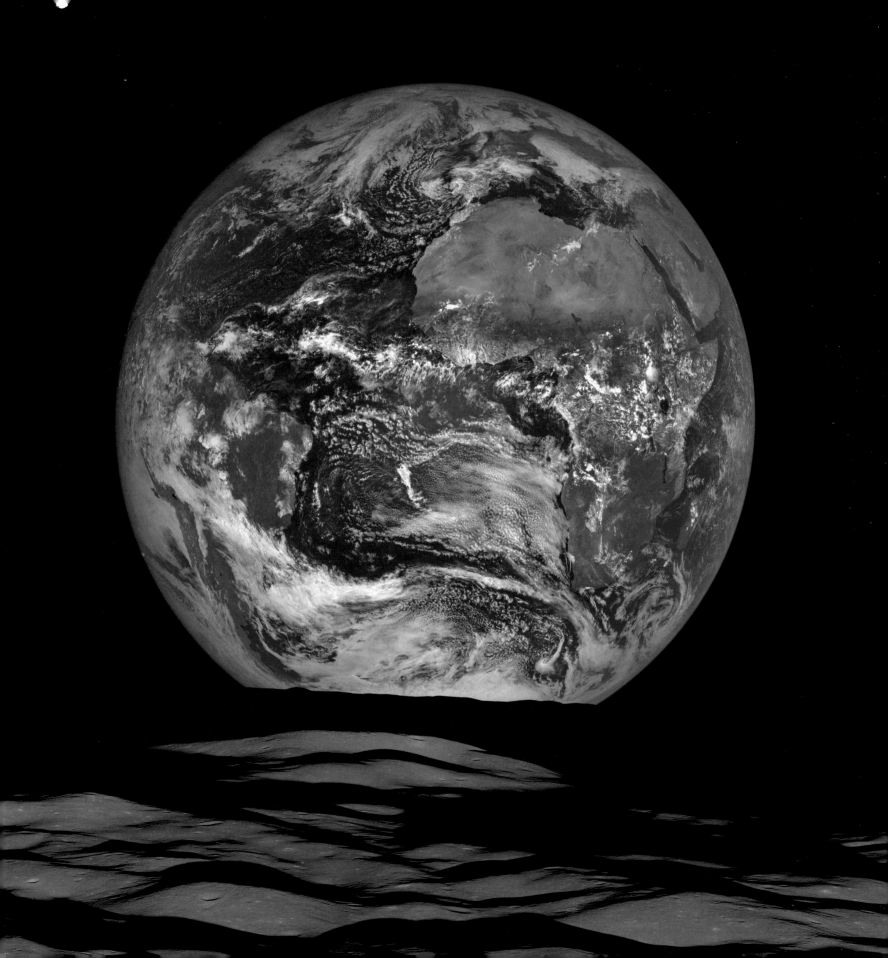

Venus

We shouldn't read too much into the fact that Venus, nominally the planet of love, was revealed by squadrons of Soviet and American spacecraft in the 1970s to be a broiling hell, with a 460° Celsius (860° Fahrenheit) surface temperature hotter even than Mercury's and an atmosphere busy drizzling such Valentine's Day surprises as sulphuric acid. Far more interesting is the fact that the surface of this inferno — a place where the rocks glow; a place as pressurized as a submarine trench — was revealed to be so incomparably beautiful by the unwinking radar eye of the early-1990s Magellan probe. Disturbingly beautiful, yes, even frighteningly beautiful, but beautiful nonetheless.

Interestingly enough, given its inhospitable properties, Venus has been visited by more spacecraft than any other planet — an astonishing 18 Soviet and six American spacecraft, starting with the very first planetary fly-by ever, the US Mariner 2 mission of 1962. In December 1978, no fewer than *ten* Soviet and American spacecraft were working simultaneously on or above our closest planetary neighbour. Although the first landing on another planet was accomplished by the Soviet Venera-7 probe in late 1970, and although several Soviet probes managed to send pictures back from the Venusian surface, the only way to get a real sense of the sweep and detail of this volcano-dominated planet is through radar, simply because a thick blanket of clouds perpetually shrouds it.

Euclid believed that the human eye worked by sending out rays, which were then returned, creating an image of what we see. While this theory didn't hold up under scrutiny, it describes the working principle that allowed the radar of the Magellan spacecraft to fire home the most accurate record of any planetary surface we currently have (including the Earth's, because so much of the ocean floor hasn't been adequately mapped). Magellan used its antenna both to pulse radar signals at the planet and to send the information thus collected to Earth at the apex of each polar orbit. It would then descend down another longitudinal Venusian stripe, repeating the procedure over and over — a process that lasted two years. Magellan's images have to be read differently to those created by visible light: the dark areas are comprised of radar-absorbing or rough materials, and the brightest are the most reflective.

All of which raises the question: was Euclid really wrong? We tend to see what we project outwards (albeit usually in visible light), as a story about astronomer Percival Lowell reveals. Otherwise best known for

facing page

Cloud-covered Venus

In visible light, the dense carbon dioxide atmosphere makes Venus look like a bright, largely featureless ball. But here, in ultraviolet light, details of its swirling atmosphere are revealed.

Ultraviolet photograph. Mariner 10, 5 February, 1974

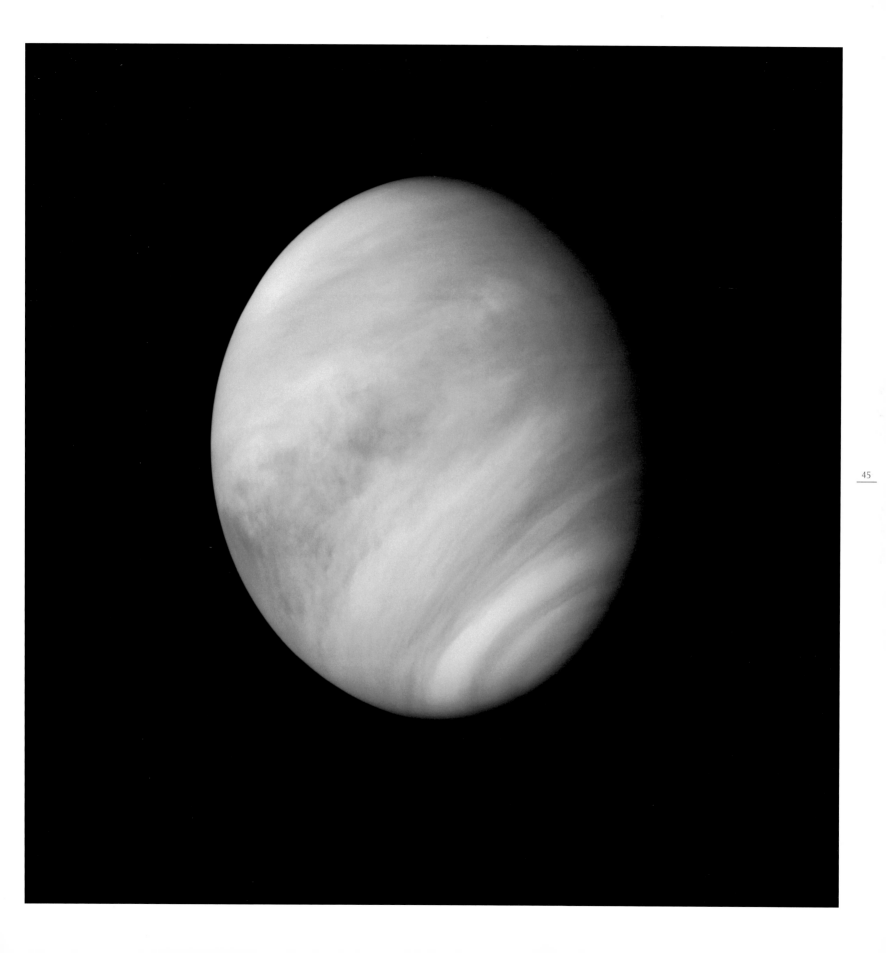

facing page

Tusholi Corona

The oval-shaped feature in the upper left is the Tusholi Corona, caused by magmatic upwellings within the planet's mantle – the layer between the surface crust and the core. It overlaps La Fayette impact crater in Venus' Tethus region.

Radar image. Magellan, 15/9/1990 – 14/9/1992

overleaf

Volcanoes on Venus

This is an image of the equatorial mountains Uretsete Mons, in the bottom left, and Spandarmat Mons in the upper right. The ancient lava flows originating from these seemingly dormant volcanoes can be seen within the southeastern part of the Hinemoa Planitia lowlands.

Radar image. Magellan, 15/9/1990 – 14/9/1992

perpetuating the idea that a thirsty Martian desert civilization had created a giant network of canals across the Red Planet, in the late 1890s Lowell also directed his imagination and telescope at Venus, where instead of canals he saw what he described as a wheel-shaped structure consisting of several spokes radiating from a central hub. No other astronomers saw it, however, and it wasn't until 100 years later, in the summer of 2003, that an article in *Sky & Telescope* magazine finally solved the mystery. The clouds of Venus, it turns out, are so bright that the aperture of Lowell's telescope had to be narrowed down to compensate — creating what amounted to an ophthalmoscope (an instrument that focuses light in order to examine the interior of the eye). What Lowell saw, according to authors Bill Sheehan and Tom Dobbins, was his own shadowy retinal blood vessels, superimposed on Venus's blank slate of clouds! Euclid redux.

For its part, and using different technology, Magellan projected its vision through that opaque atmosphere and revealed a real world of mountains, volcanoes, highland plateaus, fine spidery grooves, innumerable ridges, multiple eerily beautiful craters surrounded by radar-reflective blankets of ejecta and various incomparably weird forms soon named 'arachnids,' 'ticks' and 'coronae' by mission scientists. Most of these features are the result of subterranean volcanic plumes boiling up under the planet's surface crust, and much of Venus's equator sticks out for this reason as well — if not out of the clouds then certainly higher than the surrounding terrain. One piece of this irregular equatorial highland escarpment is a 6,000-mile-long (9,500 kilometres) scorpion-shaped continent called Aphrodite; other elevated areas on the planet include a northern territory named Ishtar Terra and a steep-sided plateau called Lakshmi.

As most people already know, planetary surface features are named under the direction of a special select sub-committee of the International Astronomical Union. In the case of Venus the members of this group decided, appropriately enough, that all the planet's various topographical formations should be named after famous women. But because the quantity of information coming from Magellan's radar was so great, a far larger number of these features required naming than on any other Solar System object — creating a very urgent problem. And this was no idle matter: according to writer Henry S. F. Cooper, all the planetary scientists needed those names pronto, so as to be able to discuss Venus comprehensibly with each other — and apparently not enough prominent, noteworthy real or mythological women existed. So the IAU sub-committee issued an all-points appeal to the public to submit names. As Cooper recounts in his book *Evening Star*:

> I learned later that among the nine members of the committee selecting names for the women's planet, there was not a single woman — the committee, in fact, was known as the nine wise men.

But although it reluctantly gave up many of its secrets to a space probe named after a man, the planet of love has a way of winning in the end. Cooper quotes the reaction of B. Stephen Saunders, a planetary geologist who had studied Venus for most of his adult life, on learning that contact with the Magellan spacecraft had been lost — temporarily, as it turned out — at the start of its first day of mapping that planet:

> 'I felt exactly like an English astronomer who in 1761 travelled to India to see the transit of Venus across the disc of the sun,' he told me. 'India turned out to be cloudy, so he missed the transit. On the way back, he was shipwrecked. When he came home, he found his wife had married someone else and sold all his possessions. Venus is a harsh mistress.'

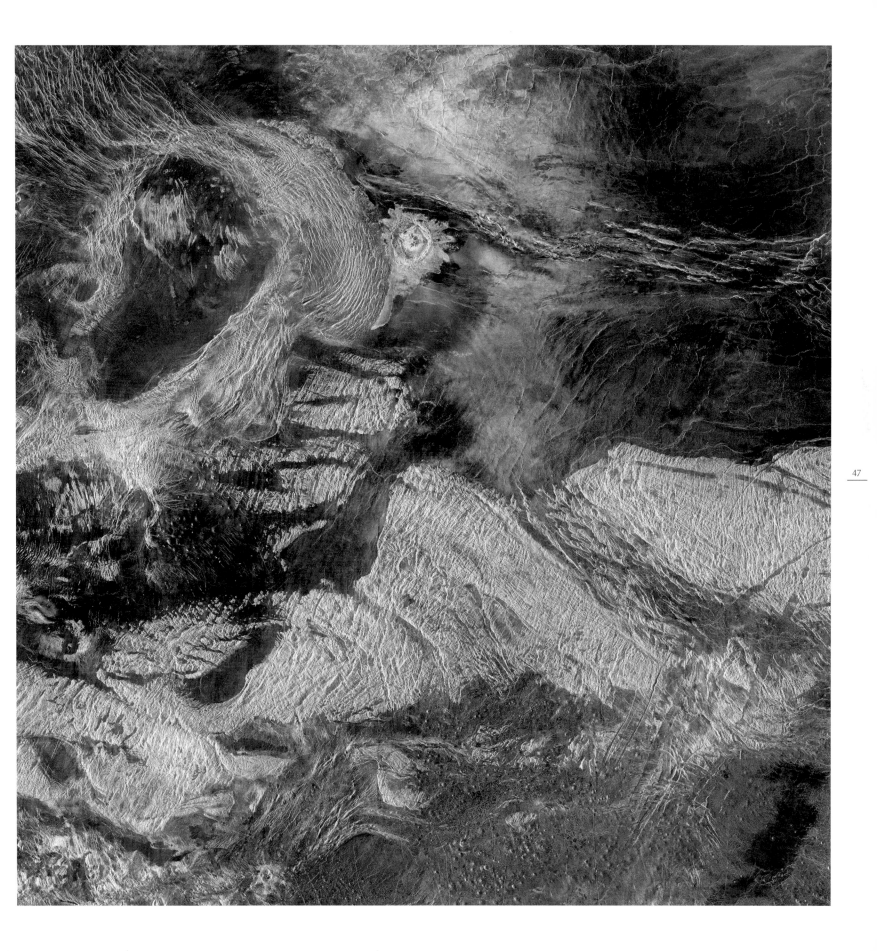

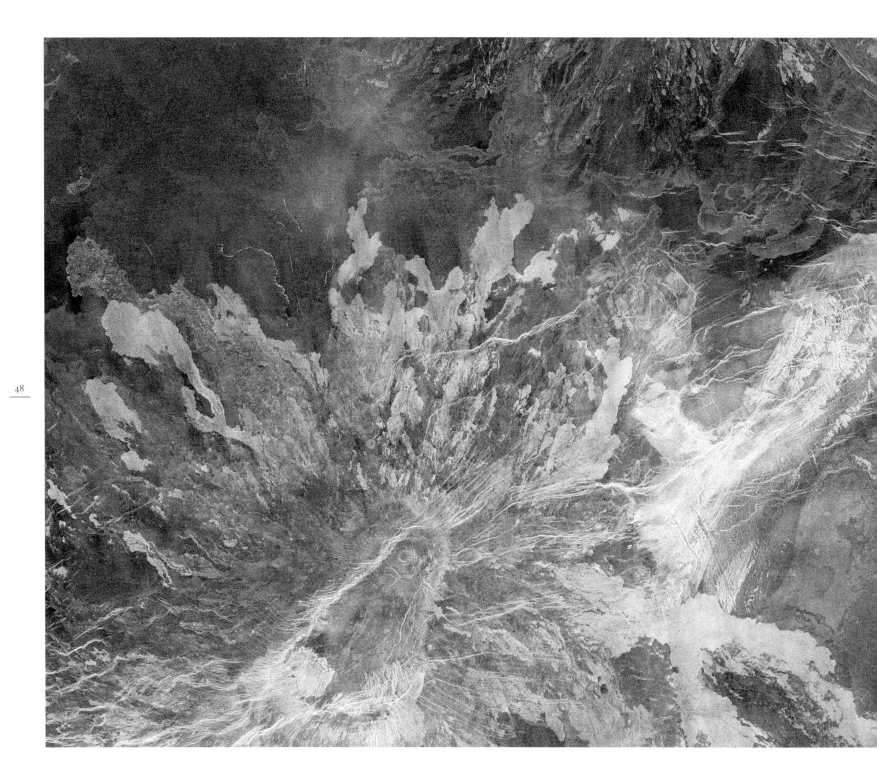

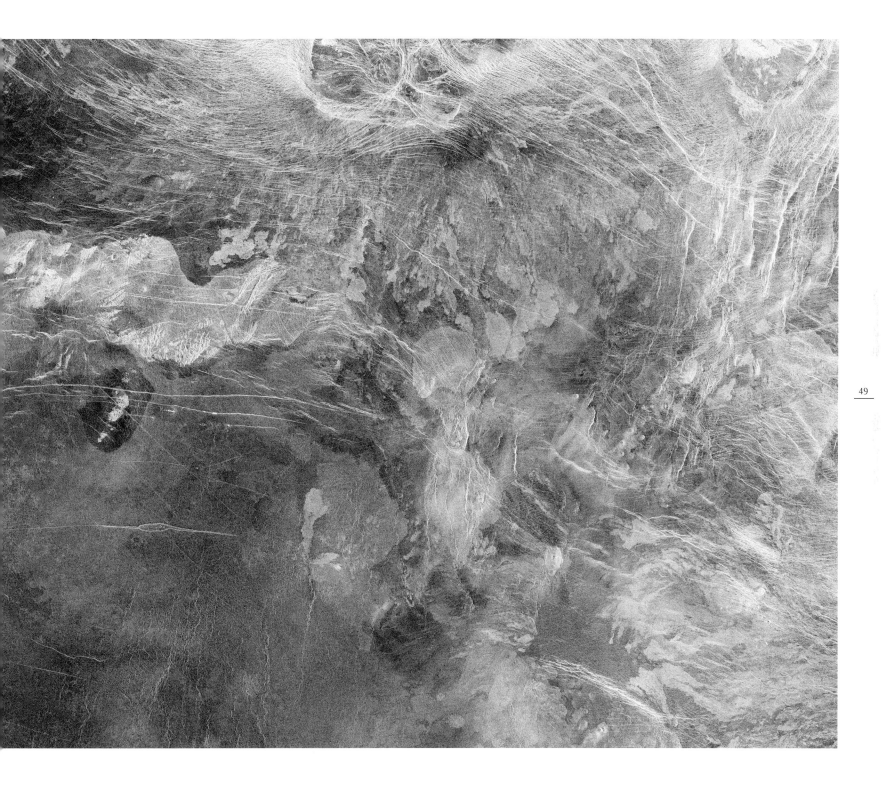

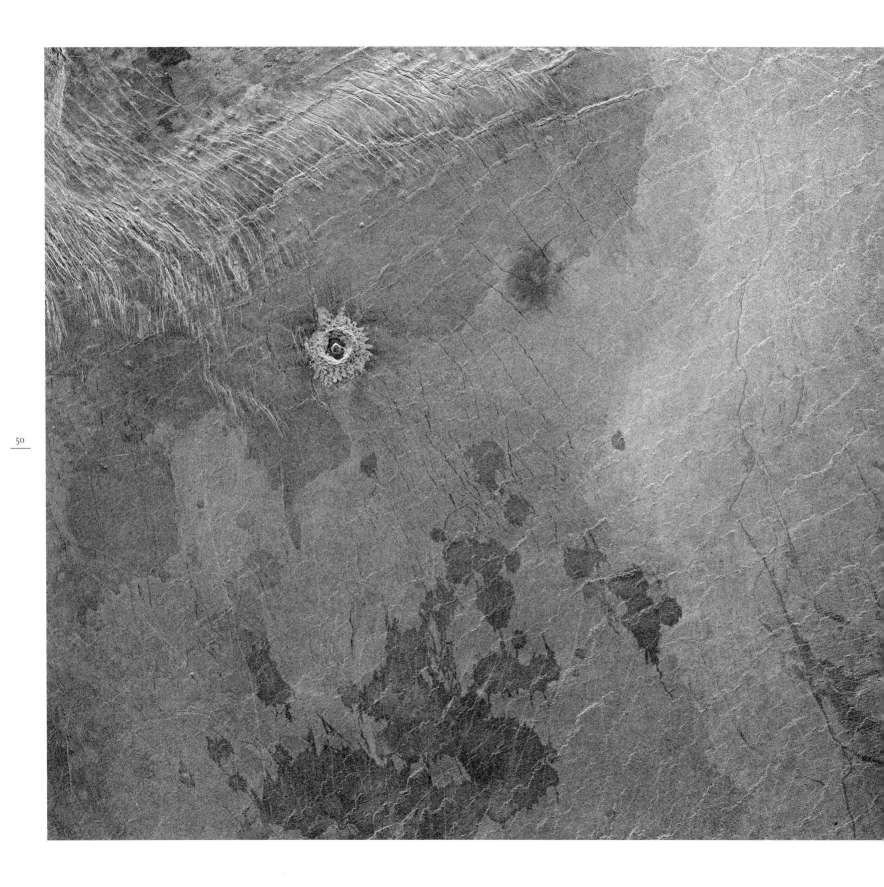

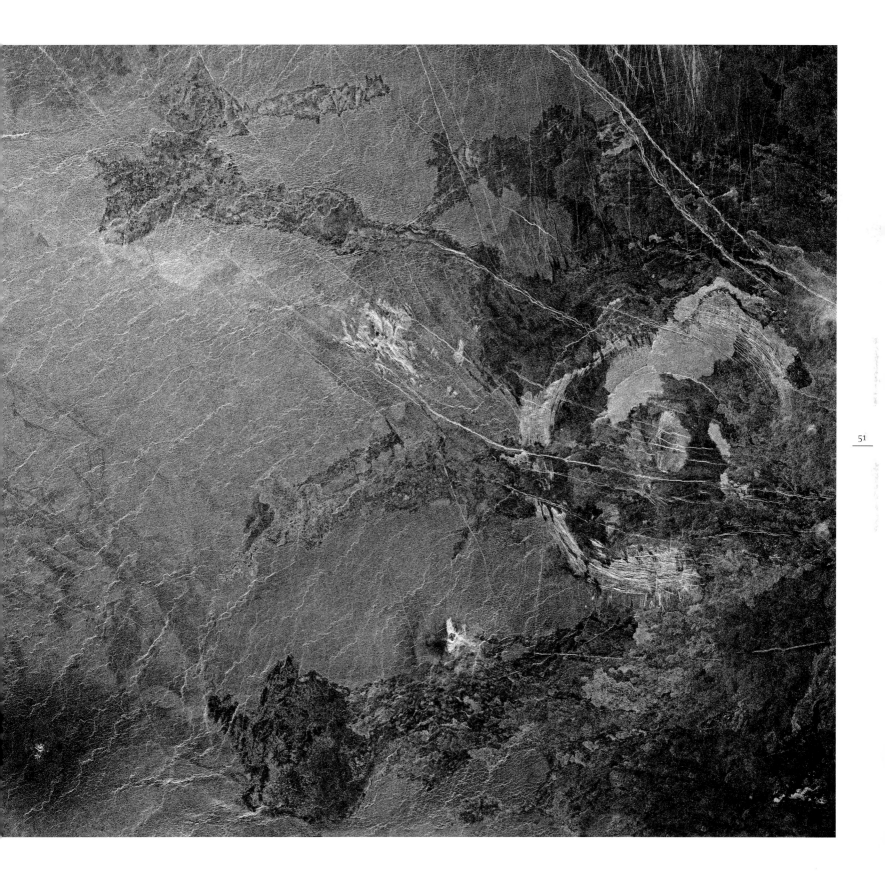

preceding two pages

Lava Flows

Lava flows from Venus' Kunapippi
Mons volcano on the right spread
across the Tan-yondozo Vallis. A
single bright meteor impact crater
can be seen on the left.

*Radar image. Magellan,
15/9/1990 – 14/9/1992*

facing page

Surface Fractures

Radar can see through the clouds
to the surface of Venus and reveal
some of the planet's geologic
history. These fractures and
extraordinarily variegated volcanic
features lie in the Atla region of
Venus.

*Radar image. Magellan,
15/9/1990 – 14/9/1992*

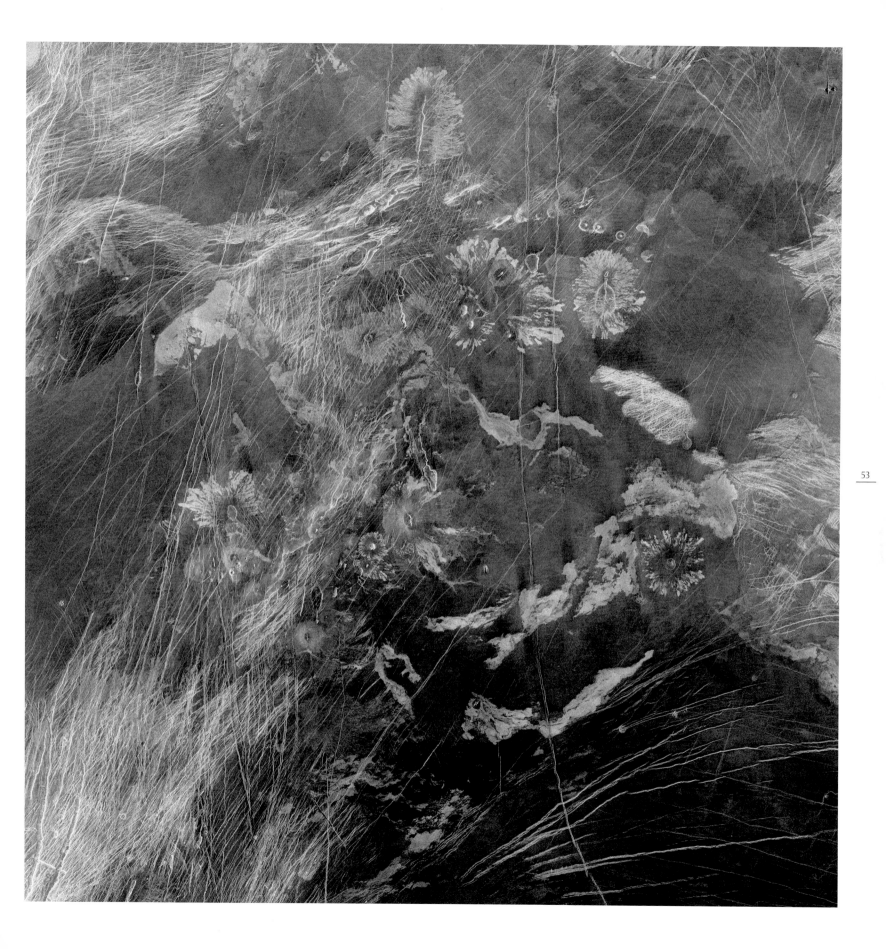

The Sun

facing page

Eclipse of the Sun by Earth

The solar corona – the outer atmosphere that surrounds the Sun – and magnetic loops during an eclipse of the Sun by Earth. The graduated reduction in our view of the Sun is due to the increased density of Earth's atmosphere from left to right, which blocks ultraviolet light.

Ultraviolet photograph. Solar Dynamics Observatory, 2 April, 2011

overleaf

Detail View

There are no shadows on the Sun. A deafening roar of raw power rages ceaselessly in a blaze of utter silence. There's no crackle of carbonizing matter here, no rush of oxygen to feed the flames — only a relentless blast of heat and energy flaring outwards in all directions into the timeless vacuum.

This 4.6-billion-year-old ball of energy, visible during the day from Earth, is a star instead of a pall of dispersing radioactive gas — and we, therefore, are walking around and scratching our sweaty scalps instead of being smoke or ice — because the seemingly inexorable explosive outward thrust of its ongoing nuclear explosion is held in check by the equally powerful force of its own massive gravity. An irresistible force has met its immoveable object in the Sun, and this is the case for all the other flaring points of light, larger or smaller, floating within or without or through the Milky Way's long spiral arms.

There aren't any shadows, but there *is* weather. The Sun's raging tempests so dwarf any other storms visible within the Solar System as to render the comparison ridiculous — like comparing a kindergarten scuffle over a stuffed toy to Hiroshima. Just as the storm clouds of Jupiter, the largest of the Sun's planets, make the worst typhoons on Earth look like a tempest in a

teapot, so does even the smallest solar eruption make Jupiter's distinctive Great Red Spot, which is actually a hurricane twice the size of Earth, appear a mere footnote. (On the other hand, the perpetually turbulent Great Red Spot has been raging for at least 300 years. No comparably long-lived solar phenomena are currently known.)

Although middling on a cosmic scale, a very average star, the Sun's sheer force (not to mention its gravitational force-field) means that in many ways all its pagan worshippers — the Egyptians, the Aztecs, the Southern Californians — got it right. Instead of fairy tales involving patriarchal space-time architects, they had no trouble identifying the energy source propelling life, driving the wind, and lighting all our pathways through the Earth's topography — and they saw good reasons to pay tribute to that power.

The surface of the sun is something like 5,500° Celsius (9,900° Fahrenheit); the core is more like 15 million (27 million) — a figure so staggering that it defies comprehension. Most of the lights of our teeming twenty-first century cities are indirectly powered by the Sun; the fossil fuels used to produce them contain the archival energy of long-gone forests. Like an immense battery, the fossilized black liquid under Middle Eastern

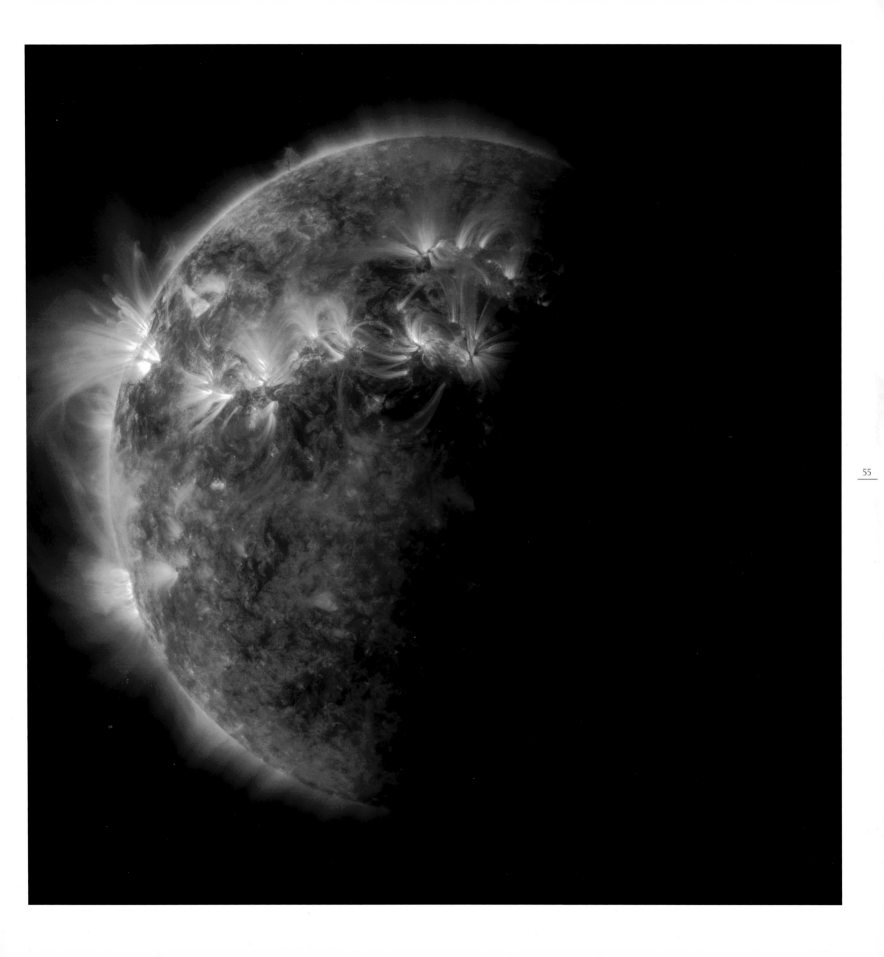

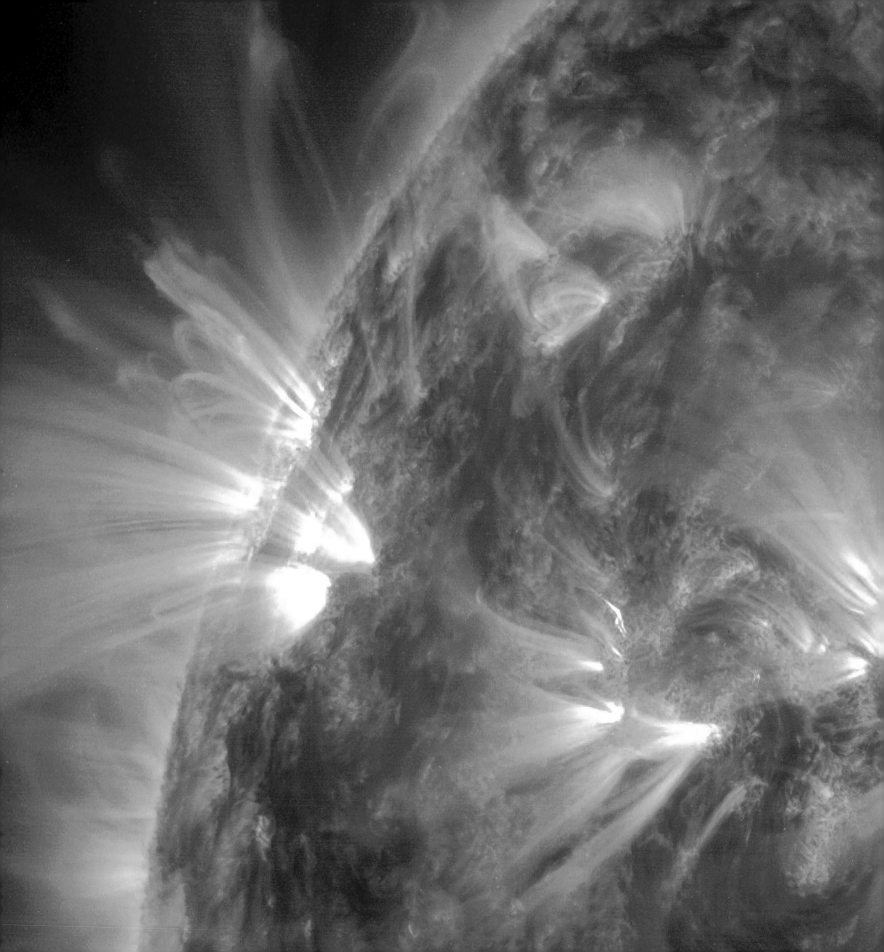

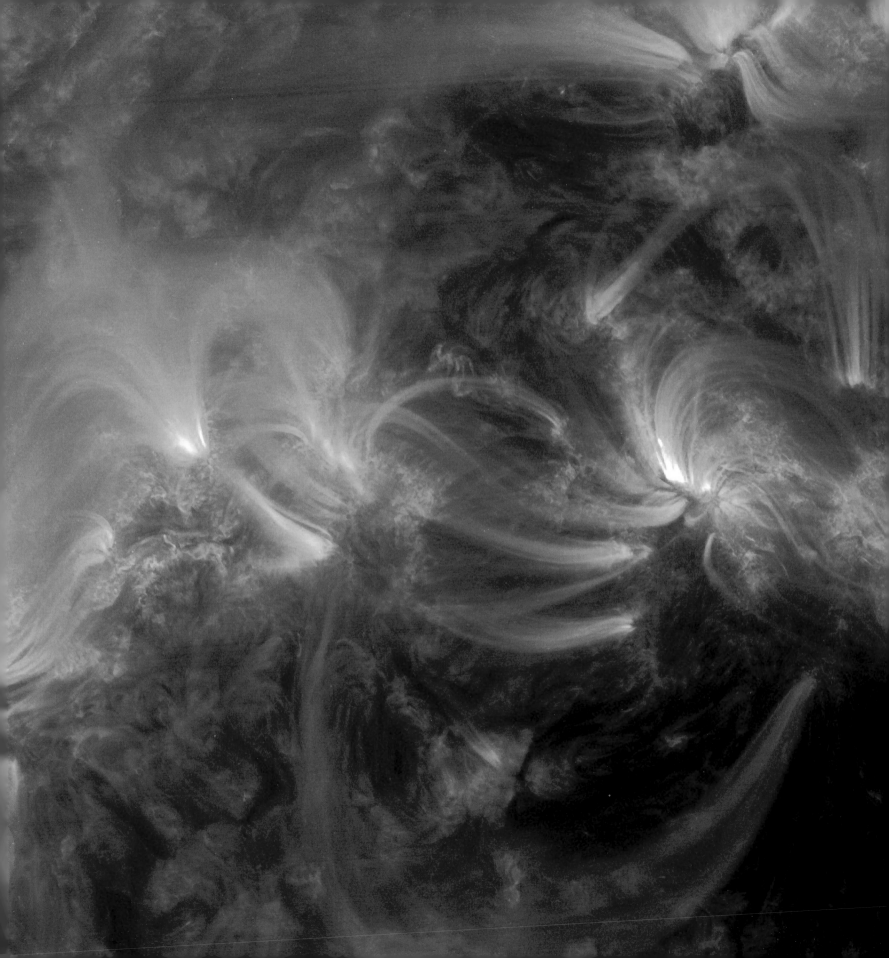

facing page

A Massive Prominence

View of the solar chromo-sphere, the second of the Sun's three main layers of atmosphere, while a massive prominence curls upwards in a characteristic looped shape.

Ultraviolet photograph. Solar Dynamics Observatory, 6 December, 2010

deserts and North Sea currents has preserved the Sun's energy for millions of years. The moonlight glinting off the polar caps and the nocturnal Indian Ocean surf is secondhand sunlight; the earthly seasons respond directly to the varying exposures of the hemispheres to the Sun during the planet's annual rotational sway.

One singular genius apparently understood our relationship to the Sun even better than the Egyptians and Aztecs. The idea that it, and not the Earth, was at the centre of the planetary order was first argued by the almost forgotten Greek scientist Aristarchus 300 years before Christ and 2,000 years before Copernicus, who is more commonly credited with the concept. Aristarchus deduced from the size of the Earth's shadow on the Moon during a lunar eclipse that the Sun must be a much larger body than the Earth, and quite far away. 'He may then have reasoned that it is absurd for so large a body as the Sun to revolve around so small a body as the Earth,' Carl Sagan wrote in his book *Cosmos*. 'He put the sun at the centre, made the Earth rotate on its axis once a day and orbit the Sun once a year.' Copernicus, says Sagan, may have got the same idea from reading about Aristarchus:

> Recently discovered classical texts were a source of great excitement in Italian universities when Copernicus went to school there. In the manuscript of his book, Copernicus mentioned Aristarchus' priority, but he omitted the citation before the book saw print. Copernicus wrote in a letter to Pope Paul III: 'According to Cicero, Nicetas had thought the Earth was moved… According to Plutach (who discusses Aristarchus)… certain others had held the same opinion. When from this, therefore, I had conceived its possibility, I myself also began to meditate upon the mobility of the Earth.'

The Sun is of course mobile as well, a fact that escaped both Copernicus and Aristarchus; it orbits the centre of the Milky Way once every 226 million years. The entire span of human history, from the cave paintings of Lascaux to the aqueducts of Rome to the moon landings of the last century, encompasses only a tiny fraction of a single such turn. To the Sun, in other words, our species has lived for only a few days — the last few days — of its own galactic year.

The Sun would still burn without us to see it, of course, just as all the prehistoric trees that indirectly fuel all our fuming vehicles made a noise when they fell, despite our absence from the scene. But it's a miracle equal to its fearsome existence in the first place that an infinitesimally small fraction of the Sun's energy actually fuels our thoughts — including those that sometimes try to understand it. If in the human race the universe has produced beings capable of appreciating some of its awesome beauty, this particular peripheral Milky Way star was its main incubator and instigator. Some residents of this planet still find the ways and time to worship the ceaseless waves of energy that flood from it. And as with us, so with our tools: the space observatories that keep an unblinking daily eye on the Sun are all solar powered.

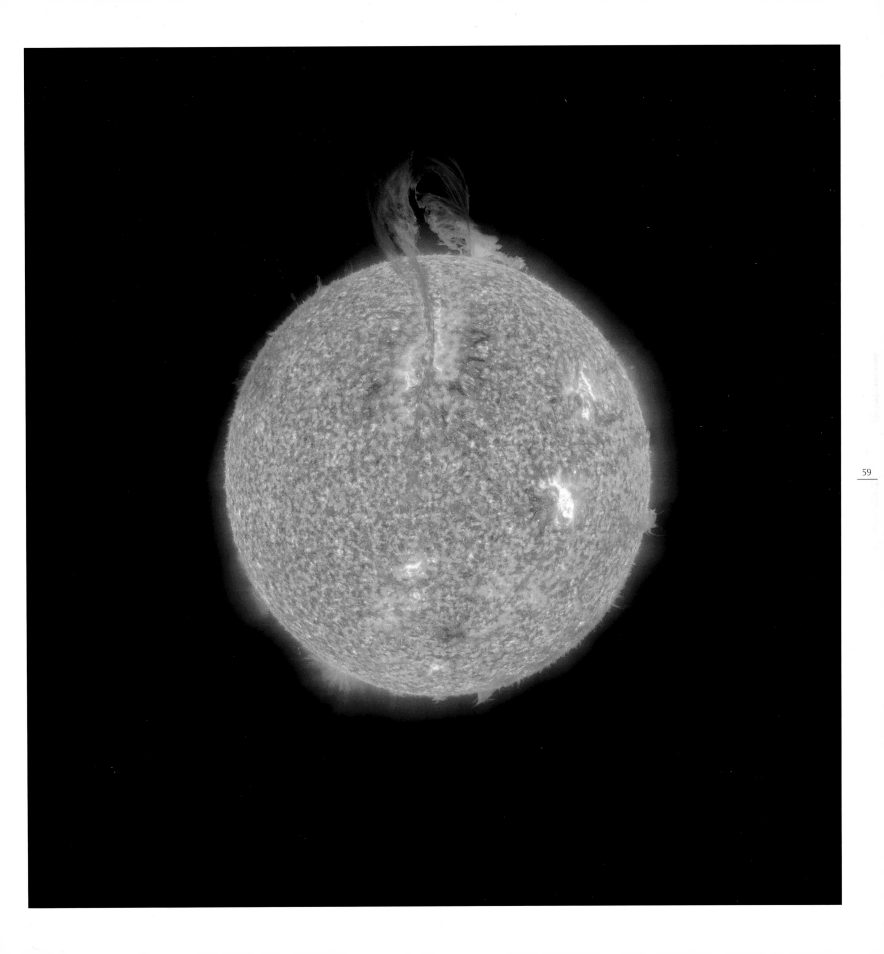

**Ultraviolet Views
of the Sun**

Solar flares occur when magnetic energy built up in the Sun's outer atmosphere, the corona, is suddenly released. This produces a burst of radiation, including radio waves, x-rays and gamma rays. The energy released by one solar flare is equivalent to millions of hydrogen bombs exploding at once.

top left

A rapidly cooling arcade of post-flare loops. Post-flare loops occur in the hours after a flare and are formed as material condenses out of corona and flows down the loops back to the surface.

*Ultraviolet photograph.
TRACE, 25 June, 2000*

top middle

Glowing plasma courses along post-flare cooling loops.

*Ultraviolet photograph.
TRACE, 19 April, 2001*

top right

A rapidly cooling arcade of loops.

*Ultraviolet photograph.
TRACE, 25 June, 2000*

bottom left

A fan-like post-flare cooling, draining loop system.

*Ultraviolet photograph.
TRACE, 8 November, 2000*

bottom middle

Solar magnetic activity at the base of coronal loops.

*Ultraviolet photograph.
TRACE, 3 July, 2001*

bottom right

A large X-ray flare.

*Ultraviolet photograph.
TRACE, 23 July, 2002*

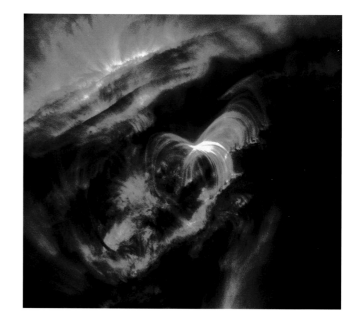

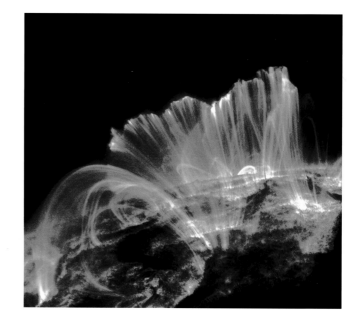

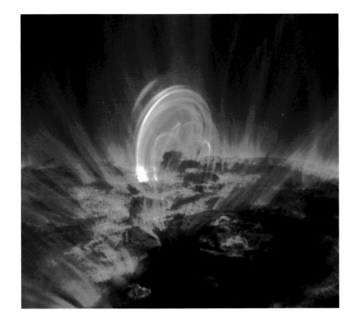

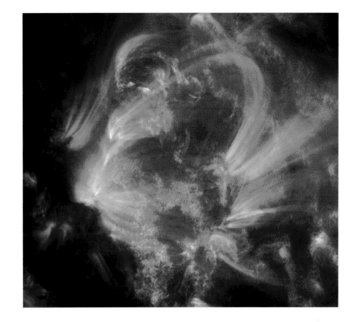

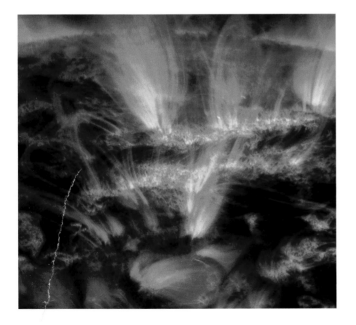

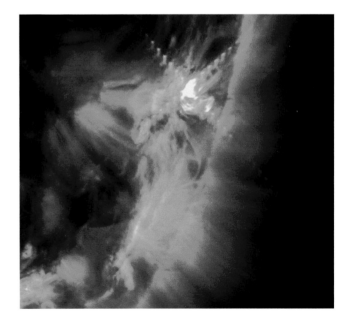

The Moon Transiting the Sun

In a sight impossible to see from Earth, the Moon transits the Sun without eclipsing it. The transit was visible only from a space-craft following behind Earth. The Moon appears far smaller than we normally see it, as the spacecraft was further from the Moon than we are on Earth.

Ultraviolet photographs.
STEREO-B, 25 February, 2007

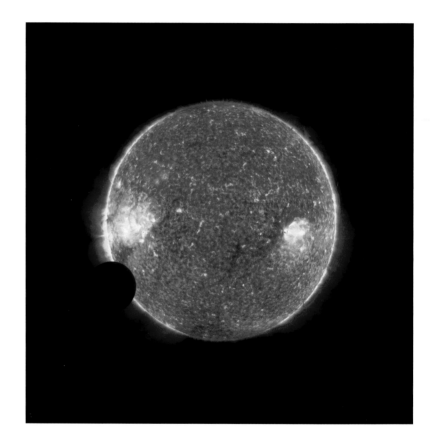

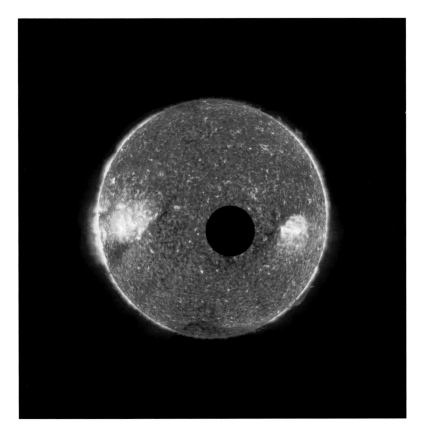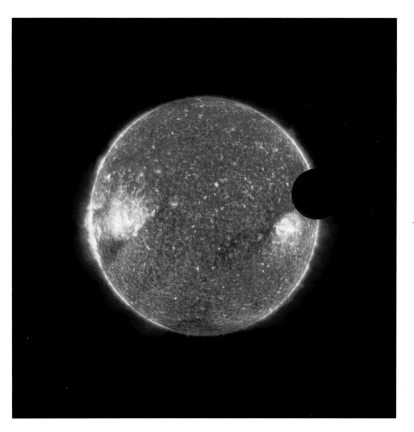

Mercury

facing page

Mercury Passing in Front of the Sun

The innermost planet, Mercury, is the small black dot in front of the flaring solar prominence below and to the left of the image centre. Because the solar observatory that took this picture was orbiting Earth, the true size of Mercury in relation to the Sun is apparent. The Sun contains 99.86% of the mass of the Solar System, and Mercury is the smallest planet.

Composite ultraviolet photograph. Solar Dynamics Observatory, 9 May, 2016

overleaf

Detail View

If ever there was a frontline world, a sphere teetering at the edge of fiery disaster, it's ravaged Mercury, the closest to the Sun and the second smallest of the ten planets. Named after the Roman messenger of the gods, a figure who also found time to usher damned souls into the fires of Hades, Mercury resembles the Moon but is 1.4 times the size of our natural satellite.

In late March 1974 the first spacecraft ever to visit Mercury conducted the first of three fly-bys. Mariner 10, which had passed Venus on the way, revealed a planet visually similar to the Earth's moon, though 40 percent larger and far denser. Mercury's daytime surface is hot enough to melt lead; its immense Caloris Basin ('Caloris' meaning 'hot' in Latin), which is 800 miles (1,300 kilometres) in diameter, looks like the Moon's Mare Orientale, and undoubtedly came from the same cause: impact with a very large asteroid. In the early 1990s scientists bounced radio waves off Mercury and discovered bright returns from the north pole of the planet, suggesting deposits of ice in the permanently shaded areas there. In 2012, NASA's Mercury-orbiting MESSENGER spacecraft provided compelling support for these observations. It appears that, as with the Moon, cometary impacts over the eons have resulted in the presence of water at both poles on this Sun-blasted world.

Both Mariner 10 and MESSENGER observed cratered but partially smooth plains, twisted escarpments and chaotic rough-and-tumble terrain, all of it seemingly frozen in time but subject to the Sun's ferociously intense assault. Mariner 10 was the first to register the presence of a magnetic field, indicating a molten core; Mercury is the only 'terrestrial' planet (that is, one with a solid surface) other than the Earth to have a global magnetic field. There is almost no atmosphere, just an extremely tenuous film of exotic gases, nor are there any signs of continuing geological activity. Mercury appears to be a dead world.

The planet has a highly eccentric orbit. At its closest Mercury is a scorching 29 million miles from the Sun; at its furthest it's 45 million miles. This averages out as about two-thirds closer to the Sun than the Earth. In combination with its very slow rate of rotation — the planet only spins three times during two of its years — this would produce some odd effects to anyone on its surface. According to software engineer and planetary website author Bill Arnett:

At some longitudes the observer would see the sun rise and then gradually increase in apparent size as it slowly moved toward the zenith. At that point

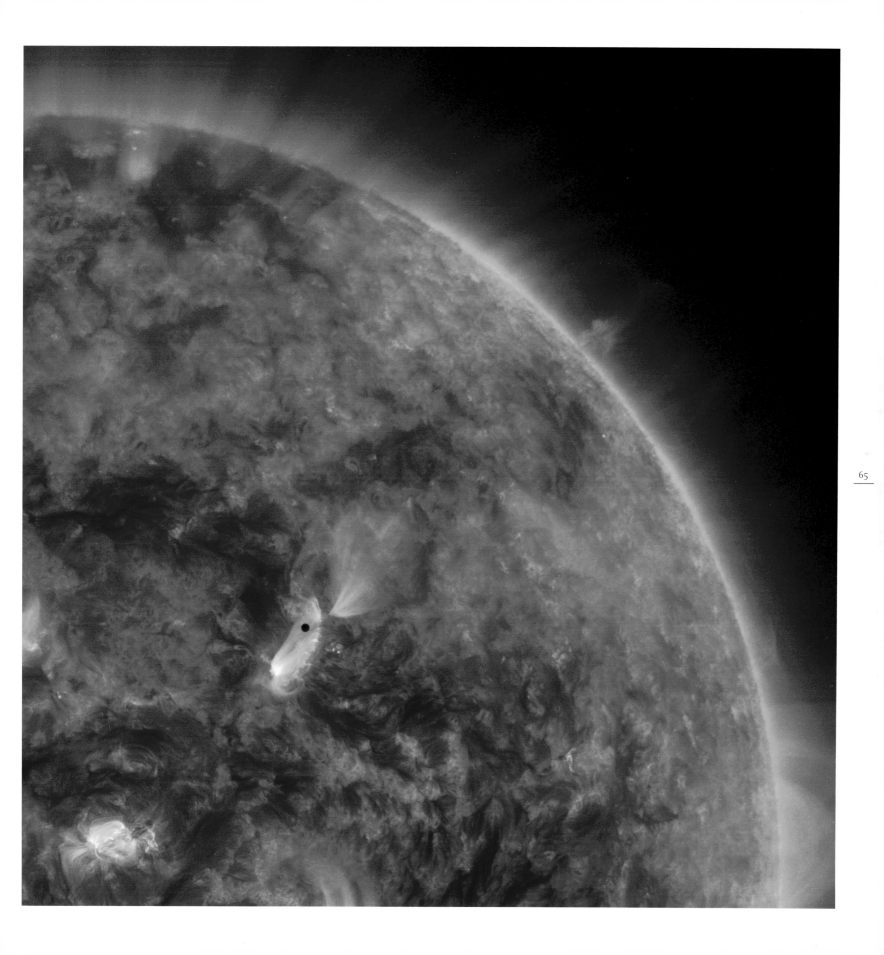

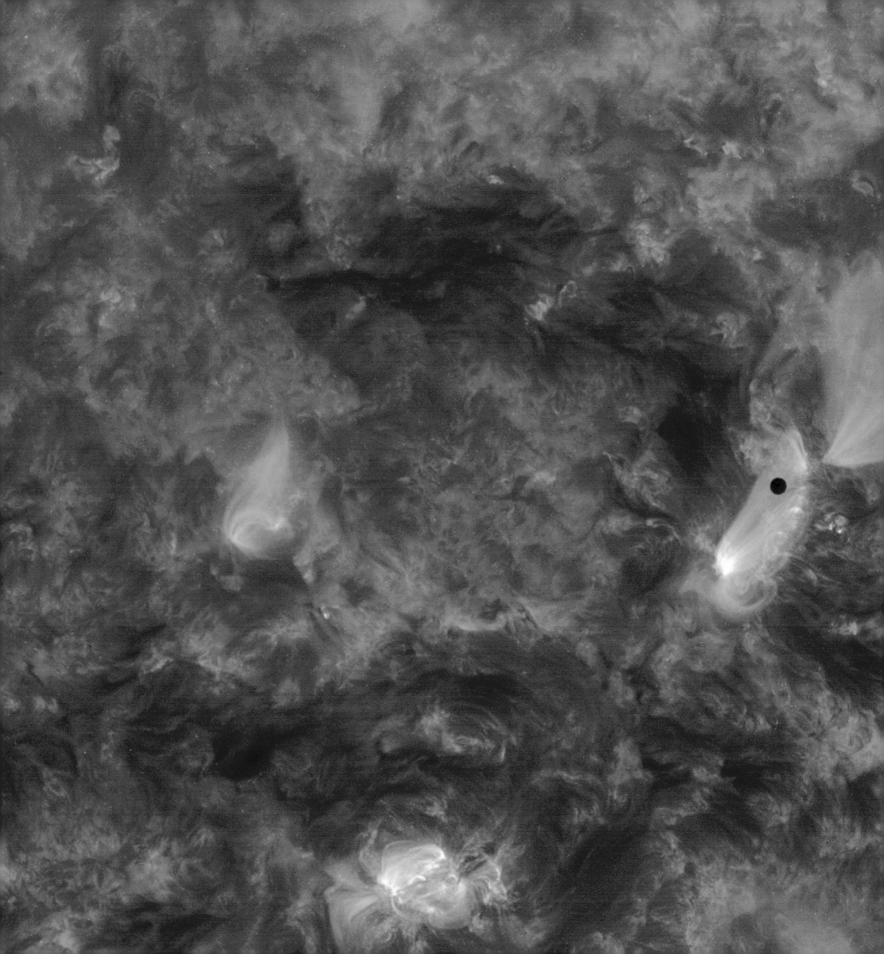

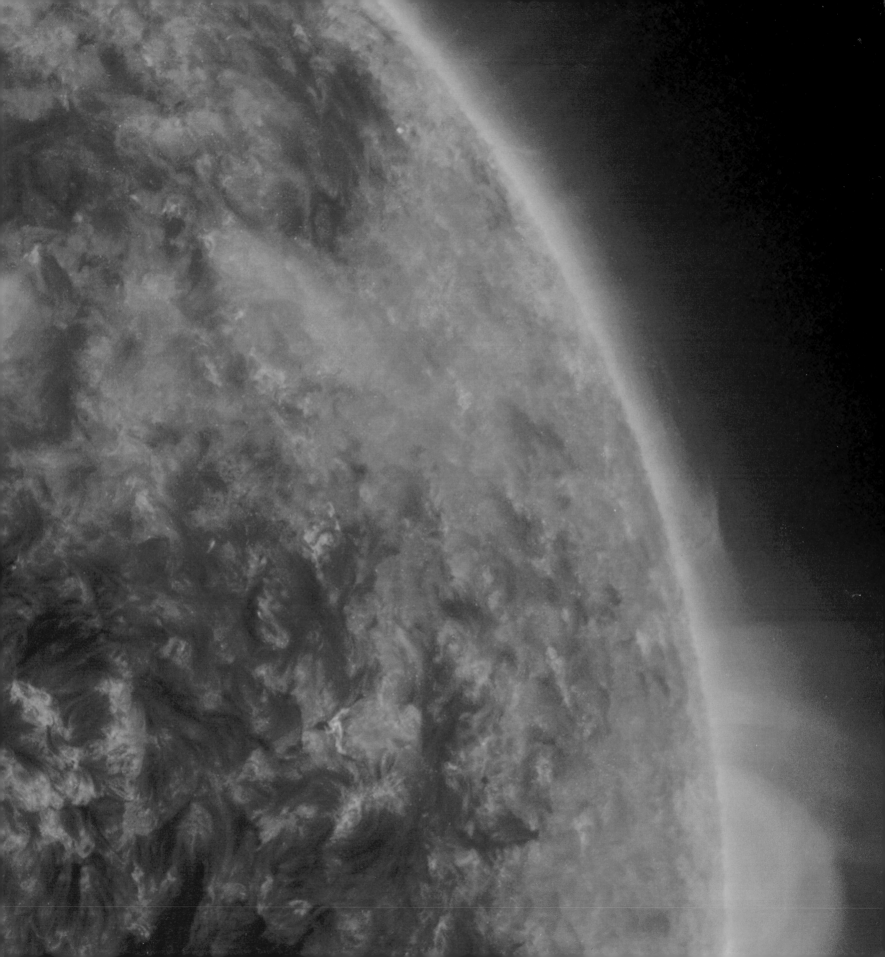

the sun would stop, briefly reverse course, and stop again before resuming its path toward the horizon and decreasing in apparent size. All the while the stars would be moving three times faster across the sky. Observers at other points on Mercury's surface would see different but equally bizarre motions.

As with Venus, individual types of features on Mercury were named in accordance with a given theme for the planet. In this case the craters bear the names of famous artists, writers or musicians; other topographical features are named after scientific expeditions and ships of discovery. As a result this savagely scarred, terminally barren world can boast craters named after Shakespeare, Beethoven, Bach, Tolstoy and Michelangelo.

Although Mariner 10 photographed less than half of the planet's surface, it took about 1,000 pictures, and its three fly-bys required the most sophisticated trajectory yet attempted by any interplanetary probe, with eight course corrections within the intricately shifting gravitational dance of Venus, Mercury and the Sun. The probe also suffered several inflight technical crises,

including a power surge on the first approach to the planet that overheated its instrument package, almost ending the mission — a situation skillfully handled by its remote controllers at the Jet Propulsion Laboratory in California. This combination of an exceedingly complex flight path, effectively handled onboard crises and a two-planet, four fly-by trajectory makes Mariner 10 one of the most important early robotic missions. It was a harbinger of more impressive feats to come, including the MESSENGER mission 30 years later.

In March 2011 MESSENGER became the first spacecraft to enter orbit of the solar system's innermost planet. Bristling with seven miniaturized instruments, the tiny robot mimicked Mercury's eccentric orbit with its own highly elliptical one, soaring 9,000 miles (14,500 kilometres) over the planet's southern hemisphere before zooming down at an altitude of only 120 miles (190 kilometres) over the spectacular northern Caloris Basin like an inquisitive gnat. After conducting a thorough survey of this hot, battered world it was finally ordered to crash into its surface on 30 April 2015, forming a new crater on Mercury about 16 metres (17 yards) wide.

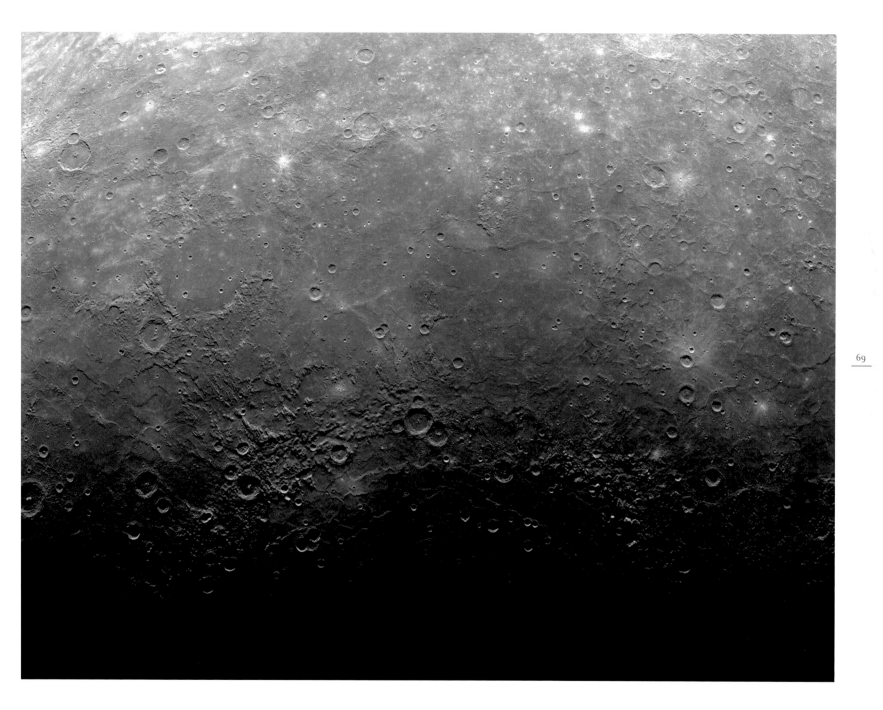

right

Day to Night on Mercury

In many ways Mercury resembles our Moon, but because the planet is about 1.4 times the size of our natural satellite, the line between its day and night sides is more gradual.

Mosaic composite photograph. Mariner 10, 29 March, 1974

overleaf

Crescent Mercury

The closest planet to the Sun as observed by the MESSENGER spacecraft in the first of three fly-bys before it entered orbit in 2011. Distinctive craters are brought into high relief at the day-night terminator line. Near the horizon at the top, white lines of ejecta can be seen extending outwards like tributaries from a compara-tively new crater.

Mosaic composite photograph. MESSENGER, 14 January, 2008

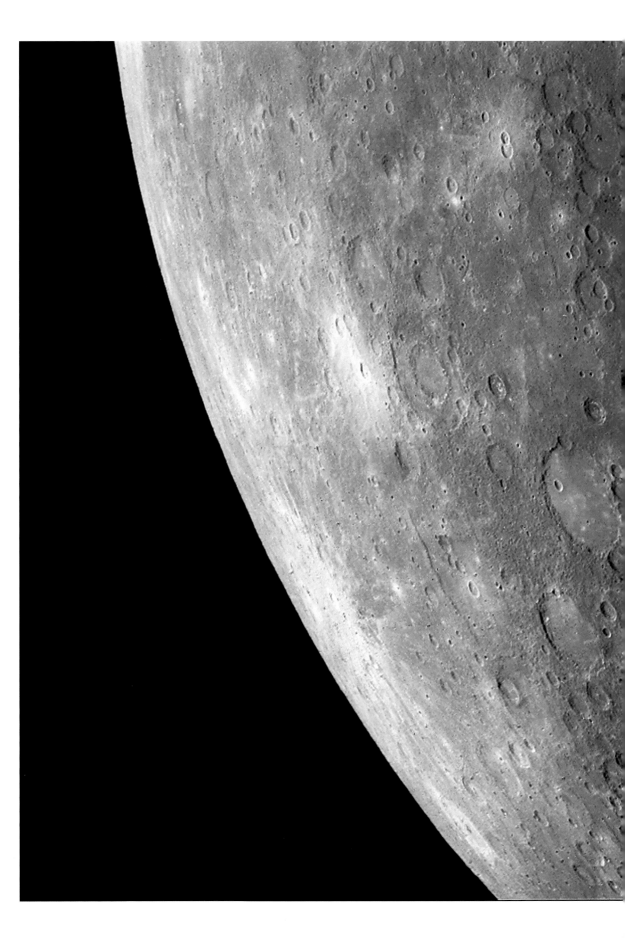

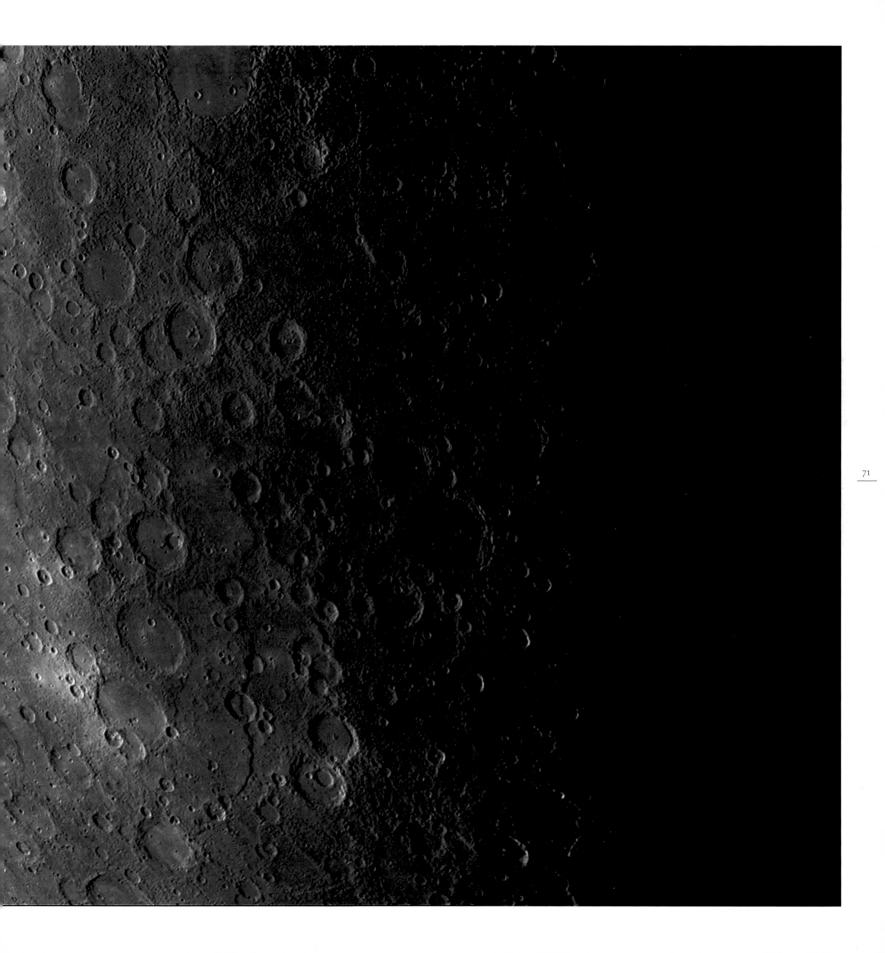

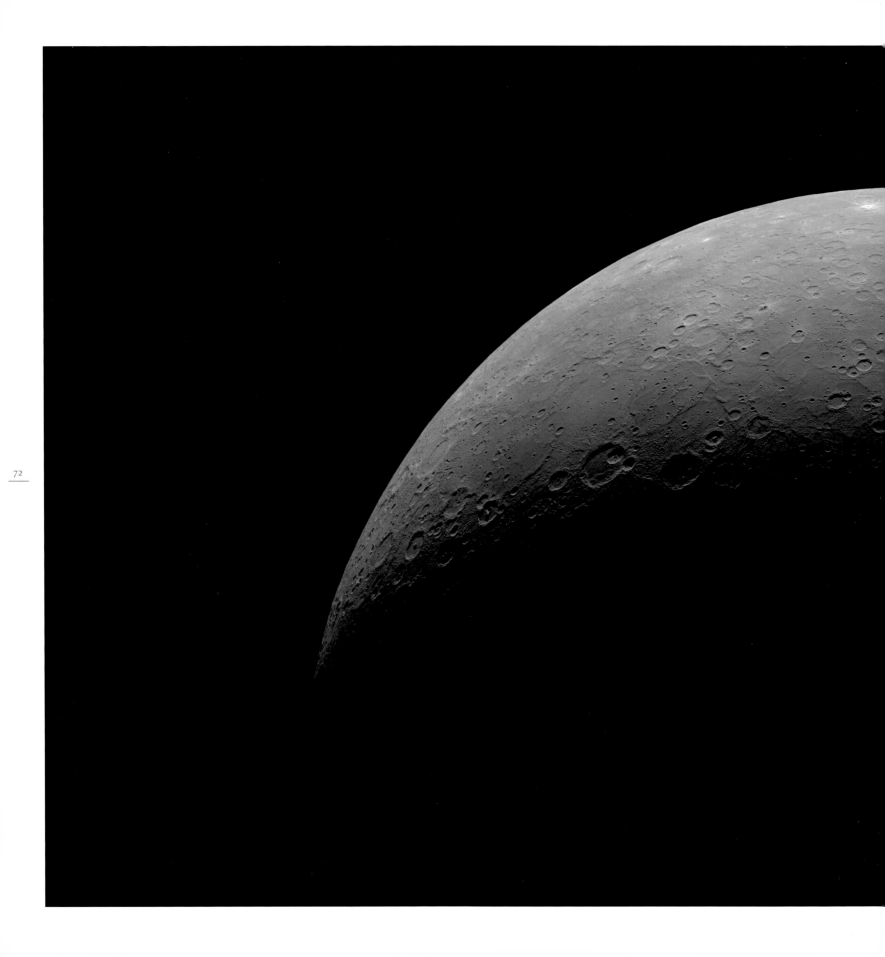

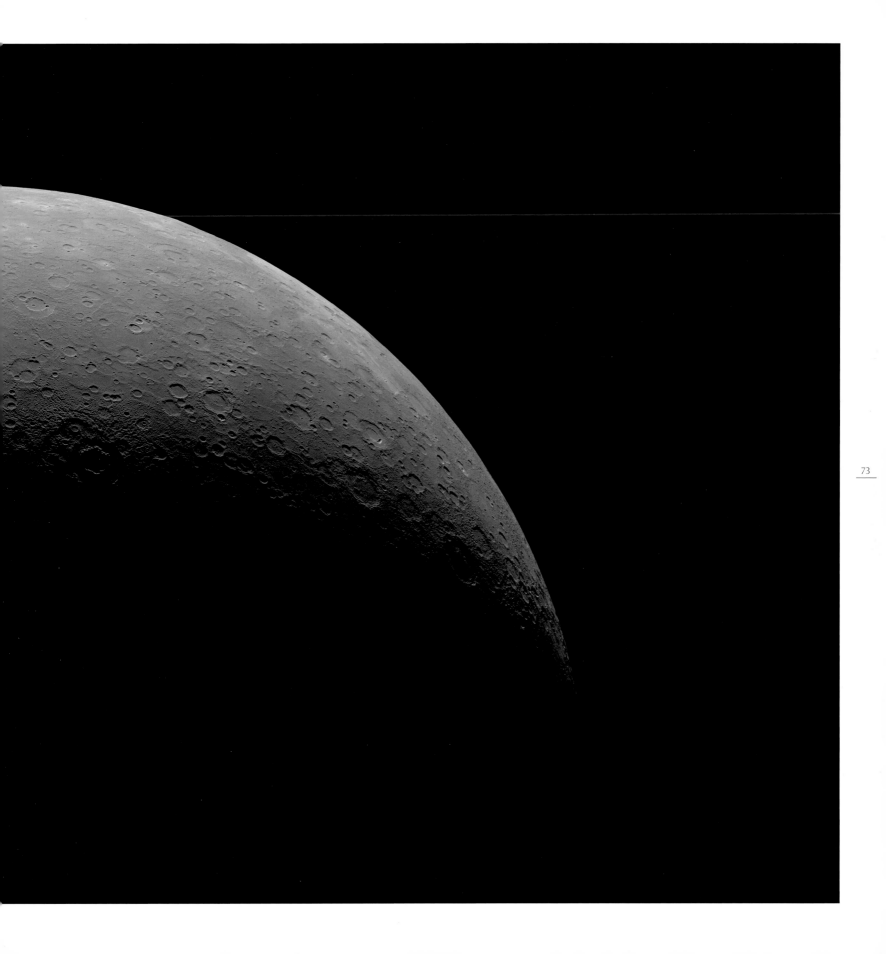

Mars

Few places either in space or on Earth have captured the collective imagination of the human race like Mars, the fourth stone from the Sun, despite (or maybe because of) the fact that the planet is extremely hard to parse through ground-based telescopes. Its coppery colour alone, which is clearly discernible even to the naked eye and is the result of a sweep of oxidized deserts equal to the total land area of Earth, must have been responsible for the planet being named after the Greek god of war, Ares, and then later the Roman one. If Mars looks hotter than Venus, it's pure illusion; the temperature on the surface averages a bone-chilling -55° Celsius (-67° Fahrenheit), and in another reversal on Venus, its atmosphere is very thin, with a surface pressure only about one percent of that on Earth.

After Venus, Mars has been the subject of the most attention from Earth-origin space probes, and for very good reasons. Not least of them is the tantalizing prospect that life may exist there — or might once have. Despite its temperature and atmosphere, Mars is the most similar of all the planets to the Earth; even as a fuzzy red blob in a lens, it was apparent that it had polar caps and experienced some indecipherable seasonal changes, and when Italian astronomer Giovanni Schiaperelli turned his telescope in the direction of Mars in 1877, he thought he discerned a faint web-work of lines on the surface. He called them canali, or channels — a word which doesn't necessarily suggest the work of intelligent creatures. But when the self-educated American amateur astronomer Percival Lowell got hold of the term, he famously took it to mean canals — if not complete with gondoliers and ribboned caps, then at least built by intelligent beings and flanked by irrigated fields. The result was almost 100 years of entertaining science-fictional speculation regarding a venerable Martian civilization struggling to eke out an existence in harsh desert conditions. Its high-point was no doubt Orson Welles's 1938 radio dramatization of H. G. Wells's seminal sci-fi novel *The War of the Worlds*. The broadcast, in which a Martian invasion of the Earth began in New Jersey, created a wave of panic across the eastern United States.

It would be easy to say that the first visits to the Red Planet by robot emissaries from Earth were anticlimactic — and admittedly, both Wells and Welles are hard acts to follow. But though there's something to that, it's really not the whole story. True, the first robot to encounter Mars, Mariner 4 in 1965, sent back only 22 blurry images of a surface apparently little different from that of the Moon's — resulting in a kind of collective groan from both science-fiction fans and the emerging planetary sciences community.

And two years later another pair of Mariner fly-bys didn't do much better. Mars appeared to be a barren and relatively uninteresting place, devoid of any suggestion of canals, or even channels. It took the arrival, in late 1971, of the first probe to actually go into orbit there, Mariner 9, to reveal the true fascination of Mars to an earthly audience.

To begin with, the spacecraft arrived in the middle of an intense planet-wide dust-storm — a phenomenon that had just ingested two Soviet Mars landers, which vanished without trace soon after plunging into the solid wall of yellow sand that had enveloped the planet. Mars, it appeared, had enough of an atmosphere to generate some very serious global weather patterns. Ordered to wait the storm out, Mariner 9 then discerned a strange circular island in the declining clouds — the crown of what eventually materialized as an immense, 15-mile-high (24 kilometres) volcano, eventually named Olympus Mons. It's the highest known mountain in the Solar System. And when the storm was finally over, the probe began methodically sending back more than 7,000 pictures during the course of almost a year. They revealed a startlingly varied landscape featuring, among other things, an immense 2,500-mile-long (4,200 kilometres) canyon system (soon named Valles Marineris, in honour of its mechanized discoverer); a northern hemisphere far younger and less scarred by craters than the south and marked by various aolean (or wind-driven) features — some of which may have accounted for the seasonal changes Schiaperelli and others saw from Earth; and finally, many different types of natural channels and even flood-plains. Mars, clearly, had once seen large quantities of liquid water course across its surface. In a sense, then, Schiaperelli had been vindicated — though in fact none of these channels were large enough to have been visible from Earth. (Both Lowell and his Italian counterpart are thought to have fallen for the typical human tendency to make illusory visual connections between distant features. To connect the dots, as it were.)

While Mariner 9's revelatory gaze put most speculation about defunct or declining Martian civilizations to rest, the evidence it presented of the one-time existence of liquid water on the desert planet revived the prospect that life of some kind may have existed — or might still be hanging on. In 1976, two of the most sophisticated devices ever to land on another planet fired their retro-rockets and settled in for a long stay: the Viking Landers. Overhead, a pair of Viking Orbiters meanwhile set about mapping the planet with an imaging system much improved from the Mariner 9's. After sending back panoramic views of landscapes in many ways indistinguishable from that of the American Southwest, the landers extended tube-like arms, ingested small quantities of top-soil and subjected them to three different microbiology experiments. These were intended to settle the question of the existence of life once and for all, only they didn't: although the results were generally accepted as negative, some dissented. And as writer Barry Lopez has pointed out, if the Vikings had landed in one of Antarctica's dry valleys — which are about as close as the Earth comes to Martian conditions — they also would have come up short, even though life does exist there, hidden in cracks within the rocks.

After the last Viking fell silent in 1982, twenty years passed without a single successful spacecraft visit to Mars. During the last decade and more, however, NASA has run an ambitious multi-spacecraft Mars program, with the highly complex 2012 sky-crane landing of the compact-car-sized Curiosity Rover only the latest triumph. Another rover, Opportunity, is still alive and well, over a decade after landing. Meanwhile the Mars Odyssey and Mars Reconnaissance Orbiter, two spacecraft currently on station above the planet, have been sending a steady stream of high resolution pictures to Earth. In September 2015, data from the latter orbiter confirmed the occasional presence of highly saline liquid melt-water in gullies on the Martian surface.

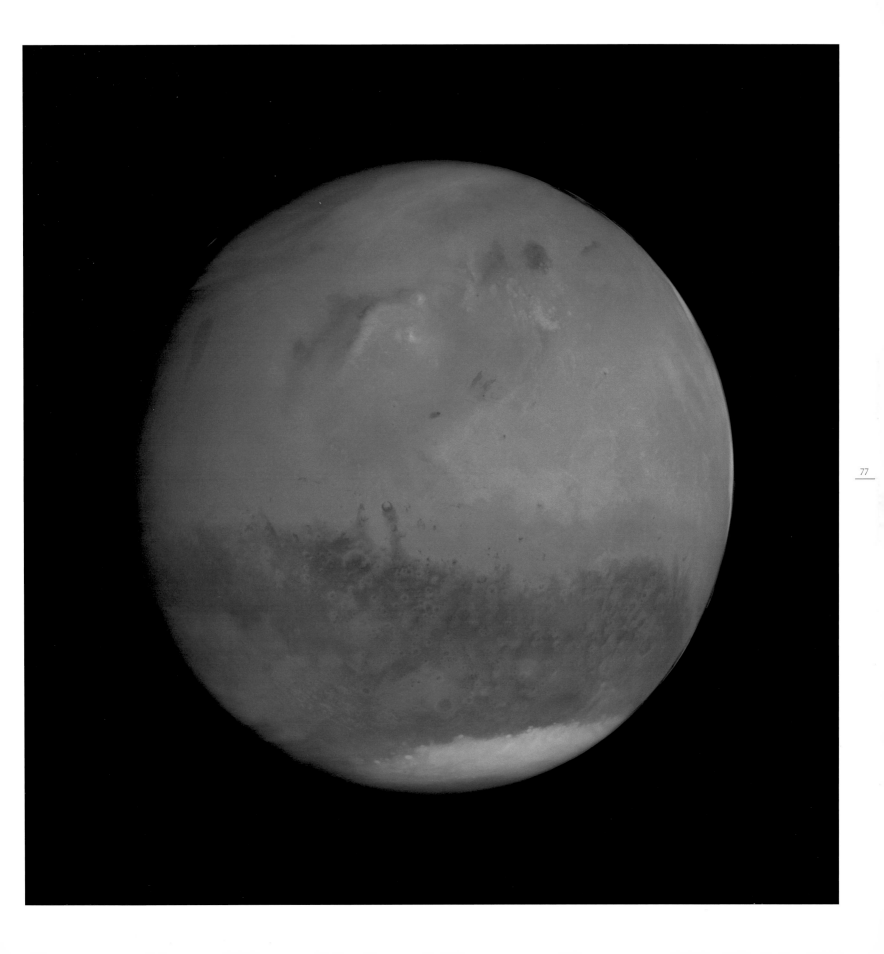

Mars Fly-by at Closest Approach

This image was taken by the
Philae lander attached to the
Rosetta spacecraft, and you can
see part of the craft and one of its
solar panels. It shows an area of
Mars close to the Mawrth Vallis
region, from approximately 600
miles (1,000 kilometres) away.

Composite photograph.
Philae Lander, Rosetta,
25 February, 2007

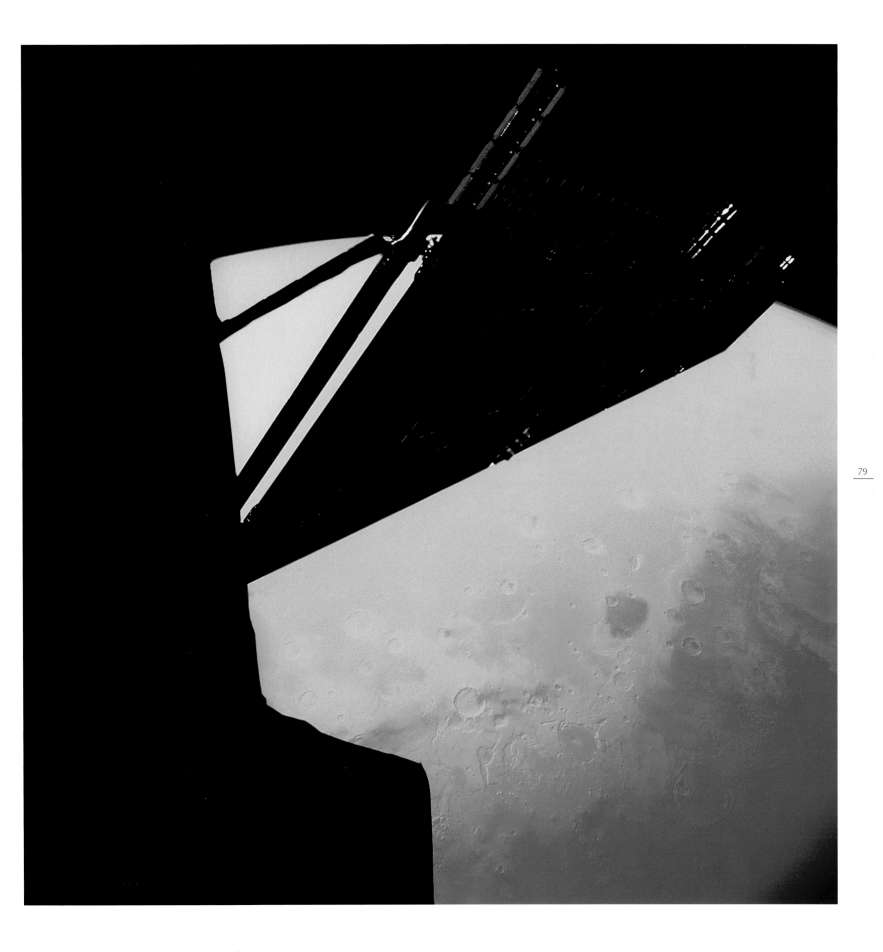

**The Valles Marineris
Canyon System**

The largest canyon in the Solar
System, Valles Marineris on Mars
is almost 2,500 miles (4,000 kilo-
metres) long – nearly the width of
the United States. A ground fog
hugs the canyon floor.

*Mosaic composite photograph.
Viking Orbiter 1, 16 July, 1978*

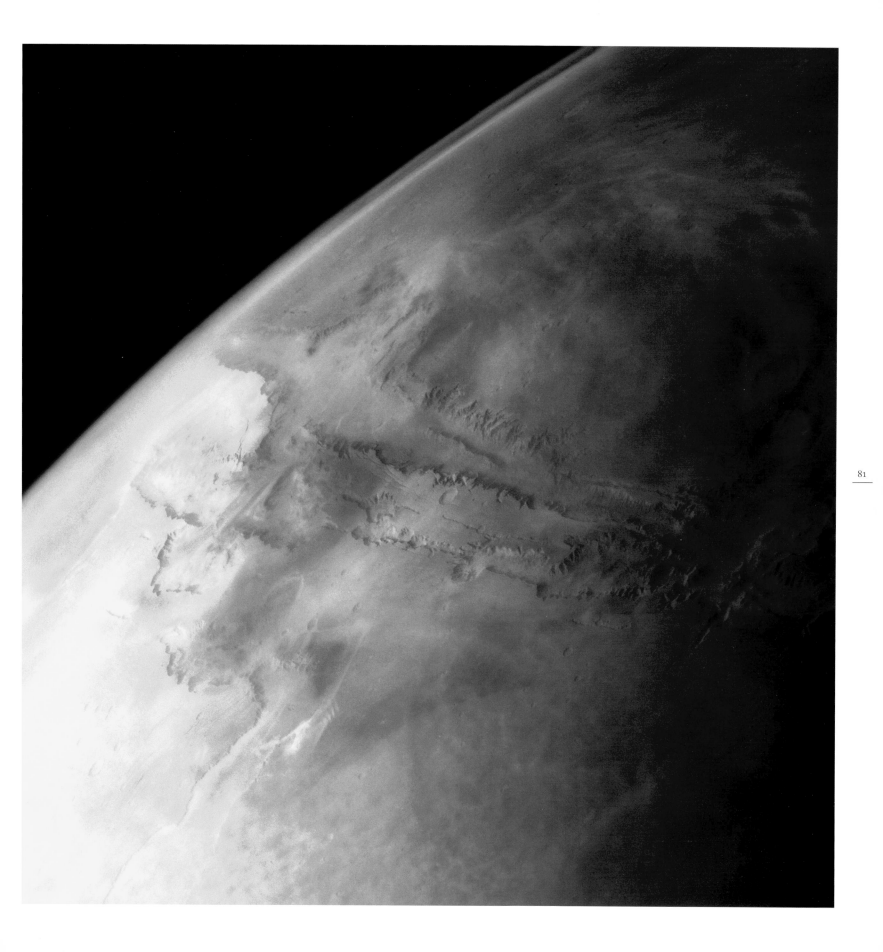

Part of Valles Marineris

South is up in this view of the maze-like curving rift valleys on Mars called Noctis Labyrinthus, or Night Labyrinth. Two giant volcanoes are visible: Arsia Mons is upper right and Pavonis Mons is lower right.

Mosaic composite photograph. Viking Orbiter 1, 22 February, 1980

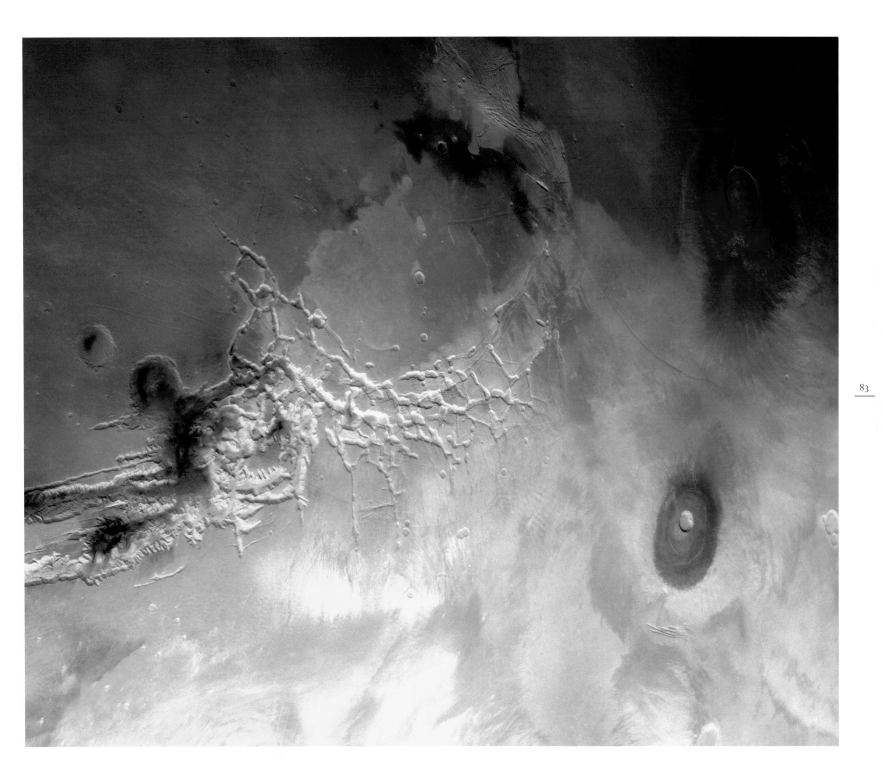

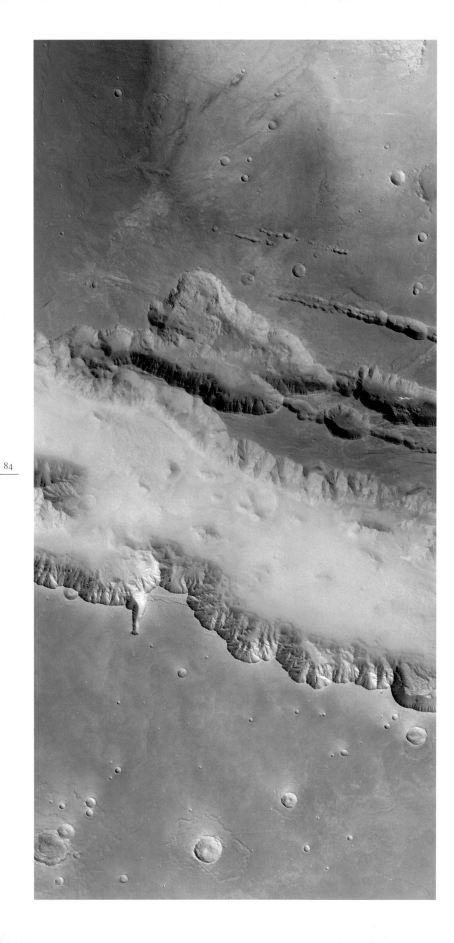

left

Ground Fog in Valles Marineris

The western part of the 1,900-mile-wide (3,060 kilometres) Valles Marineris canyon system is seen here covered in morning water-ice and water-vapour ground fog. The canyon is more than four miles (six and a half kilometres) deep in places, over three times deeper than the Grand Canyon in Arizona, the United States.

Mosaic composite photograph. Mars Express, 25 May, 2004.

right

detail view

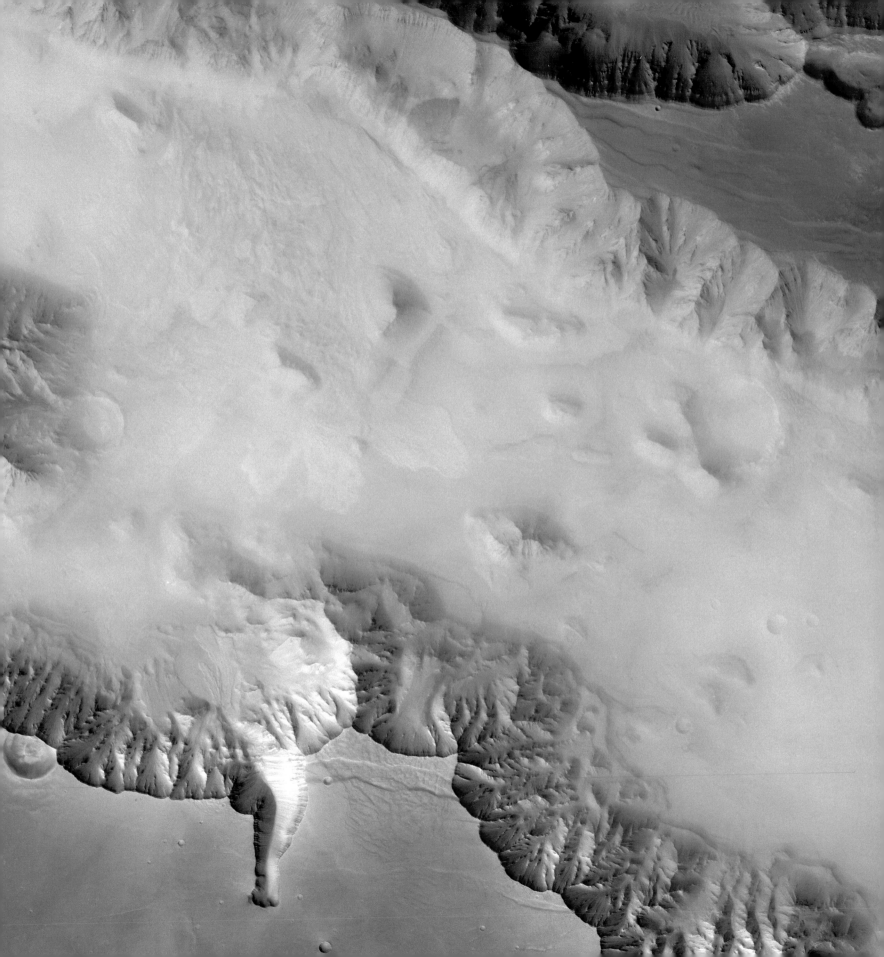

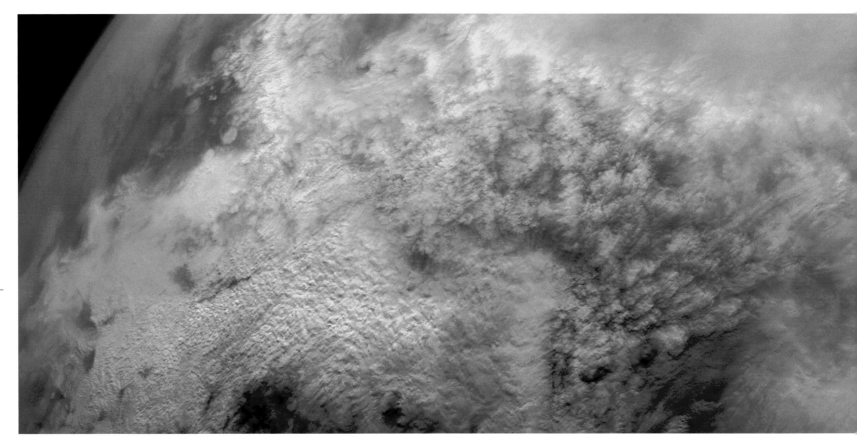

above

Global Dust Storm on Mars

Mars is the only planet that has truly global
storms. Dust storms such as the one captured
here can last for months. The giant Valles
Marineris canyon system is visible through a
veil of dust to the right of the image near a
denser wall of advancing sand.

Mosaic composite photograph.
Viking Orbiter 2, 19 February, 1977

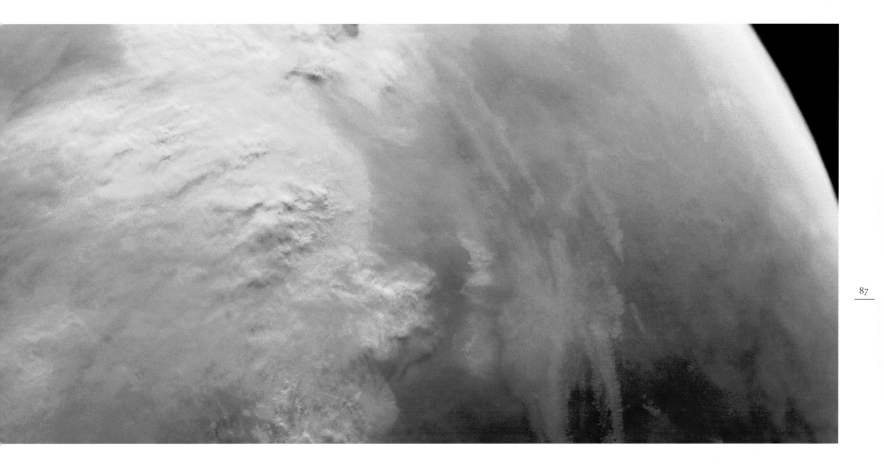

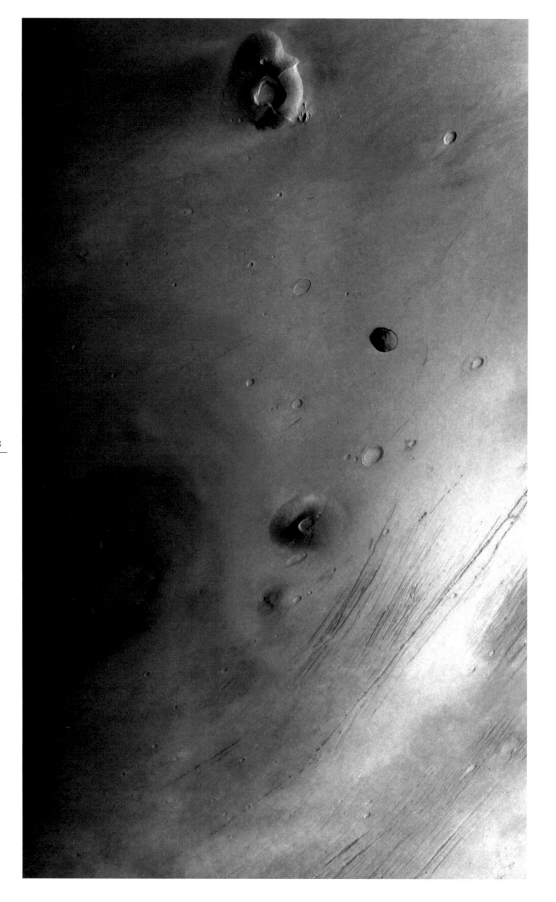

left

Phobos over Volcanic Terrain

Martian moon Phobos is the dark object above and right of centre. Here it orbits past the Tharsis Tholus volcano (top) and the Ceraunius Tholus and Uranius Mons volcanoes (centre and centre left). Phobos orbits only 3,700 miles (6,000 kilometres) above the Martian surface, closer than any other known moon to its parent planet. South is up.

*Mosaic composite photograph.
Viking Orbiter 1,
4 September, 1977*

facing page

**Phobos High Above
Herschel Impact Basin**

The larger of the two tiny Martian moons, Phobos (the grey object to the right) is only seven miles (11 kilometres) wide. Herschel, the large crater in the centre, is more than 180 miles (300 kilometres) across. Phobos is one of the darkest objects in the solar system because its mineralogy makes it very unreflective. South is to the right.

*Mosaic composite photograph.
Viking Orbiter 1,
26 September, 1977*

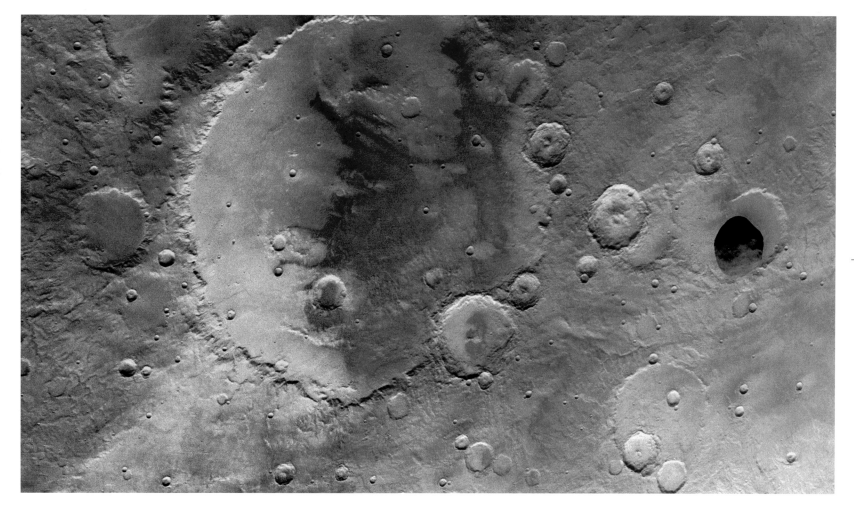

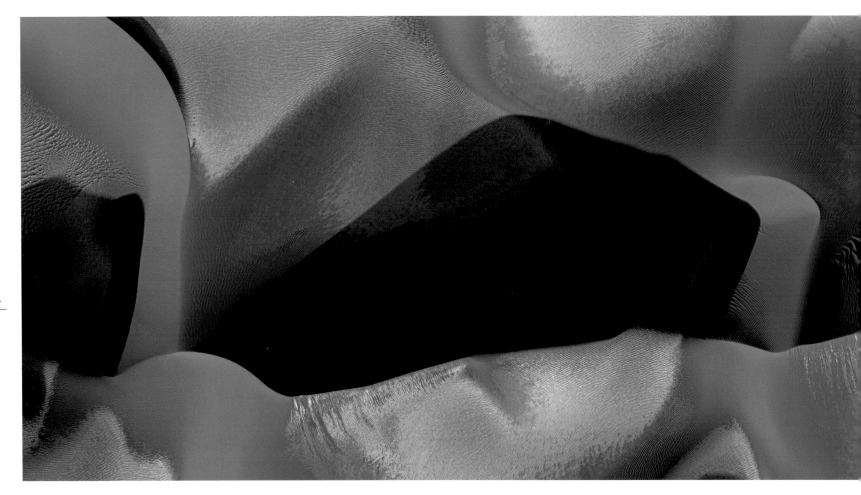

above

Frosted Mars Dunes in Winter

Frozen dunes during winter in Mars' southern hemisphere are covered in seasonal carbon dioxide ice, commonly known as dry ice. The cold temperatures on Mars mean that its south pole is covered in a dry ice cap all year round.

Mars Reconnaissance Orbiter, 25 November, 2006

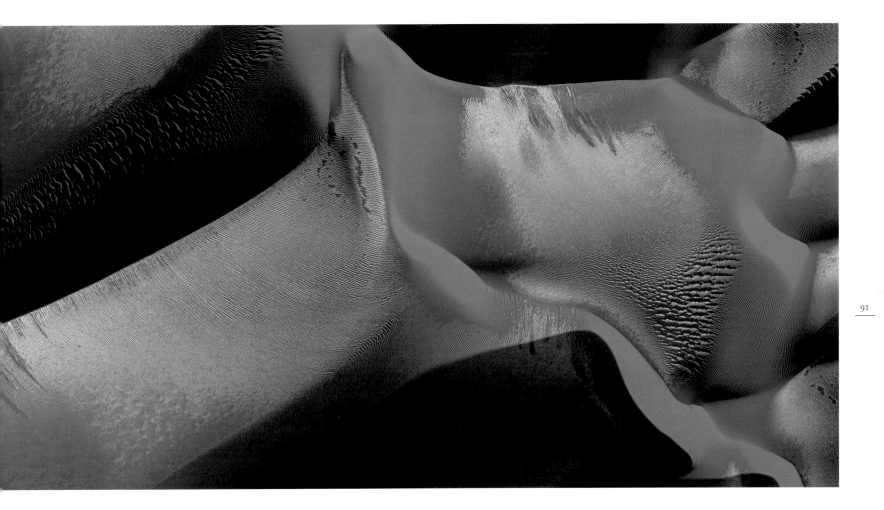

Rover Tracks on Mars

This view looks back at the tracks
of the largest, Curiosity, over a
sand dune within Gale Crater.

*Mosaic composite photograph.
Curiosity Rover, 9 February, 2014*

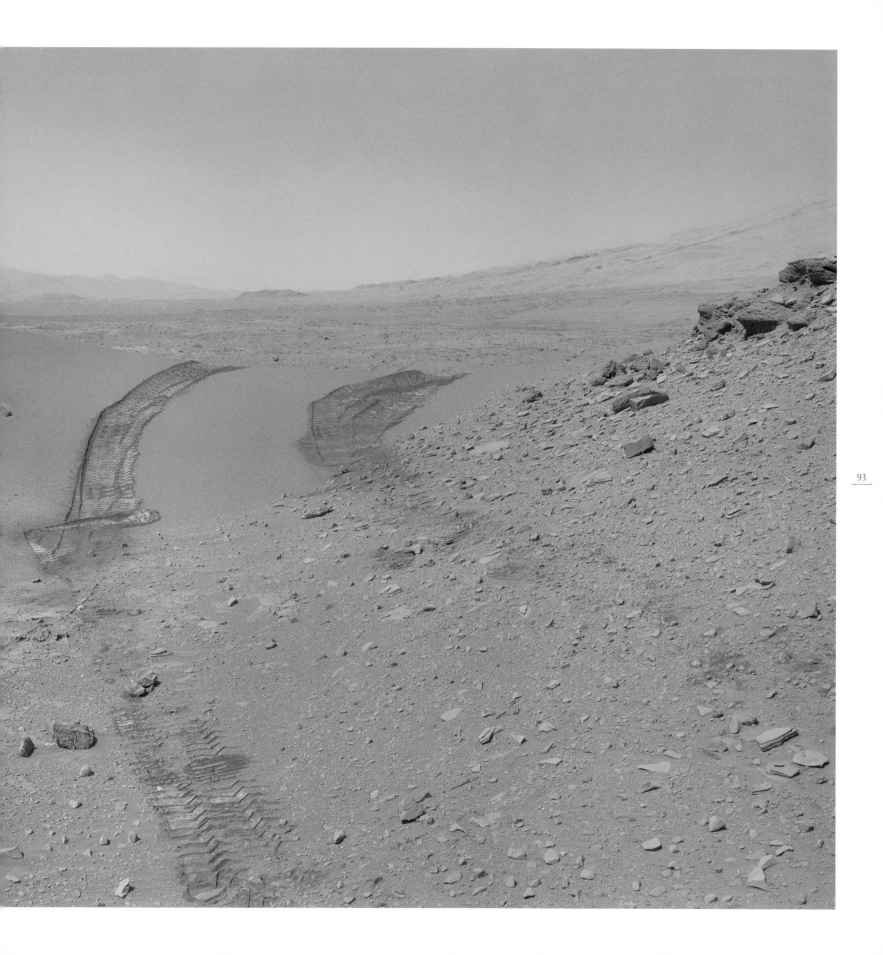

Basaltic Dune Field in Gusev Crater, Mars

View of El Dorado, a basaltic sand dune field inside Gusev Crater. The dark field of dunes hugs the base of Husband Hill, one of the Columbia Hills. The dunes were created when Gusev Crater, more than 100 miles (160 kilometres) wide, was filled in with volcanic rock which has since been eroded by winds to form these sand formations.

Mosaic composite photograph. Spirit Rover, 30 December, 2005 – 1 January, 2006

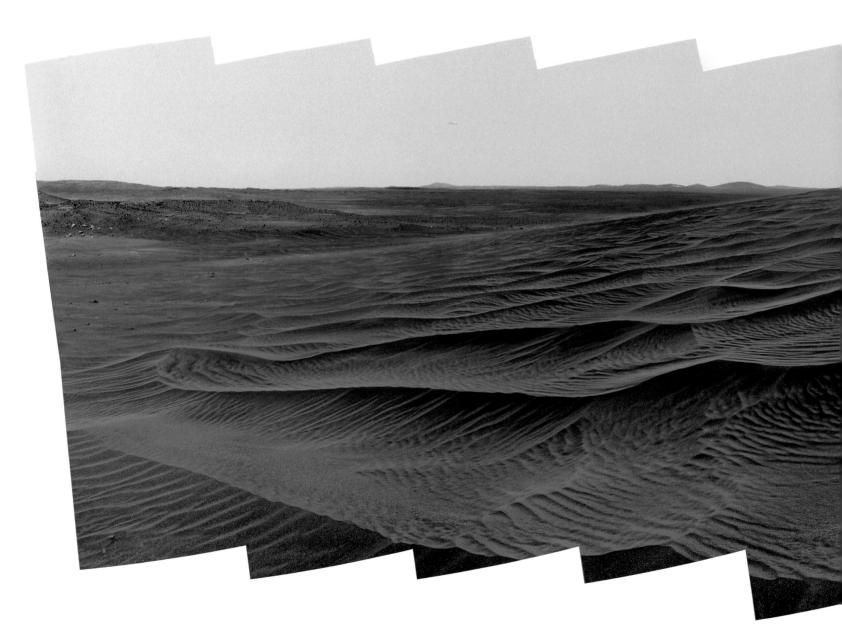

overleaf

Gale Crater Landscape

A chain of serrated buttes – isolated hills with
steep sides and flat tops – and eroded rock layers
define the horizon in this view of Gale Crater.
Investigation of this 3.5-billion-year-old
equatorial impact structure with its exposed
geological layers is the primary reason why the
Curiosity Rover was sent to Mars.

Mosaic composite photograph.
Curiosity Rover, 4 May, 2014

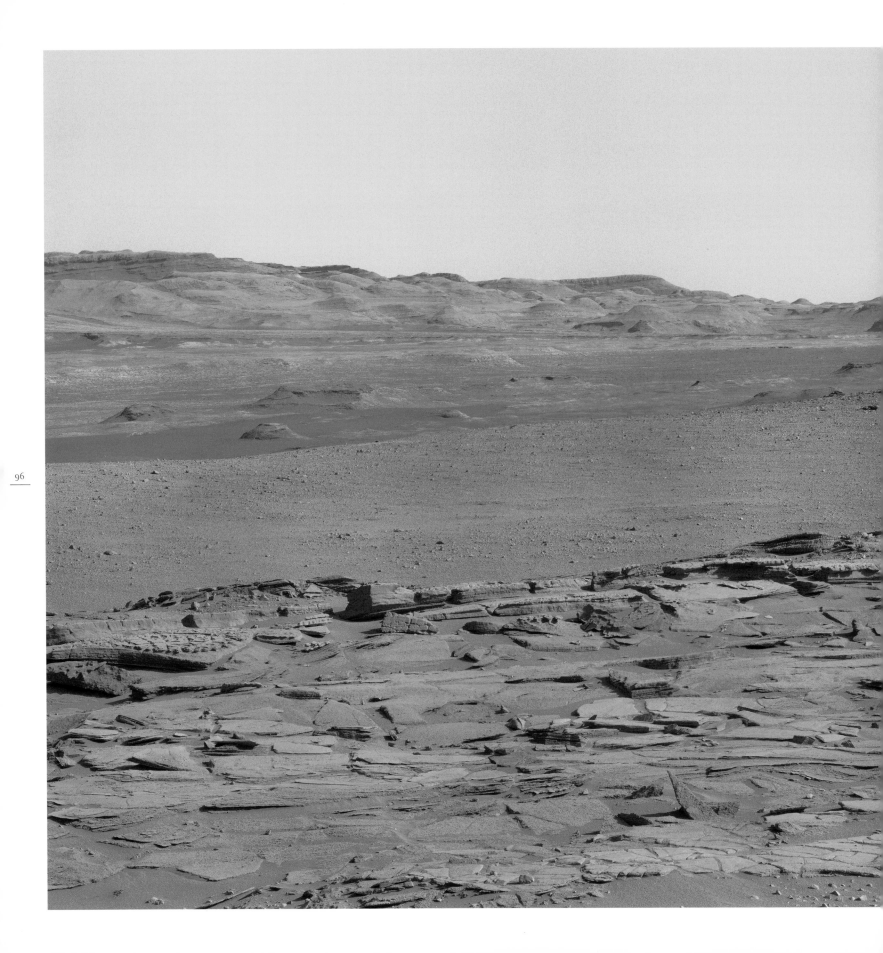

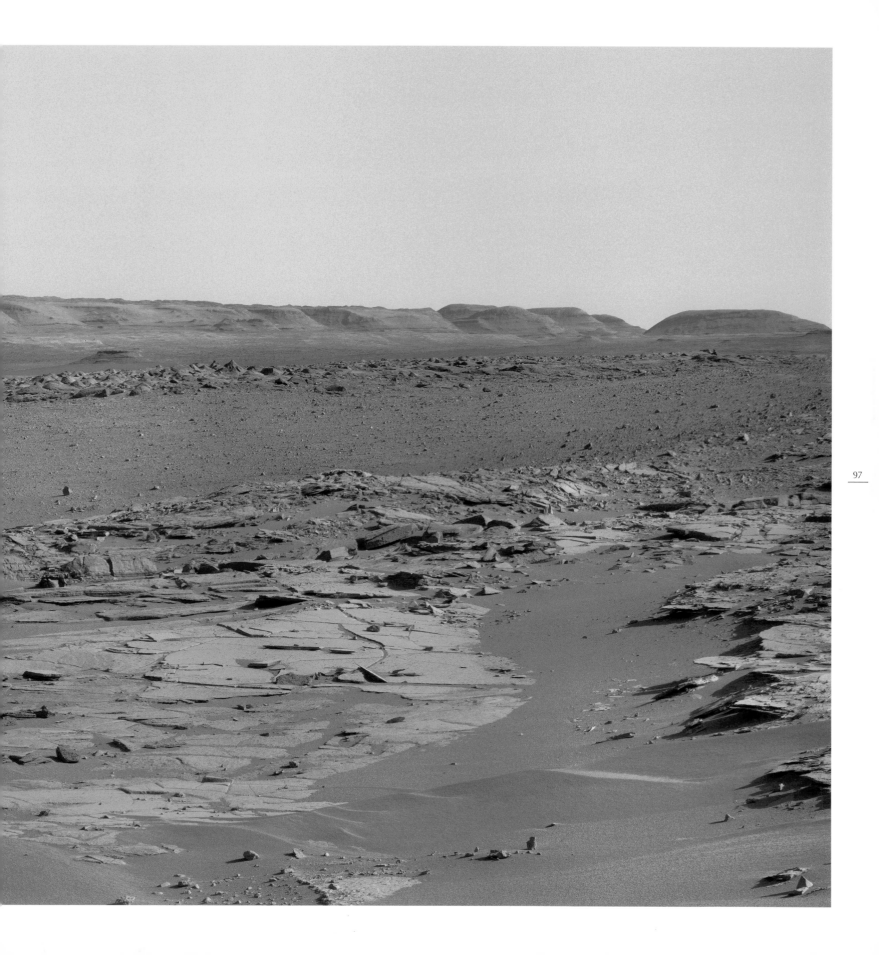

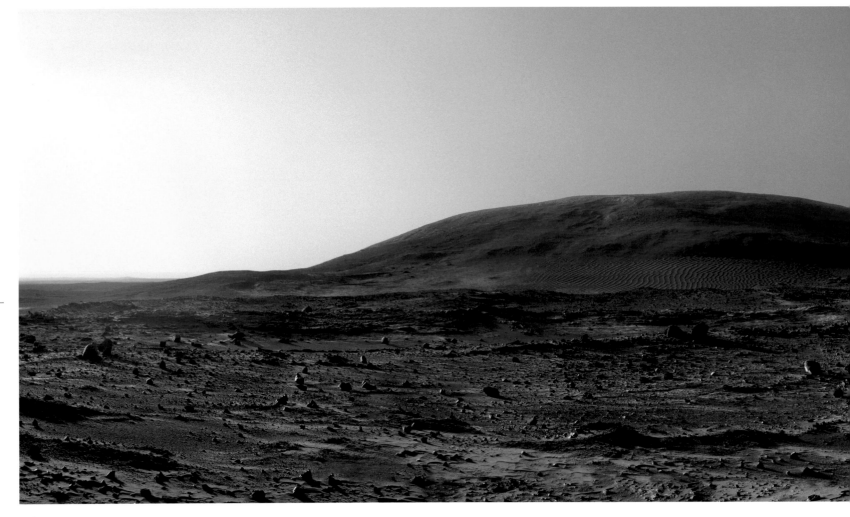

above

Late Afternoon on Mars

View of Husband Hill within Gusev Crater, in the late afternoon light. Husband Hill was named in memory of Columbia Space Shuttle Commander Rick Husband, who died when Columbia disintegrated on entering Earth's atmosphere in 2003.

Mosaic composite photograph. Spirit Rover, 16 April, 2006

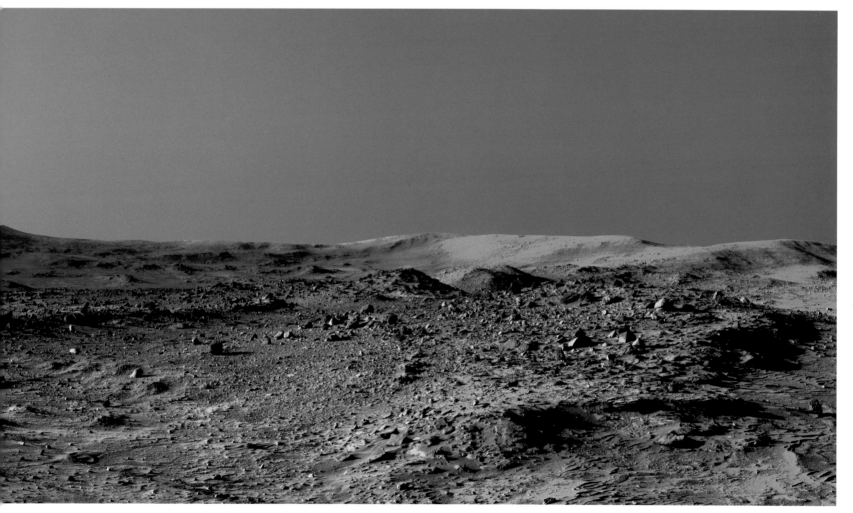

Sunset on Mars

Sunset colours on Mars in far cooler tones than those typically seen on Earth. The central blue glow is caused by sunlight scattering in the Martian atmosphere, the same phenomenon that makes Earth's sky blue. Dust suspended in the atmosphere gives the rest of the sky a copper colour.

Composite photograph.
Spirit Rover, 19 May, 2005

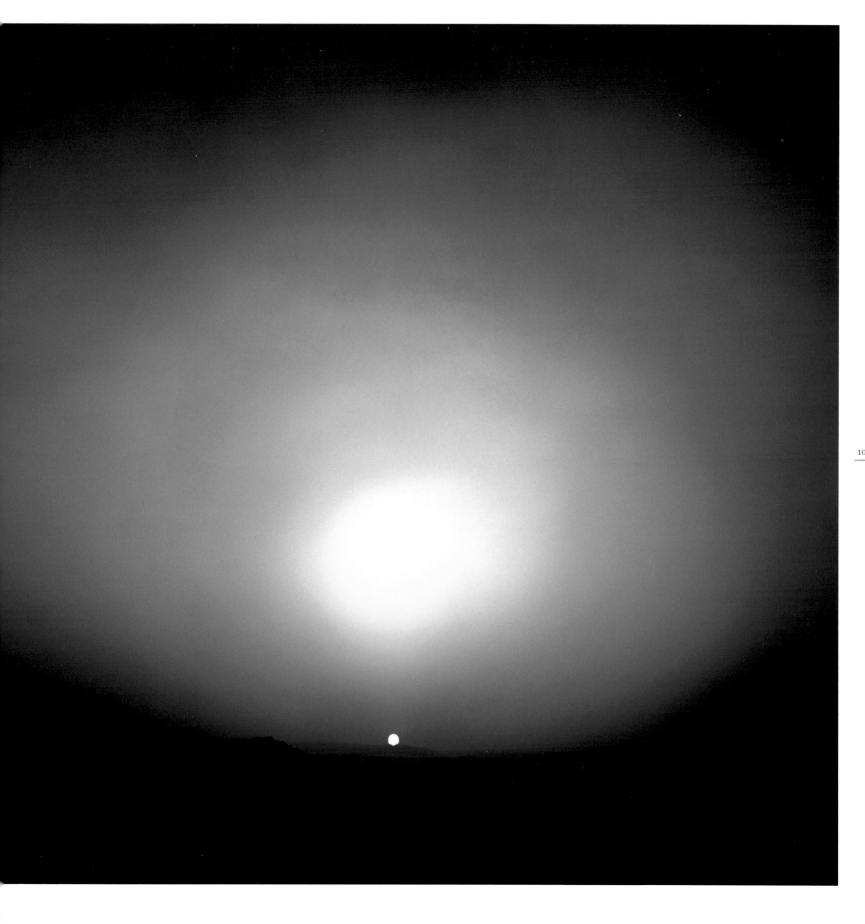

Asteroids and Comets

Although when we think of the Sun's satellites we tend to dwell on first-string worlds like Mars, Jupiter and Saturn — places with weather, moons, even rings — there's a lot of fascinatingly variegated small fry tumbling along various trajectories throughout the Solar System. These objects, many of them thought to comprise truly primordial matter largely unchanged since the collapse of the solar nebula into a proto-planetary disc about 4.5 billion years ago, travel under various names. Even a short list gives a sense of their confusing variety: asteroids, long-period comets, short-period comets, protoplanets, dwarf planets, Kuiper belt objects (KBOs), trans-Neptunian objects (TNOs), cis-Neptunian objects and meteoroids, not to mention Trojans and centaurs. Just to keep things as lively as possible, many can fairly be accused of wearing multiple masks. An asteroid can be a protoplanet or a planetary embryo. A KBO may be a dwarf planet, which can simultaneously be a protoplanet; in fact, it usually is. An asteroid that shares some characteristics with a comet is called a centaur; centaurs are generally suspected of having once been KBOs, which have been gravitationally slung into closer orbits of the Sun, thereby becoming cis-Neptunian objects — and on and on.

While classifying smaller celestial objects is a field clearly in need of more disciplined nomenclature, the jumble is either a function of the fact that we're still in the very early days of exploring such objects — and presumably refining our categorization schemes as well — or it's simply because nature's awesome complexity is giving our need to name all its constituent parts a serious workout. Or both. In any case, one needs to start somewhere when it comes to the inchoate, and during the twenty-first century these smaller Solar System objects have increasingly become the target of inquisitive robots from Earth.

On July 4, 2005, a NASA spacecraft with the Hollywood-derived name Deep Impact did its moniker and nation proud by launching a projectile to smash into the nucleus of short-period comet Tempel 1 — an irregularly shaped snowball just under five miles (eight kilometres) wide. (Short-period comets have orbits of less than 200 years; long-period ones take thousands, even millions of years to complete a single elliptical orbit.) The collision produced a scientifically productive kind of fireworks display, and it also triggered a spectacular outgassing of cometary material that lasted for 13 days. The crater produced by the impact, which had an energy wallop equivalent to about five

facing page

Comet Tempel 1 After Projectile Impact, Near View

The nucleus of comet Tempel 1 soon after being struck by a projectile launched from the appropriately-named Deep Impact spacecraft. A cloud of dust and ice expands into space.

Composite photograph. Deep Impact, 4 July, 2005

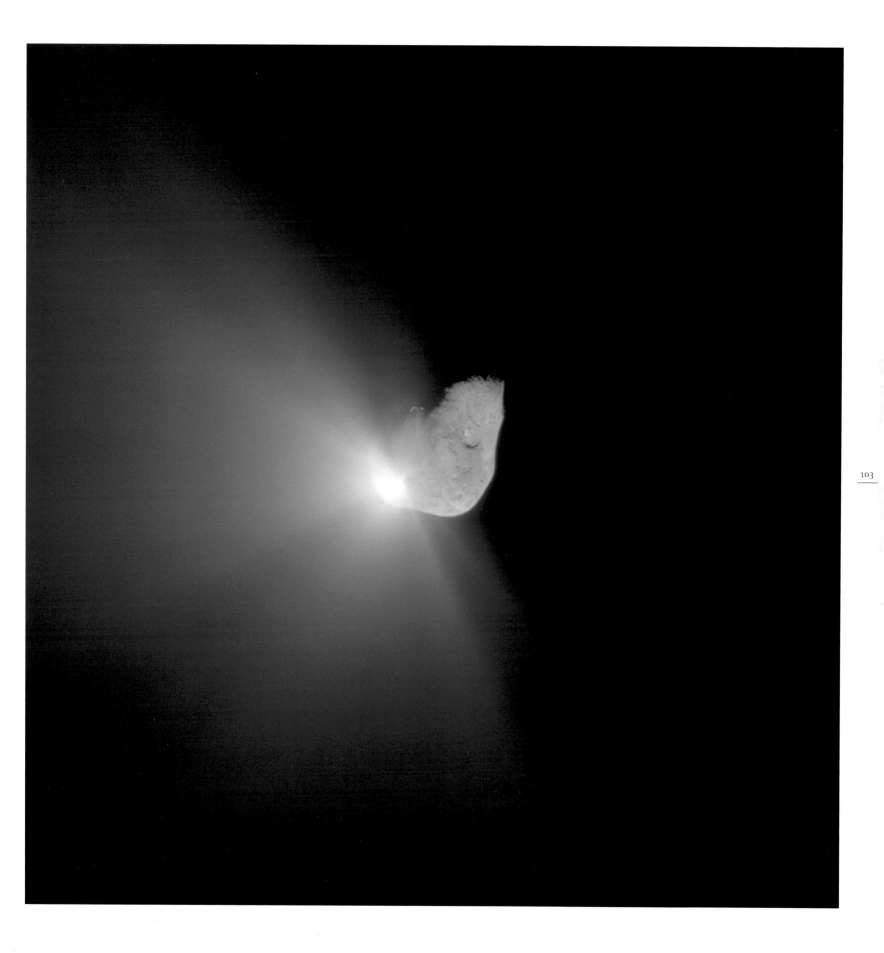

facing page

Comet Tempel 1 After Projectile Impact, Far View

Comet Tempel 1 at the centre of an expanding cloud of dust and ice caused by the Deep Impact projectile.

Composite photograph. Deep Impact, 4 July, 2005

tons of dynamite, was quickly photographed before the expanding cloud obscured it from view. Tempel 1 was discovered to have a far higher percentage of dust to water than assumed, with about 5 million kilograms (11 million pounds) of the latter and between 9-25 million kilograms (20–55 million pounds) of the former venting into space. The material released was much finer in composition than suspected — closer to powder than sand — and spectroscopic analysis revealed the presence of clays, carbonates and even sodium, which is typically hard to find in space.

Tempel 1 was also determined to be quite porous; only about 25 percent of its volume is matter rather than space. Although the comet was already at its closest approach to the Sun, and had been observed venting material into its coma — a halo of vapour produced due to the effects of solar heat on the cometary snowball — Deep Impact's projectile produced such a cloud of additional material that Tempel 1 reflected six times as much sunlight as usual. All in all it had to have been the most viscerally satisfying encounter with a comet in human history; if comets were once considered bad omens, veritable harbingers of doom, we really showed this one who's the boss.

A bit later the same year, in October 2005, the Japanese spacecraft Hayabusa edged up to asteroid Itokawa, an object that crosses the orbits of both Earth and Mars. Named after a Japanese rocket scientist, Itokawa was discovered to be less than 550 metres (600 yards) long, and presented the fascinating spectacle of an interplanetary rubble pile — essentially what you'd get if you dumped an equivalent volume of rocks and sand into space and watched the landfill agglomerate loosely together under the influence of its own feeble gravity. Although such an object had long been theorized, it had never been observed up close, so this was already a triumph for Japan's space program. But then Hayabusa, which was designed as a sample return mission, proceeded to touch down on the asteroid, collect dust from its surface, and return to Earth — ultimately landing its capsule in Australia in June 2010, the first time asteroidal material had been returned to Earth.

In 2011, the NASA spacecraft Dawn entered orbit of Vesta, the second-most massive object in the asteroid belt — that broad and dispersed ring of tumbling rocks between Mars and Jupiter. Although asteroid Vesta is big enough for its shape to be largely determined by its own gravity — it's irregularly spherical, in other words, albeit in a distorted, potato kind of way — certain surface irregularities mean it doesn't quite meet the International Astronomical Union (IAU) definition of a dwarf planet. It is, however, considered a remnant protoplanet — a planetary embryo that never managed to accrete enough material to grow to a planetary size. As such, it's a fascinating relic of the early days of the Solar System. It harkens back to the period between three and ten million years after the Sun's formation; a time during which orbiting dust and debris clumped together into planetesimals, which in turn further aggregated into a few hundred protoplanets. Vesta may well look like an early incarnation of Earth, although one without substantial future prospects.

In July 2012, Dawn fired its ion thrusters and gradually departed Vesta, heading for Ceres, the largest asteroid in the Solar System. It currently orbits that object, and will almost certainly remain there long after its propellant runs out and its systems go cold. Cratered Ceres, much more spherical than Vesta, is also a dwarf planet, an IAU-approved protoplanet, and a nominal cis-Neptunian object. It is not a centaur.

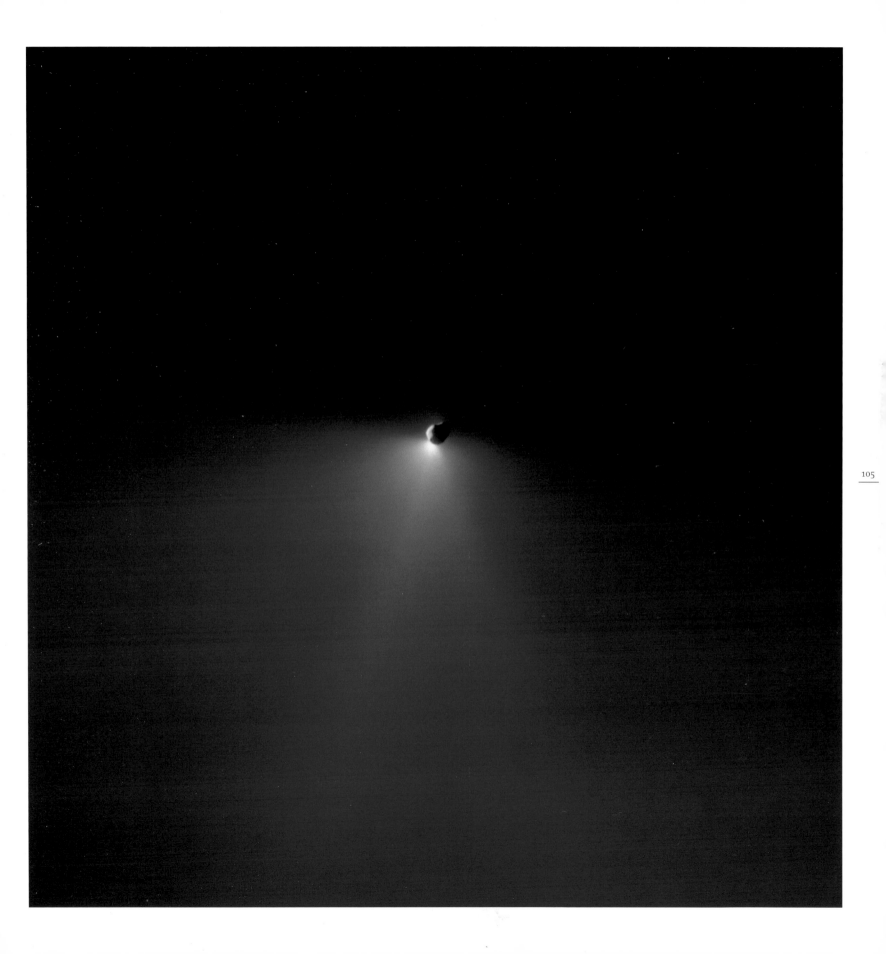

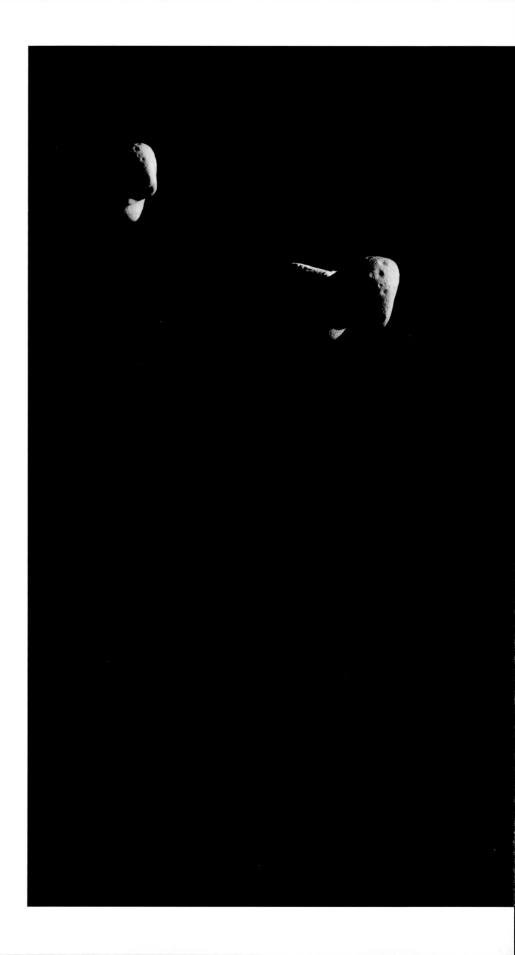

Asteroid Eros

Tumbling through space, 433 Eros is the first near-Earth asteroid ever discovered, in 1898. About 21 miles (34 kilometres) long, it makes one complete rotation in just over five hours. Studying meteorites from asteroids similar to Eros tells us it may contain more gold, silver, zinc, aluminium and other useful metals than exist in Earth's upper crust.

Mosaic composite photograph. NEAR, 16 February, 2000

106

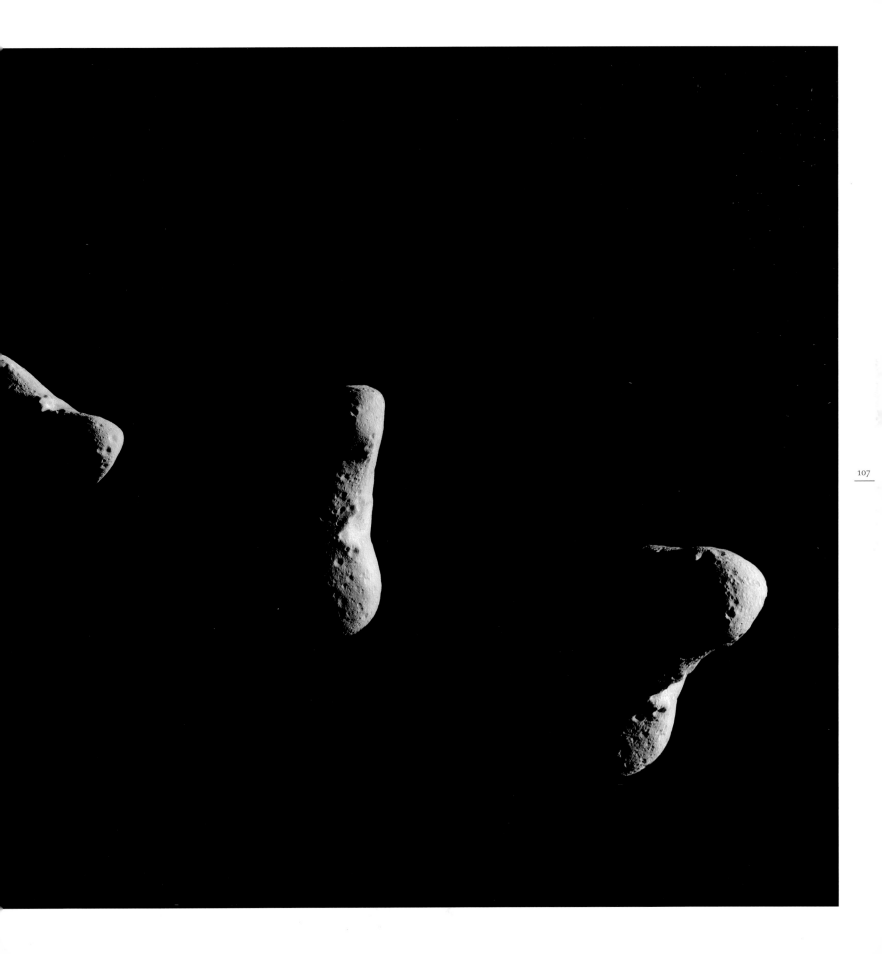

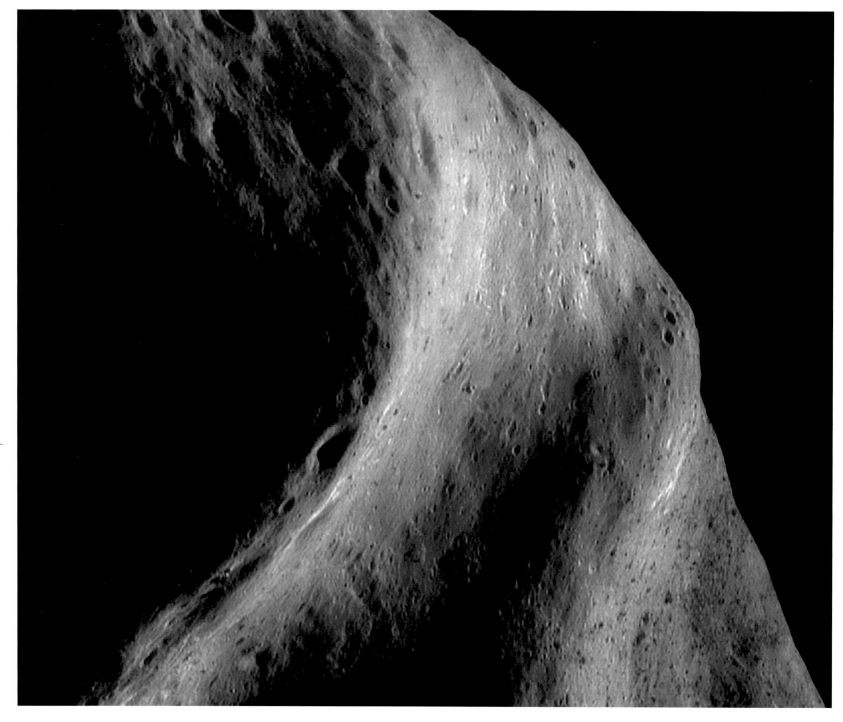

above

Asteroid 433 Eros

A ridge, informally called the saddle, on 433 Eros resembles the trunk of an olive tree.

Mosaic composite photograph.
NEAR, 26 September, 2000

facing page

A Warming Comet

The oddly twin-lobed Comet 67P/Churyumov-Gerasimenko vents gas and dust about a month before perihelion – the closest point to the Sun along its orbit. Outflows and jets of cometary material can be seen as the comet heats up.

Rosetta, 7 July, 2015

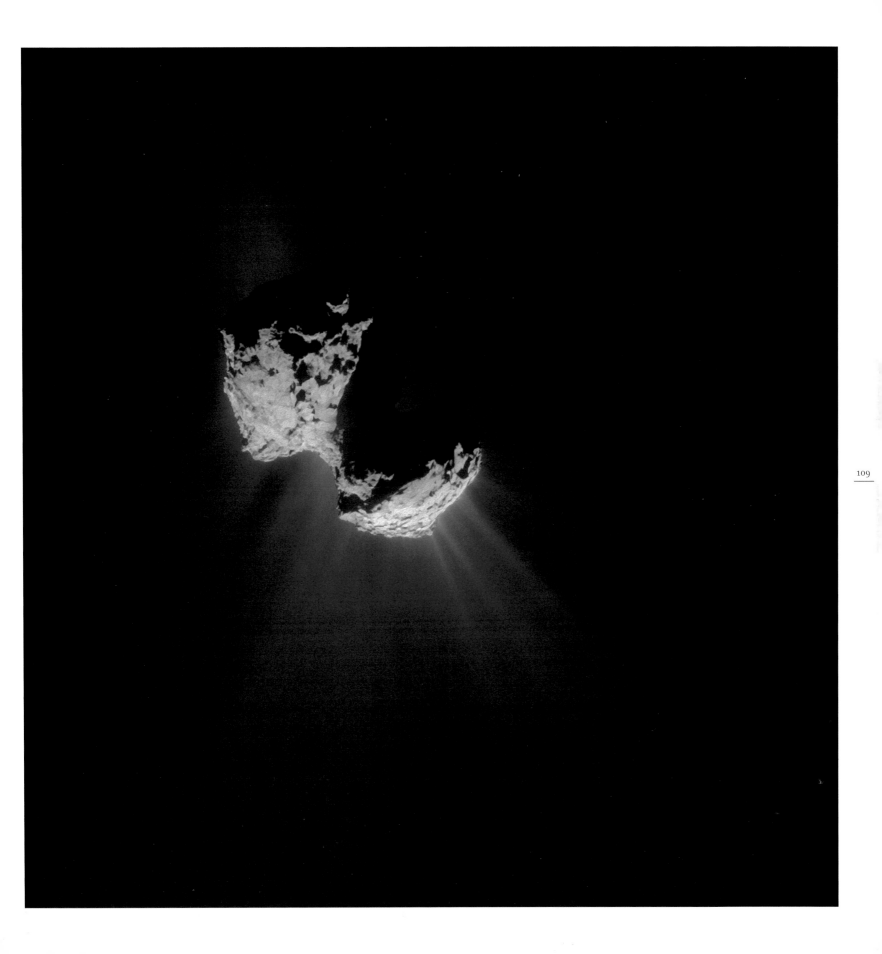

Jupiter

facing page

Transit of Io

Jupiter's innermost large moon, volcanic Io, is the small globe on the far right of this image. Io orbits 220,000 miles (350,000 kilometres) from the gas giant planet's turbulent, banded clouds. Just a bit bigger than our Moon, Io takes only 42 hours to orbit Jupiter. South is up in this view.

Mosaic composite photograph. Cassini, 1 January, 2001

overleaf

Detail View

Jupiter, the king of all the planets, rules an intricate extended system consisting of faint rings, dusty particles, large moons and asteroid-like moonlets. Most are icy and frozen, one is unstoppably volcanic, collectively they're fascinating in their broad-spectrum variety, and individually they're dazzling in their singular strangeness. The endlessly kinetic Jovian archipelago is a kind of solar system in miniature. Its immense centrepiece planet is sometimes considered a kind of failed star — one that didn't quite manage to gather together enough mass from the proto-solar nebula (that disc-shaped disc of gas and dust out of which the Solar System formed more than ten billion years ago) to ignite. But Jupiter still radiates far more heat than it gets from the Sun, and it didn't do so badly in the size department either: this rapidly spinning ball of hydrogen and helium is more than twice as massive as all the other planets combined. It's also big enough to cause the Sun, 483 million miles (777 million kilometres) distant, to wobble slightly in its orbit — which is one way that observers from places light-years distant might be able to determine that our star has worlds orbiting it. The fifth planet from the Sun, Jupiter occupies the Solar System's middle ground and shepherds 61 known moons of various sizes.

Although dwarfed by their incomparable master, four of Jupiter's largest moons have the heft of terrestrial planets in their own right, and although the inner three are locked in a mathematically precise, syncopated orbital resonance — a dance that might have caused Johannes Kepler, the discoverer of the laws of planetary motion, to nod in profound appreciation — from there they diverge in many details. Grooved Ganymede, one of four large moons discovered telescopically by Galileo from Padua in 1610, is the biggest moon in the Solar System and larger than the planet Mercury. Callisto, one of the most cratered objects known, is only slightly smaller. But the 'fire and ice' pairing of Io and Europa, the innermost two, presents a bizarre spectacle. They may be the two most fascinating deep-space objects ever seen.

About the size of the Earth's moon, Europa almost certainly contains a liquid water ocean under its intricately ribbed and fissured ice, one that may contain more salt water than all the Earth's oceans combined. Arcuate cracks on Europa's face — crevasses tugged into wave-form-like chains, each link crescent-shaped according to the shifting tidal pull of the planet's powerful gravity — give clear evidence that Europa's ocean isn't just wishful thinking. So do jumbled fields of

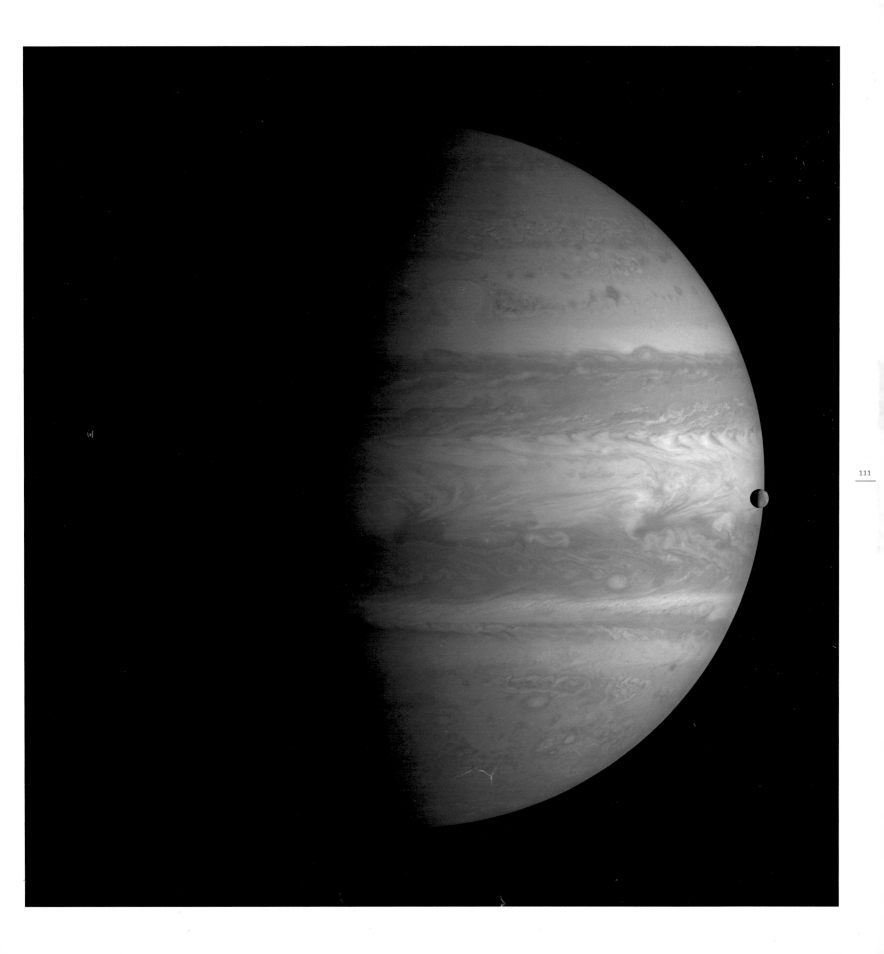

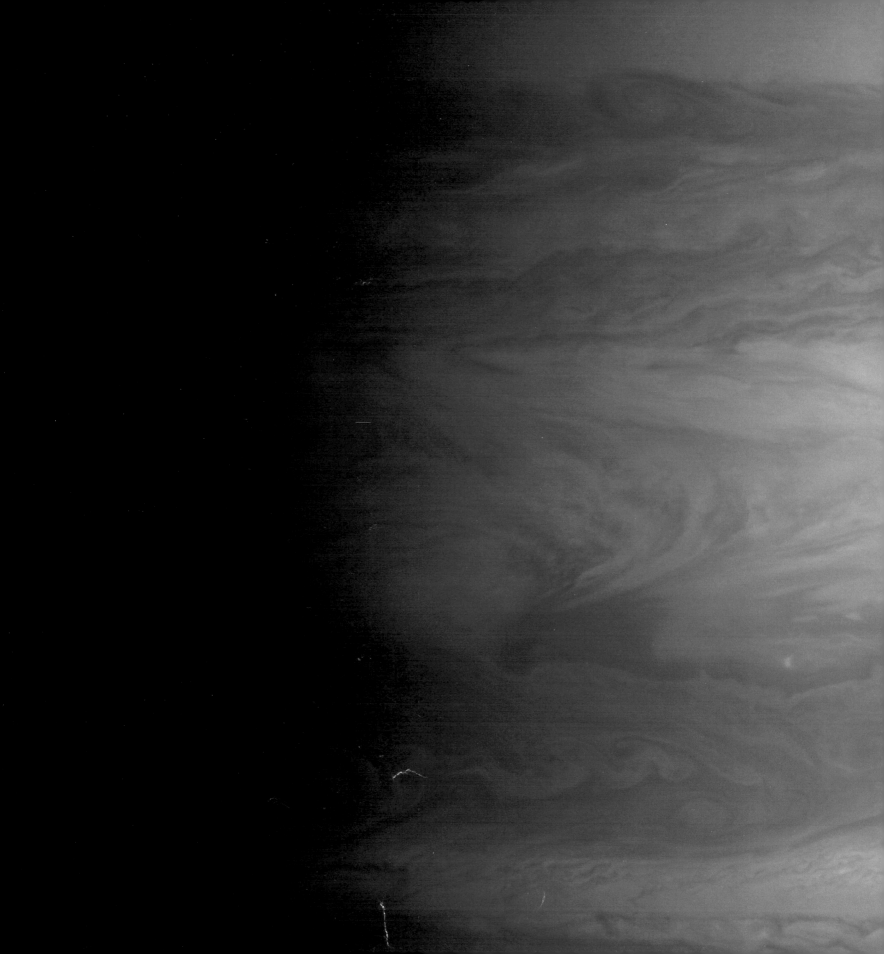

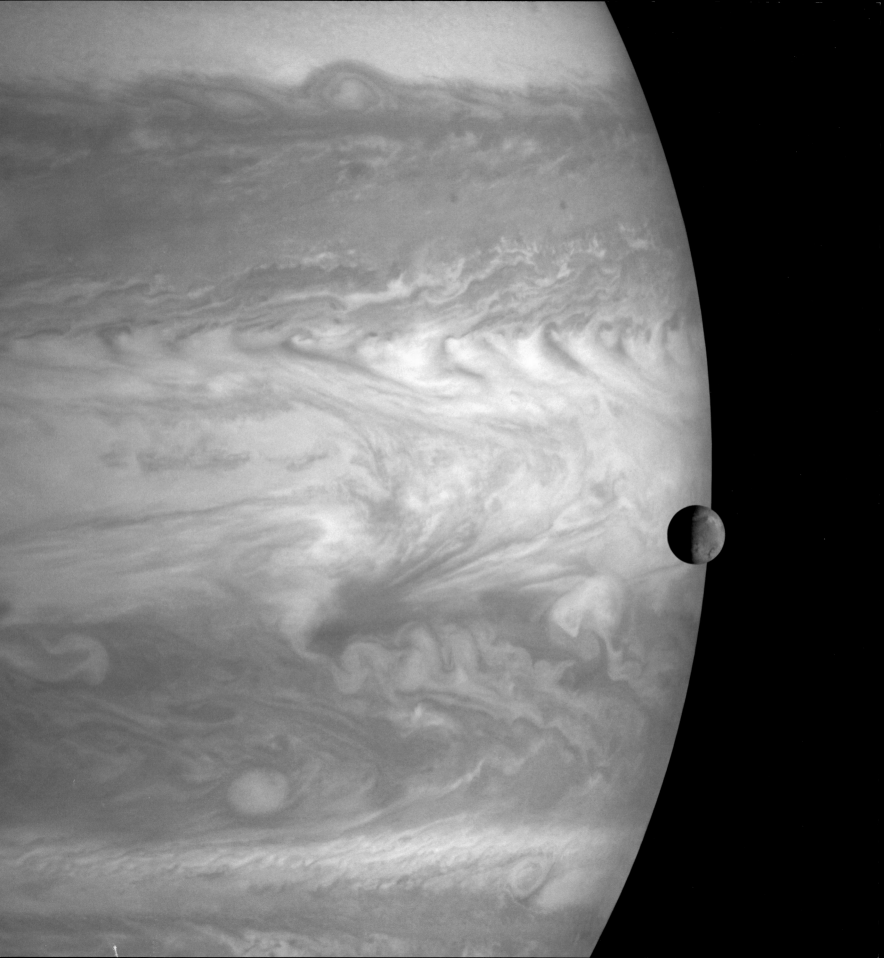

apparently partly thawed and then re-frozen icebergs, seemingly indicative of melt-throughs in the indeterminate past and measurements of the moon's magnetic field, which also indicate the presence of a conductive sub-surface liquid layer. And despite its complex vocabulary of features, Europa possesses the smoothest surface in the Solar System, yet more evidence of a liquid substrate.

Intriguingly, the mid-1990s discovery of submarine colonies of organisms in the Earth's oceans entirely independent of solar energy, and gathered instead around towering volcanic vents called 'black smokers,' raises the prospect that Europa's ice-capped ocean might incubate life as well. In fact there is speculation that life on Earth started this way, only gradually moving toward dependence on photosynthesis. During the 1990s, as the Galileo mission to Jupiter incrementally augmented the Voyager data of the late 1970s, the case for an ocean on Europa has been almost entirely closed, to the point where the moon now ranks up there with Mars as potential extraterrestrial biosphere. But even without these provocative speculations, Europa possesses a jewel-like lustre. It's simply a pearl in space.

By contrast the innermost Galilean moon, Io, is more a piece of ravaged gold — and certainly the most lurid sphere under the Sun. Sulphurous and fuming, more volcanic than any other known Solar System object, Io is so torn by the gravitational pull of Jupiter and the counter-tug of its three large sister moons that it's constantly forced to replace its outer surface with materials expelled, at extremely high temperatures, from the boiling subterranean lavas around its core. One result is Io's varying shades of red, orange and yellow, with each hue thought to correspond to the initial temperature of the sulphur when it cooled (or its current temperature, or the amount of time it has been

exposed to Jupiter's fierce blasts of radiation). When eclipsed by the shadow of its parent planet, Io's colours don't quit: the place fizzes with astoundingly lysergic combinations of blue and orange light, the result of interactions between its volcanic plumes and Jupiter's powerful magnetosphere. Fiery flashes dance in syncopation at Jupiter's poles in response. Io is an altogether hallucinatory world.

The immense banded object bulging at the centre of this collection of strange moons is no less fascinating and strange, however: a raging ball of storms, cloud-currents and flickering lightning bolts named, very appropriately, after the Roman king of the gods. Jupiter's first telescopic observers in the seventeenth century must have suddenly realized just how spookily prescient that name really is. Apart from its baleful, Olympian red eye (actually a storm system more than twice as large as Earth and at least 300 years old), the very fact that Jupiter rules its own system of captive worlds was substantial confirmation of the Copernican theory. If they waltz around Jupiter, the controversial conclusion went, then the planets must in turn orbit the Sun.

This well-reasoned argument got Galileo into all kinds of papal hot water, but he was eventually forgiven by that same office. In January 1997, the same beneficent Pope who had finally acknowledged, all of 300 years later, that Galileo may have had a point also granted an audience to the scientists running the mission named after the Pisan heretic. Presented with robot Galileo's pictures of Jupiter's satellites by project director Bill O'Neil — who took pains in particular to outline the potential implications of Europa's global ocean — multilingual John Paul II studied that moon's icy faults and pondered for a moment.

Then the Pope said, 'Wow.'

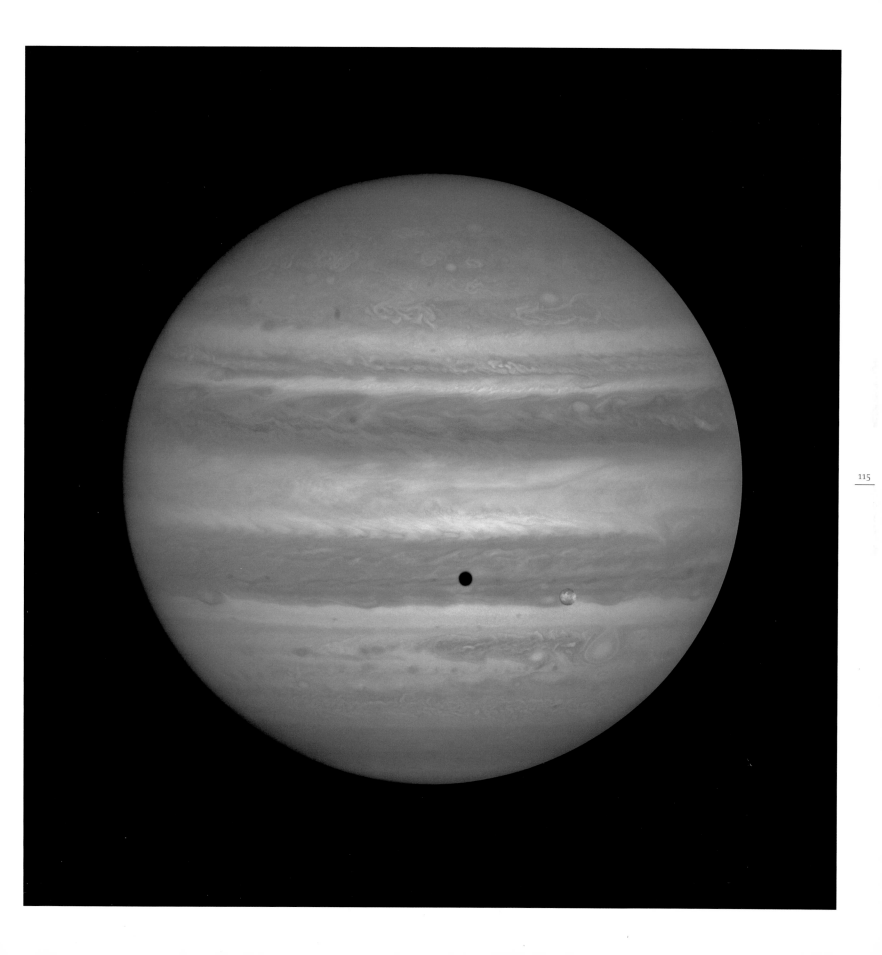

**Volcanic Io with Two
Eruptions Visible**

The closest of Jupiter's large
moons, Io is the most volcanic
object in the Solar System. The
gravitational pull of Jupiter com-
bined with a regular counter-pull
by its sizeable sister moons,
squeezes the moon, heating its
interior and forcing lava to the
surface in continuous eruptions
from more than 400 active
volcanoes.

*Mosaic composite photograph.
Galileo, 3 July, 1999*

116

overleaf

Io Rising

Jupiter's volcanic moon Io, the
golden spot on the far right of
this image, rises over the planet's
night side. Io has been partly
obscured by Jupiter's night-time
horizon.

*Mosaic composite photograph.
Voyager 1, 24 February, 1979*

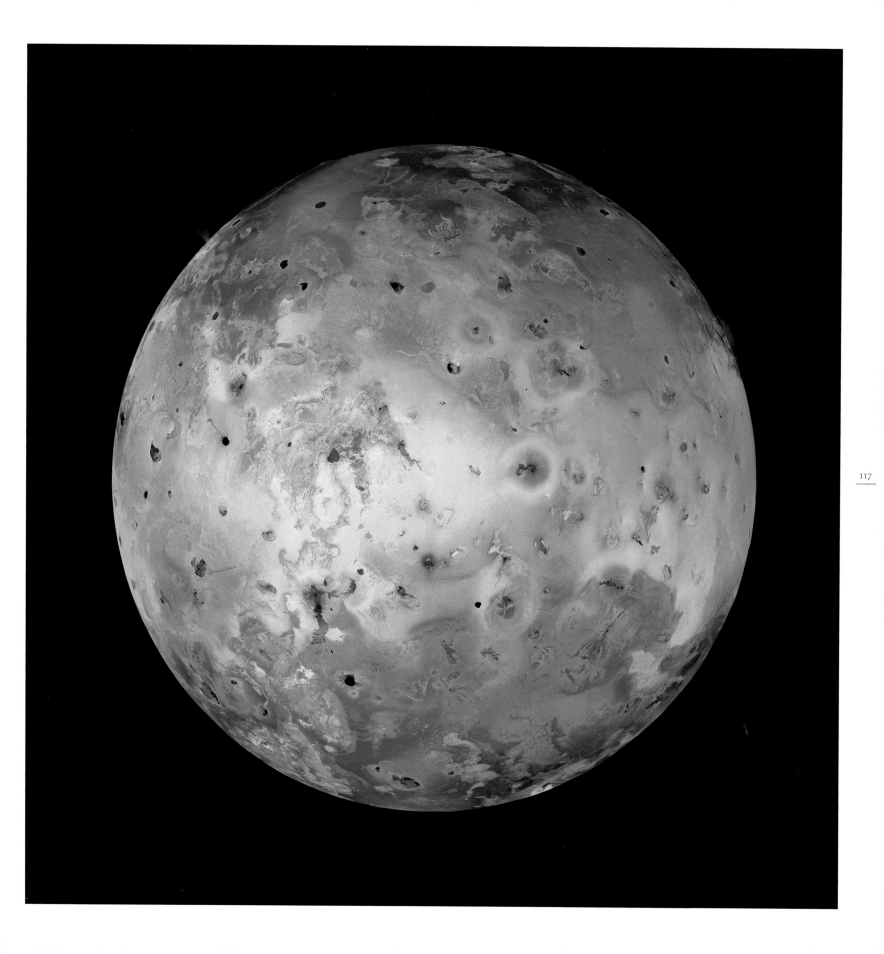

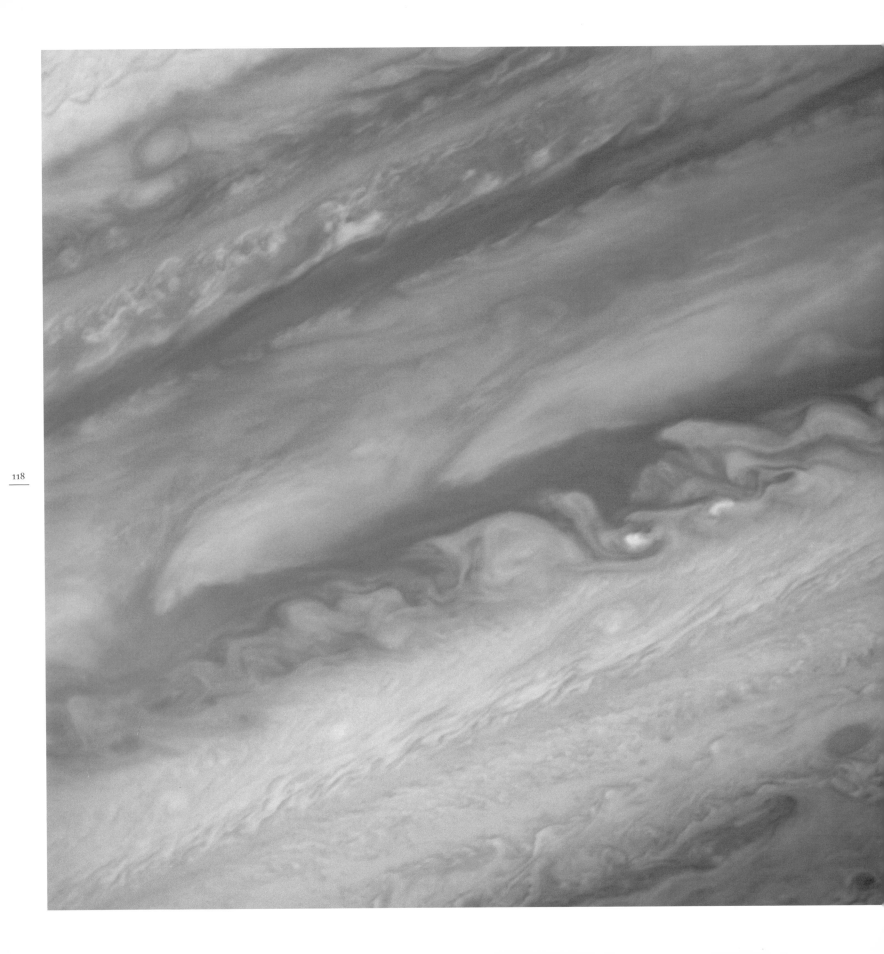

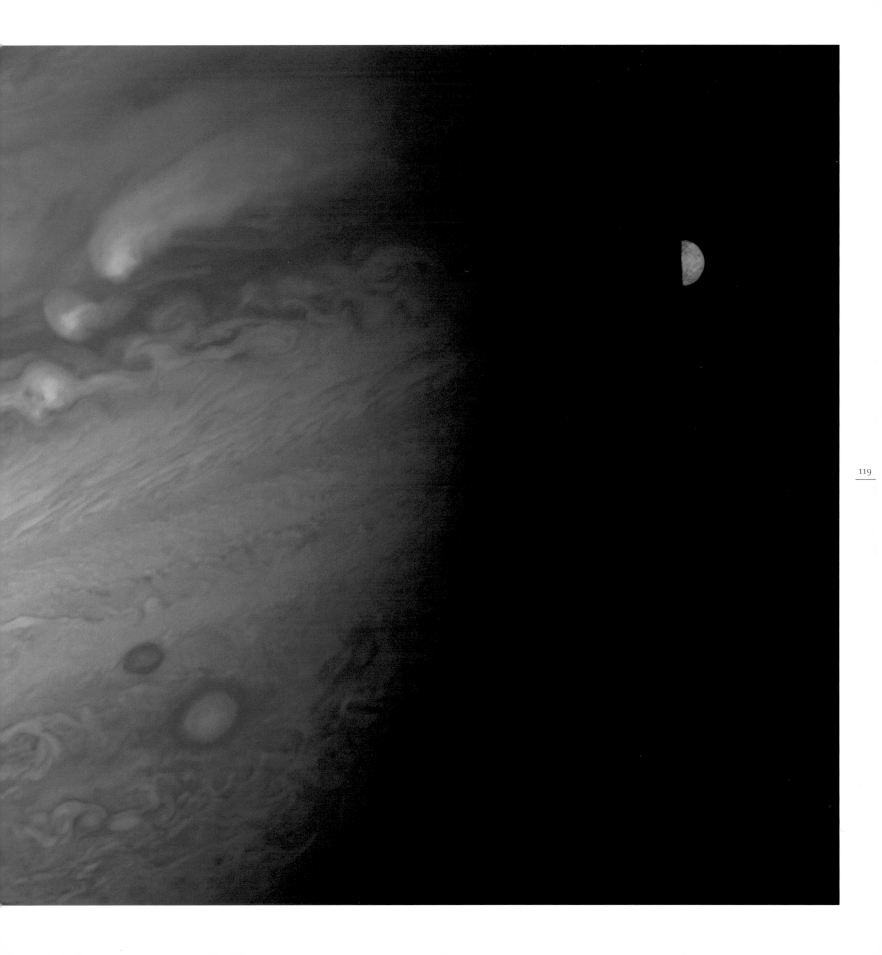

**Europa, an Ice-covered
Ocean Moon**

Jumbled faults and curving ridges
cover the face of Europa, one of
the most enigmatic bodies in
the Solar System. Europa's vast,
ice-capped ocean is kept warm by
the gravitational effects of Jupiter
and its moons, and perhaps by
volcanoes on the sea floor.

*Mosaic composite photograph,
Galileo, 29 March, 1998*

overleaf

Ice-sheathed Europa

This tangled web of cracks cover-
ing Europa's frozen surface could
be the result of the gravitational
pull exerted on Europa's large
sub-surface ocean of liquid water
by Jupiter and its other large
moons. The darker wider bands
are thought to form as the crust
is slowly pulled apart, allowing
warmer ice to well up from below.

*Mosaic composite photograph.
Galileo, 26 September, 1998*

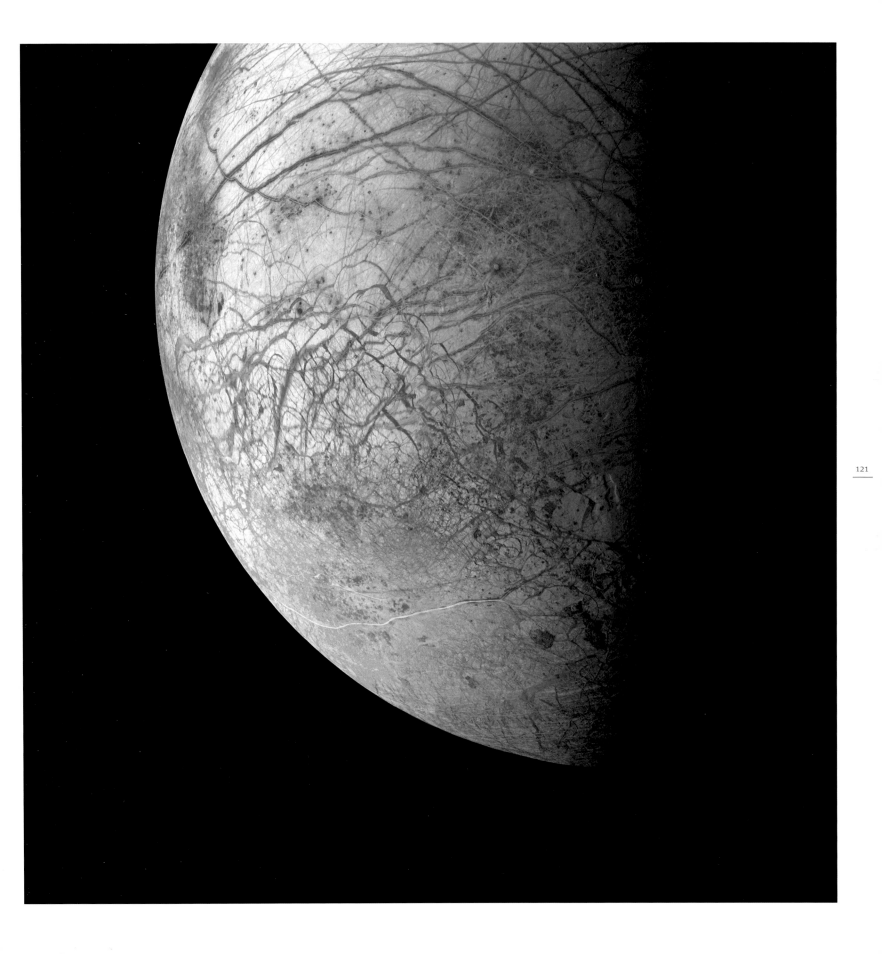

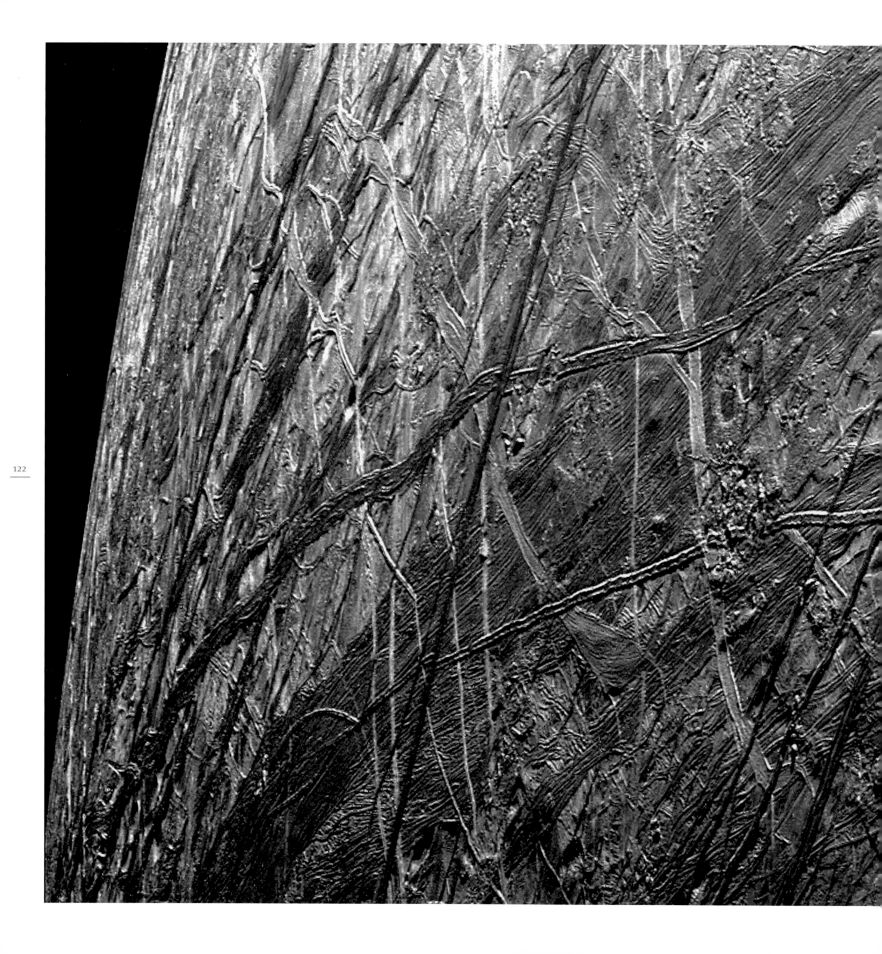

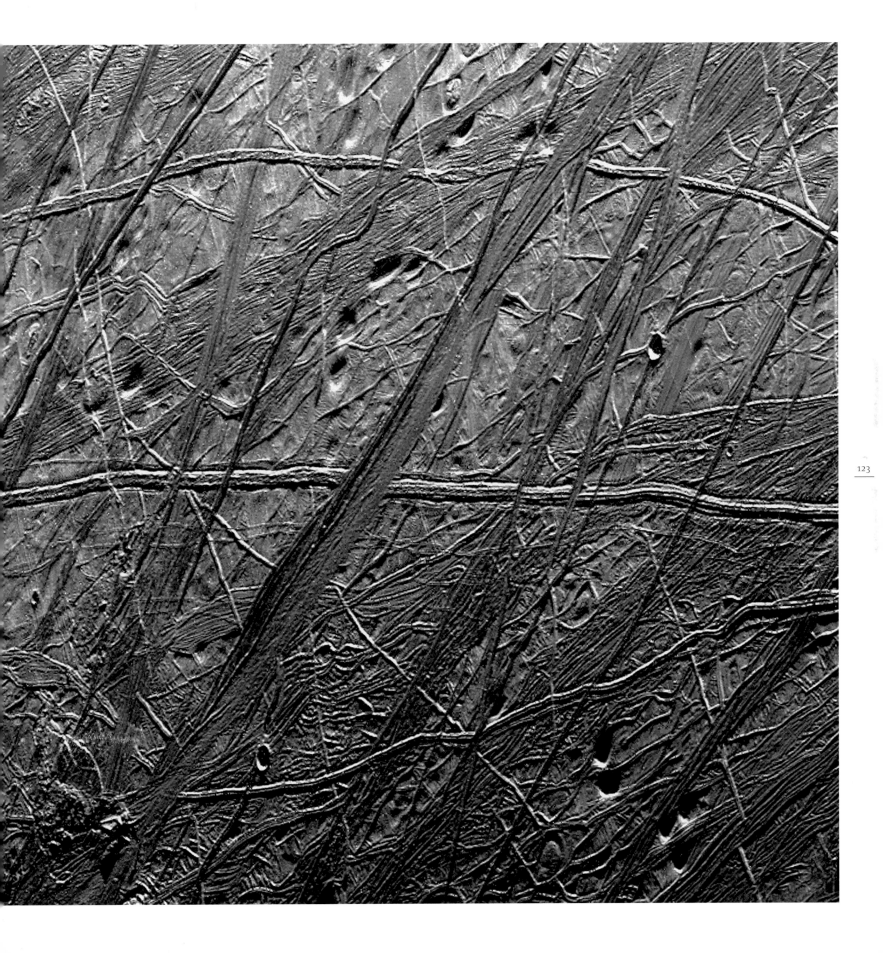

Europa and the Great Red Spot

Europa is the second closest large moon to Jupiter, and can be seen on the right hand side of this image. It is slightly smaller than Earth's moon. To the left is Jupiter's Great Red Spot, a vast storm system three times the size of Earth that has been raging for at least 348 years.

Mosaic composite photograph. Voyager 1, 3 March, 1979

overleaf

Crescent Jupiter and Ganymede

Jupiter's largest moon Ganymede, seen here on the right, is the ninth largest object in the solar system and is bigger than the planet Mercury. Like Europa, Ganymede's surface is composed of water ice, and it is thought to have a sub-surface ocean.

Mosaic composite photograph. Cassini, 10 January, 2001

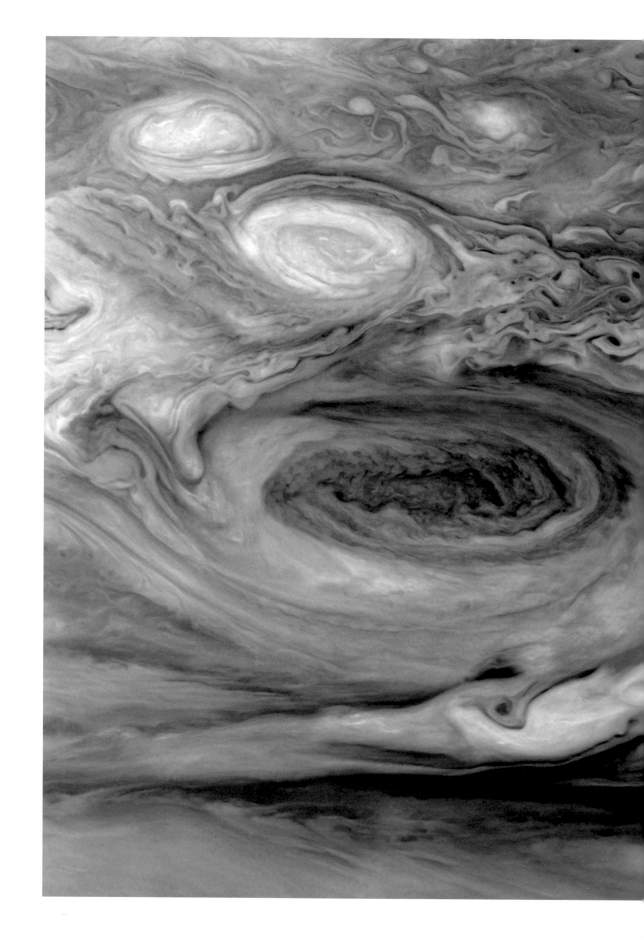

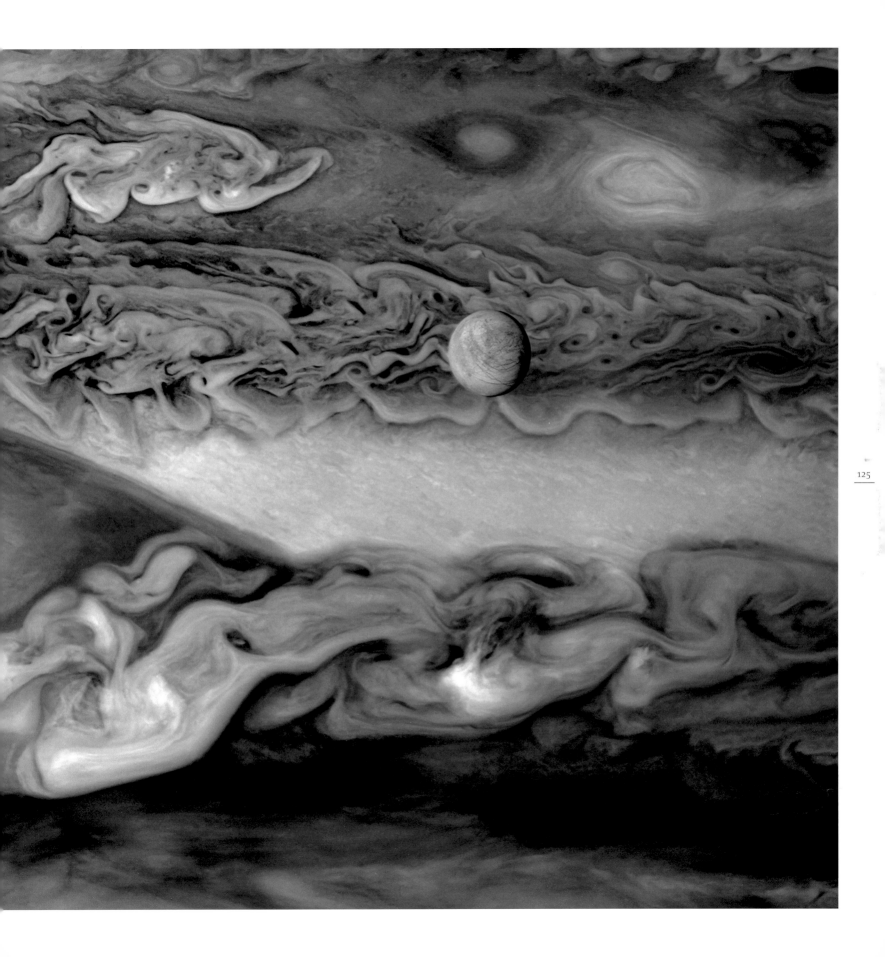

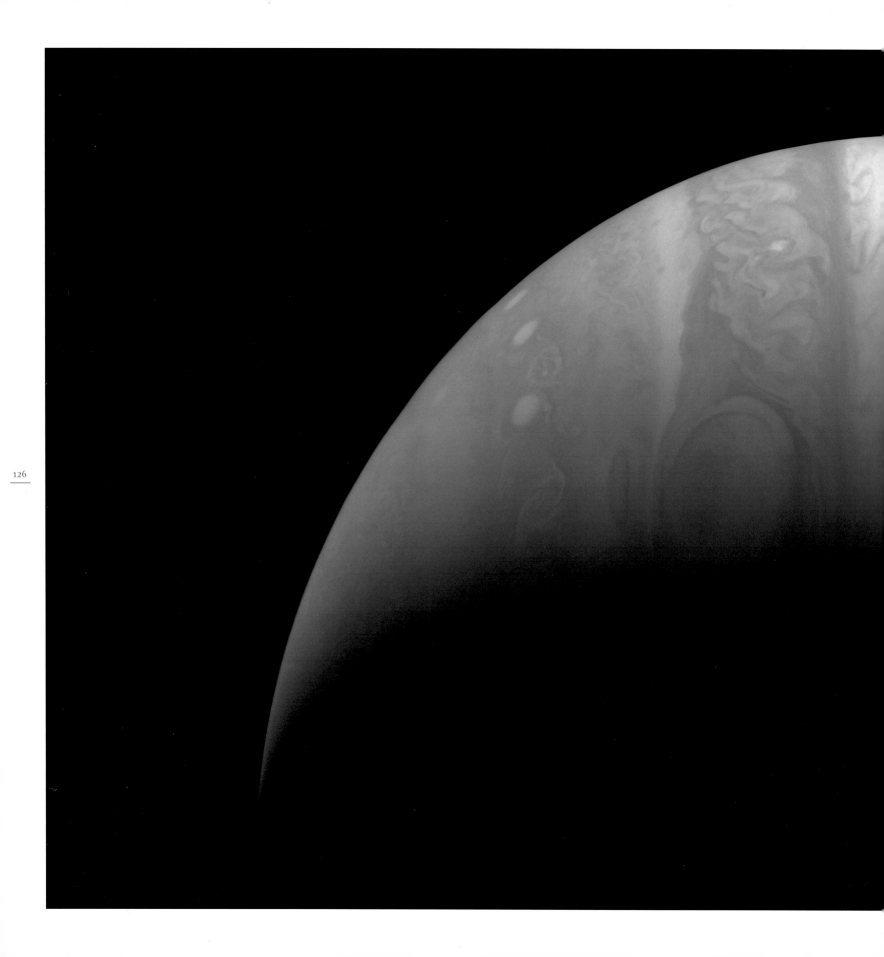

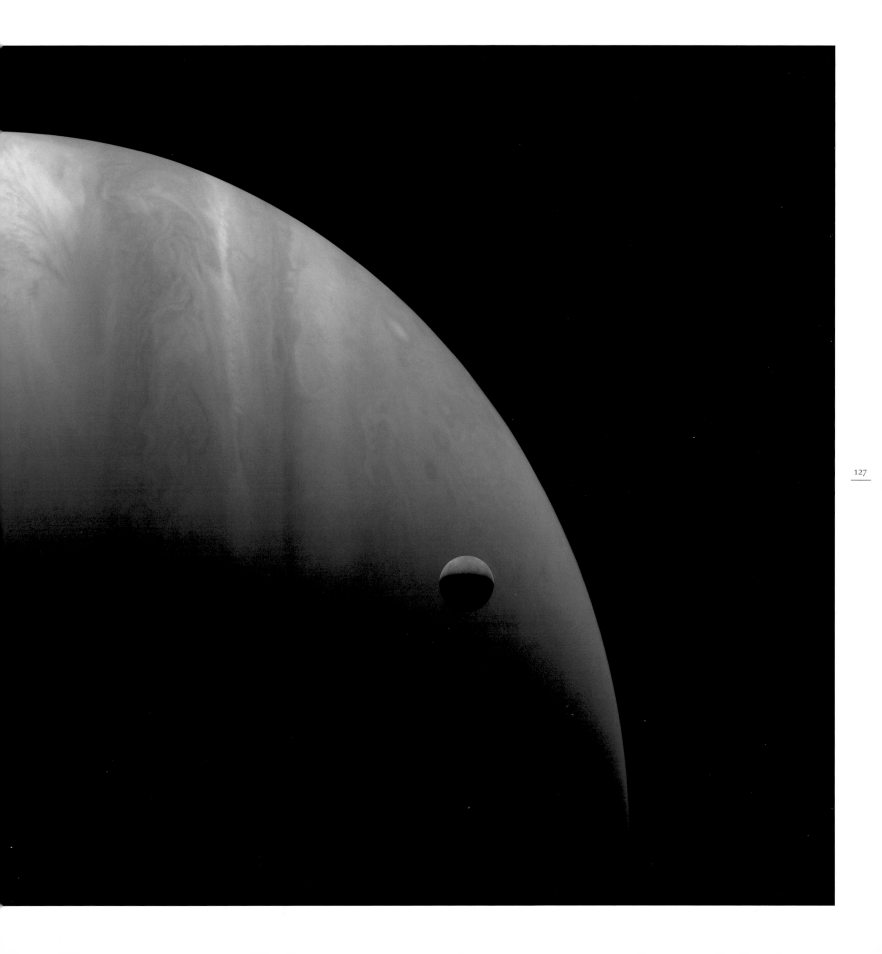

Saturn

When Galileo Galilei laid his optically-assisted eye on magnificent Saturn in 1610, he was truly stumped for the first time. His earlier observations — mountains and craters on the Moon; a Venus that went through phases; satellites orbiting Jupiter; pinpoint stars within the Milky Way — all lent themselves readily to understanding. But here was a world with — well, what? Handles? Ears? Large, equidistant moons? And to make things even more perplexing, two years later these strange symmetrical artifacts vanished entirely. 'I do not know what to say in a case so surprising, so unlooked for and so novel,' he confessed in 1612. Although he clearly didn't realize it, Galileo had become the first astronomer to witness a Saturn ring-plane crossing — which occurs approximately every 15 years, when the sixth planet tilts in such a way that its incredibly thin rings are edge-on to the Earth, making them effectively vanish for a while.

Galileo, it goes without saying, was equipped with a first-class imaginative mind, but his telescope could only magnify to the 20th power, and Saturn's angle in the years when he observed it didn't lend itself to easy comprehension. It wasn't until 1655 that Dutch astronomer Christiaan Huygens, equipped with a 50-power telescope that he had designed himself, correctly

deduced that the second largest planet is surrounded by 'a thin flat ring, nowhere touching.' By 1676 another Italian, Giovanni Cassini, had discovered the demarcation in the rings now called the Cassini Division. From then on Saturn had an 'A' and a 'B' ring, and this was only the beginning.

Saturn's delicate ring system is comprised of innumerable pieces of mostly water ice. Some are thought to be about the size of a Mars rover, while others are closer to snowflakes or even smoke. This ring material is combed, divided and subdivided into infernally complex whorls, waves and bands, and further divided by gaps where ring-particle density drops off. Some of these gaps are caused and policed by patrolling shepherd moons such as Pan and Daphnis. These are small, irregular, asteroid-like objects that effectively clear and sweep the Encke and Keeler gaps respectively. Other gaps are caused by gravitational resonance with various of Saturn's 60-plus moons. Spiral density waves caused by the passage of these satellites have been observed moving inward within the ring material toward the planet like a vast self-winding watch spring.

At about half a mile (one kilometre) thick to 55,000 miles (88,500 kilometres) wide, the rings are one of the more visually tremendous phenomena ever observed

facing page

Above Saturn's North Pole

Girdled by its magnificent rings, Saturn is perhaps the most striking object in the Solar System. Here, all the planet's main rings can be seen, lit by the Sun. The planet casts a shadow across the rings to the left. The rings reflect so much light on the planet's night side that a perpetual twilight lingers.

Mosaic composite photograph. Cassini, 10 October, 2013

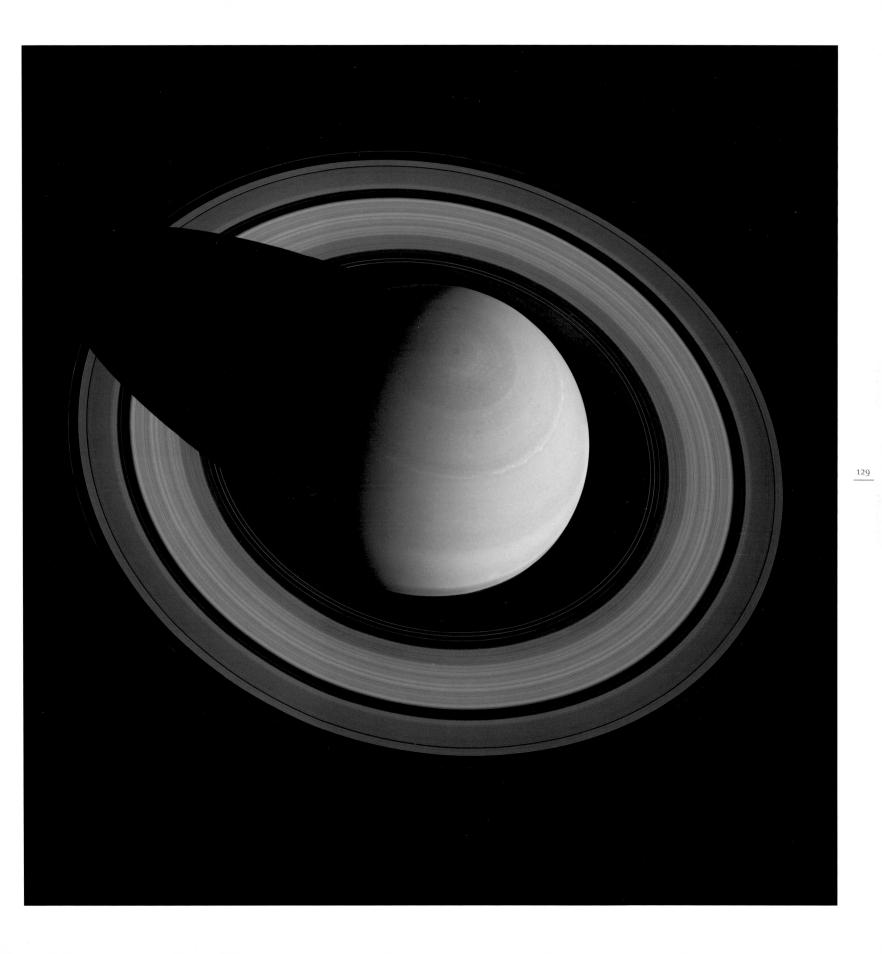

in nature. From end to end, the most visible rings extend about 190,000 miles (300,000 kilometres) — about three quarters of the distance between the Earth and Moon. The most commonly accepted theory holds that they are debris left over after the disintegration of a large icy satellite, either due to collision with another object or because it came close enough to Saturn to be broken up by tidal forces. Either way, the rings are probably almost as old as Saturn itself, or more than four billion years.

Saturn's moons are dominated by giant, smog-shrouded Titan, a sphere bigger than planet Mercury and the only moon in the Solar System with a substantial atmosphere. Titan is the only place other than Earth where stable bodies of surface liquid have been observed. Titan's lakes, some of which are the size of Earthly seas, are filled with a mixture of liquid ethane and methane — essentially, lighter fluid. This moon is far too cold for liquid water to exist on its surface, which is in fact largely made of water ice, granite hard at Titan's average surface temperature of about -179° Celsius (-290° Fahrenheit).

One of Cassini's most important discoveries was that Saturn's sixth-largest satellite, ice-covered Enceladus, which shares many characteristics with Jupiter's far larger moon Europa, is perpetually venting geysers of freezing water from its south pole. This plume of flash-frozen water particles then joins Saturn's tenuous E ring; Enceladus, which orbits in the densest part of that ring, had long been suspected as the source of its material. Both the existence of liquid subsurface water within Enceladus and the steam-valve eruption of some of it into space could be due to tidal gravitational forces similar to those that perpetually squeeze Jupiter's moon Io, causing volcanic eruptions; a similar dynamic keeps Europa's liquid subsurface ocean from freezing.

Whatever the reasons, the sight of this geysering moon, lit on one side by the Sun and on the other by a wash of golden light bouncing off Saturn, is one of the more spellbinding visions in the history of planetary exploration. With its strangely veinlike surface features, its dual-source lighting, and its eruptive prominence, at times Enceladus is in uncannily visual sync with Swiss designer H. R. Giger's creepy, extraterrestrial egg — the one depicted on the poster for the first *Alien* film. That's a sinister comparison, since the presence of liquid water beneath the moon's surface raises the clear possibility that life may have evolved there — presumably, nothing as horrifying as in the *Alien* films. But the fact is that Enceladus has now definitively joined Europa on the short list of potential places where extraterrestrial life may exist.

Although Saturn itself is normally far more sedate than Jupiter, with relatively undifferentiated pastel banding in its atmosphere and the occasional stray circular storm far smaller than Jupiter's Great Red Spot, this serene picture started to change in late 2010. Early in December, a slow-building but ultimately gargantuan spring storm began to erupt in the planet's northern hemisphere — a part of the planet that had only recently emerged into unobstructed sunlight after more than seven winter years under Saturn's striated ring shadows. By early January, the storm's head had extruded a kind of turbulent comet's tail across the northern latitudes, and by late February the head was catching up with the tail. Around August, the head merged with the tail, creating a vast, globe-encircling storm similar to Jupiter's more long-lived tumultuous cloud bands. It was the largest storm seen on Saturn for more than 20 years, and the first that could be observed up close by an orbiting spacecraft.

If the visual legacy of 50 years of interplanetary spaceflight constitutes an important volume in the history of photography — something hard to dispute — then the eight years so far spent by the Cassini spacecraft recording the wondrous Saturn system has created a revelatory and important latter-day chapter.

facing page

A Giant Storm on Saturn

The biggest seen on the planet in over 20 years, the storm started in late 2010 and dominated Saturn throughout 2011. Its head, seen on the left, eventually merged with its tail, producing a single turbulent band. On the left Rhea, Saturn's second-largest moon, floats in front of the rings, here seen edge-on.

Mosaic composite photograph. Cassini, 25 February, 2011

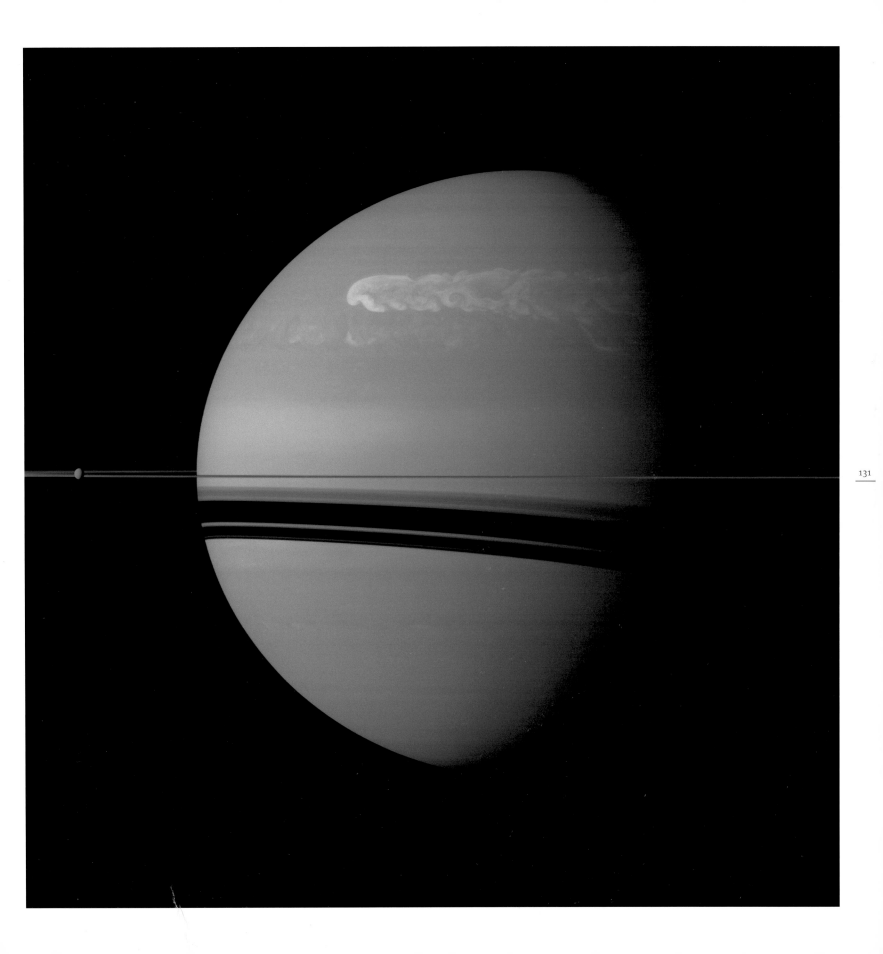

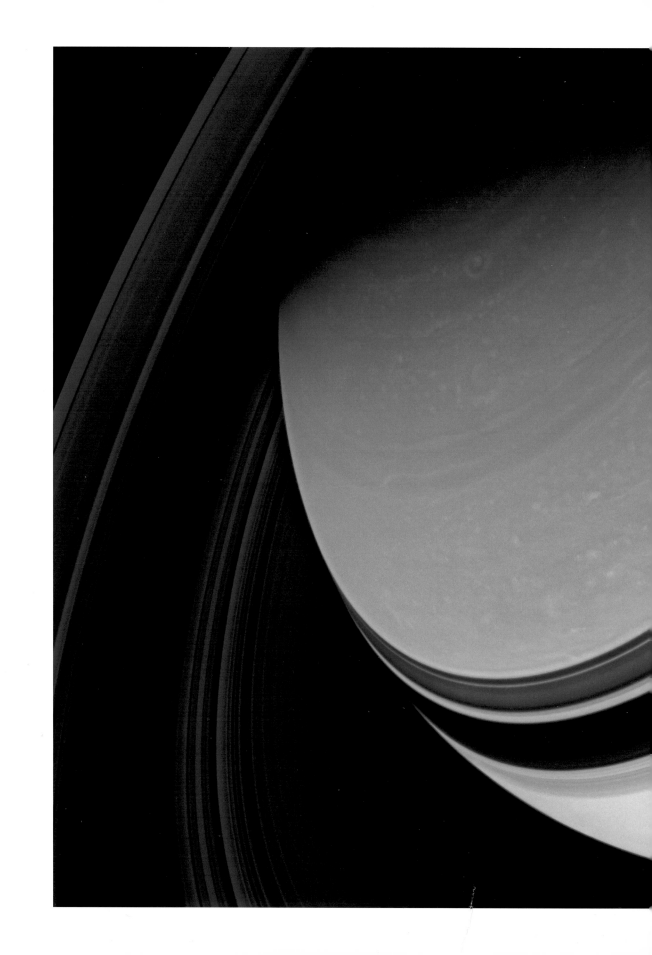

right

Dark Side of the Rings

This spectacular view looks down on Saturn's northern regions, with its pole still in the darkness of the northern hemisphere winter. The rings cast a band of shadow across the gas giant world.

Mosaic composite photograph. Cassini, 20 January, 2007

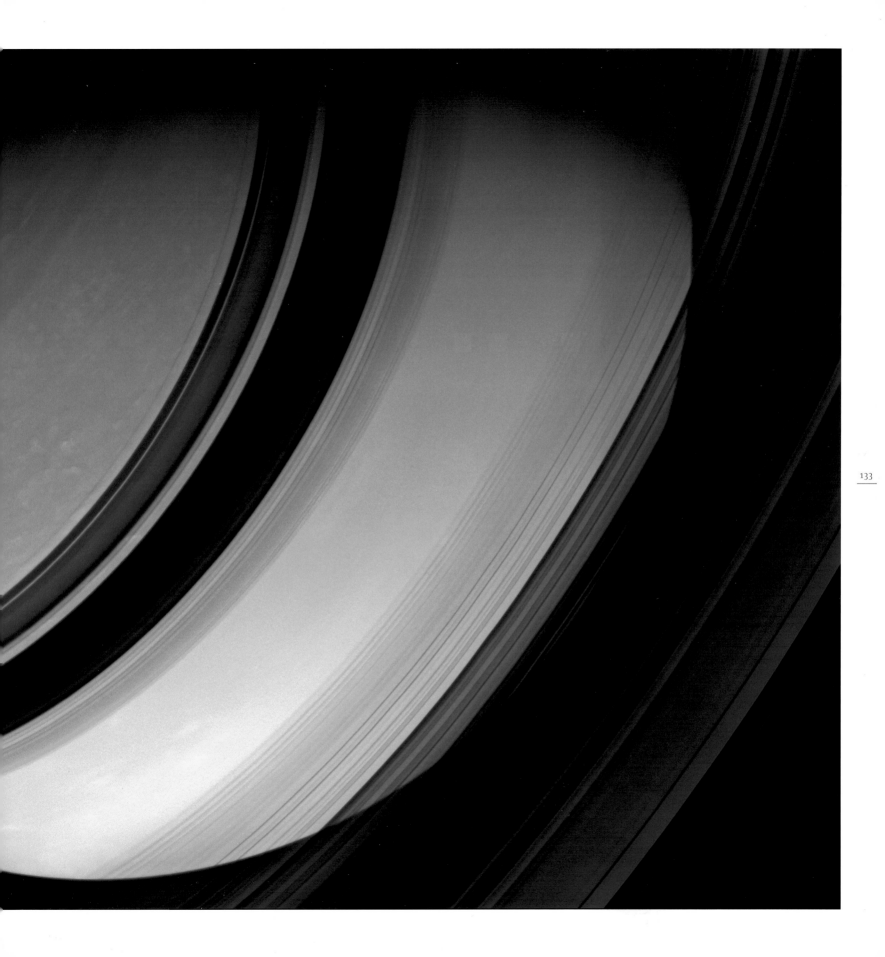

Saturn, Mimas and Tethys

The rings are nearly edge-on in
this equatorial view of Saturn
and two of its moons. Tethys,
the tiny black dot to the left of
the dark line in the centre, can be
seen with Mimas above. Tethys
seems smaller here due to their
relative distances, but is actually
far bigger than Mimas, being 662
miles (1,066 kilometres) across
compared to Mimas which is a
mere 246 miles (396 kilometres).

Mosaic composite photograph.
Cassini, 16 July, 2005

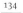

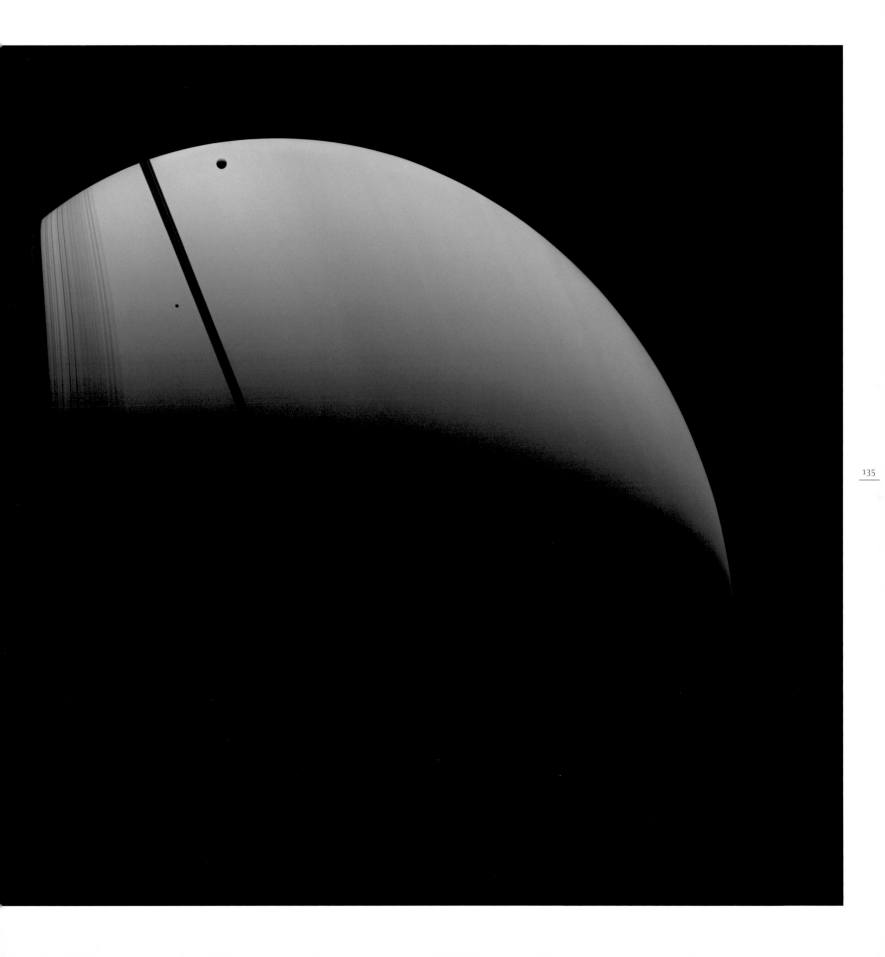

**Mimas Transits Saturn's
Ring Shadows**

Saturn's tiny moon Mimas drifts
against the backdrop of the
planet's northern latitudes. The
long, dark lines are shadows cast
by Saturn's rings. Just like Earth's
atmosphere, Saturn's atmosphere
– when relatively cloud-free - can
scatter blue light, giving the plan-
et a bluish hue.

*Mosaic composite photograph.
Cassini, 18 January, 2005*

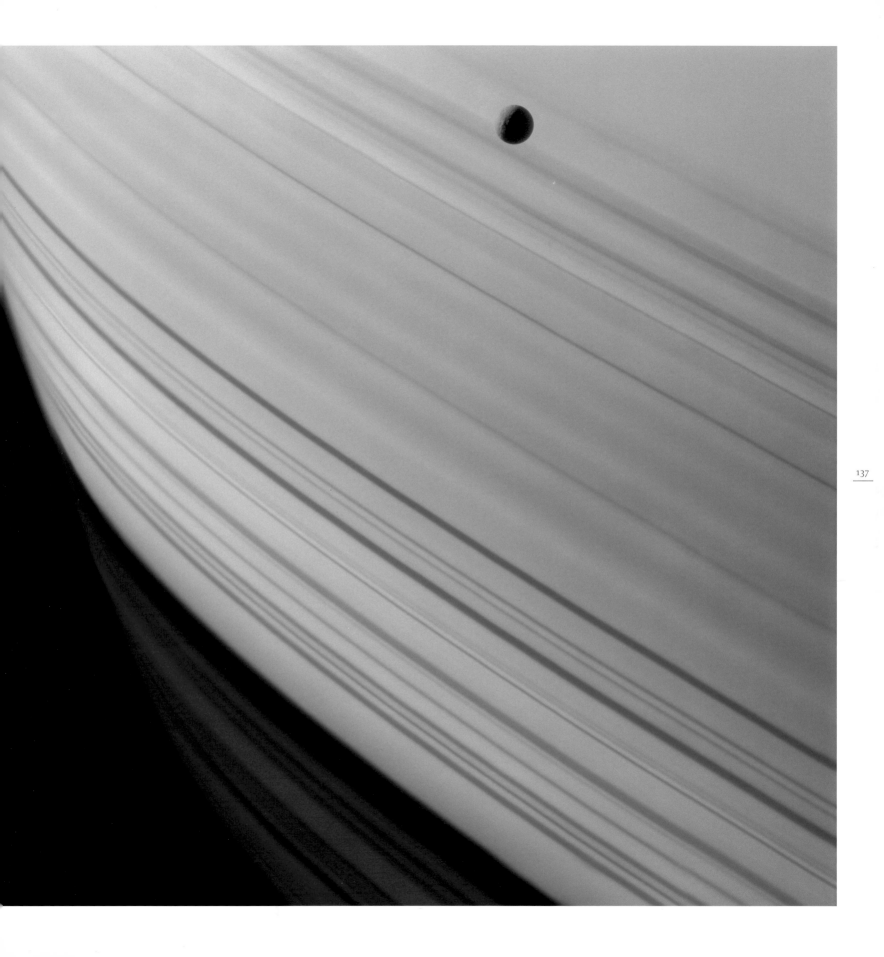

**Mimas Above Saturn's
Rings and Shadows**

Mimas appears against the
blue-streaked backdrop of the
planet's northern hemisphere.
The rings (bottom) cast graceful
shadows across the planet, with
the shadows fading into darkness
on Saturn's night side to the left.
Mimas is only 246 miles (396
kilometres) across – less than the
distance between London and
Land's End in Cornwall.

*Mosaic composite photograph.
Cassini, 7 November, 2004*

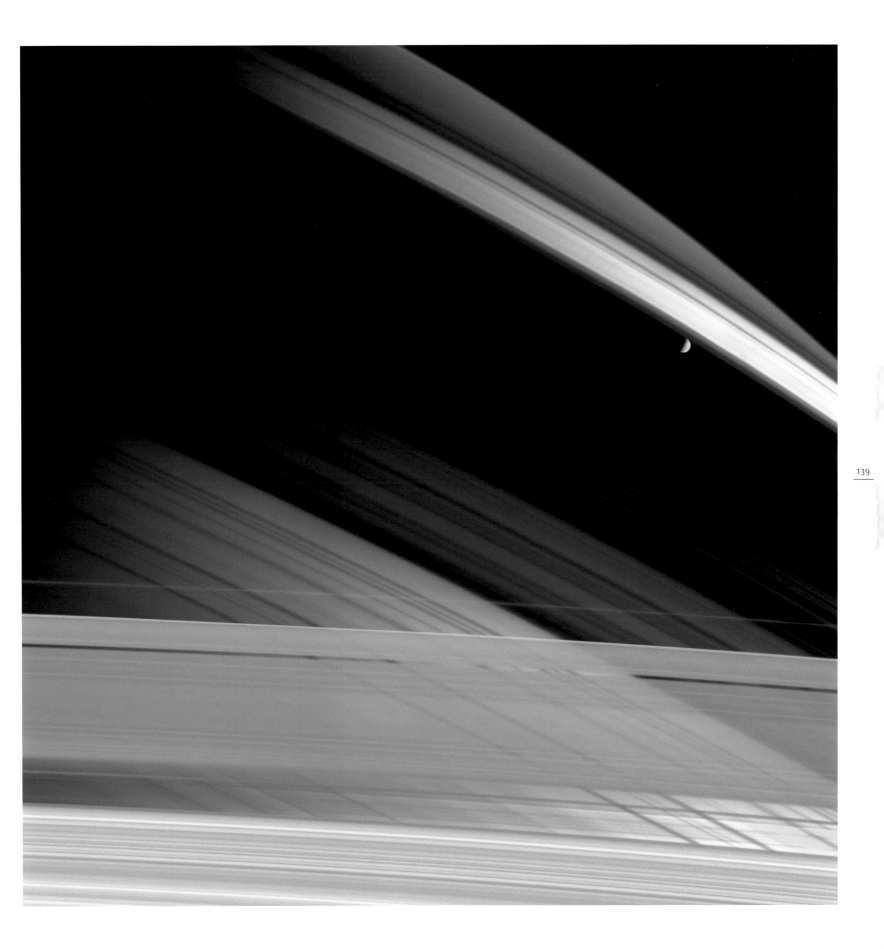

Night Side of Saturn

South is up in this nocturnal view
of Saturn. The planet's night side
is illuminated by sunlight re-
flected off its rings. Sunlight also
filters through the innumerable
chunks of ice and dust that make
up the rings. The planet's shadow
cuts across the rings at top centre.

Mosaic composite photograph.
Cassini, 28 October, 2006

overleaf

Saturn Sunlight Triptych

In this triptych view from
Cassini's imaging system, each
frame displays lens flare due to
unshielded sunlight spilling into
the telescope's mirror. The view
is onto the southern hemisphere
from the nightside. Only a bright
sliver of Saturn's day side can be
seen. North is up.

Mosaic composite photograph.
Cassini, 31 October, 2006

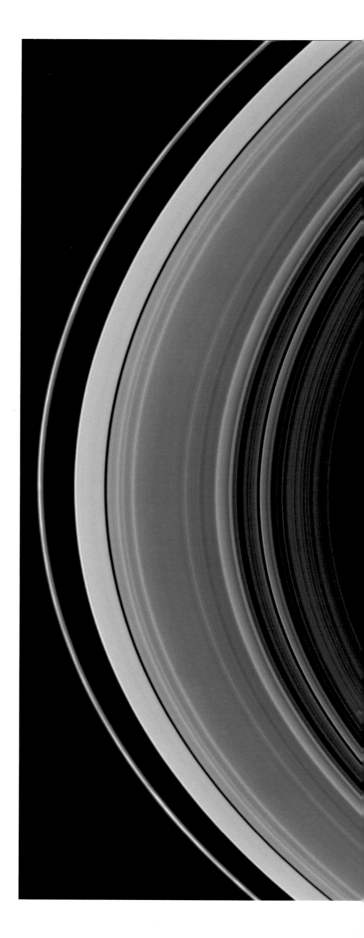

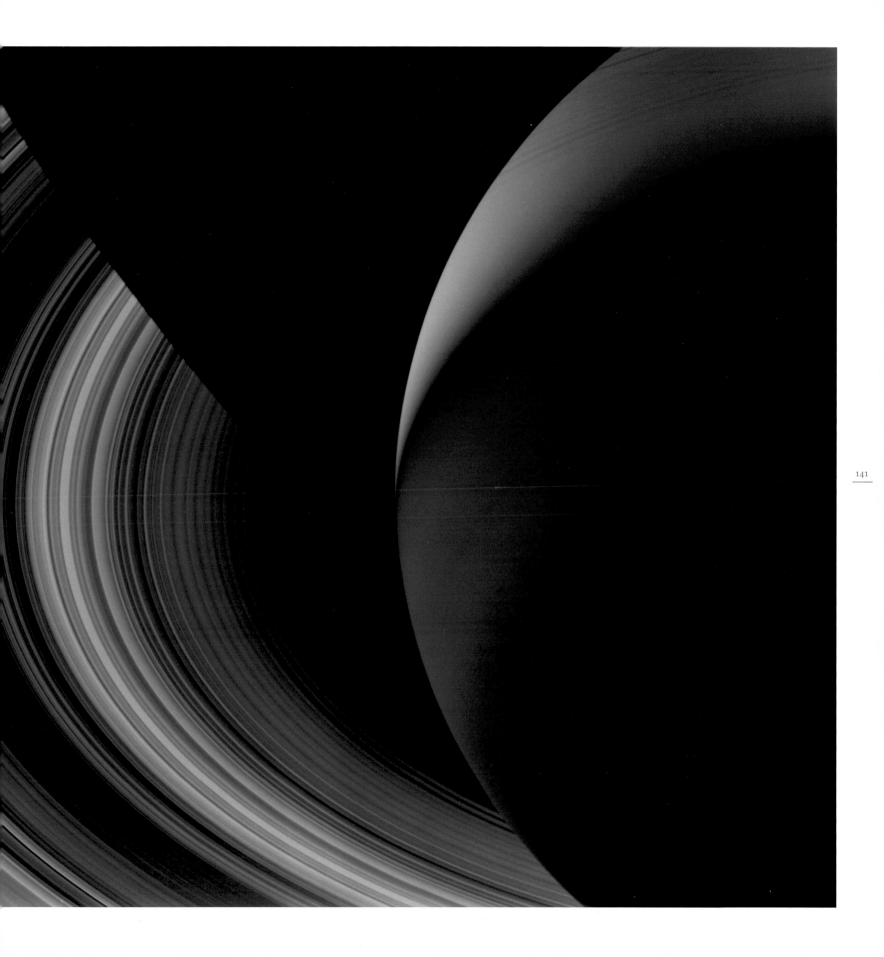

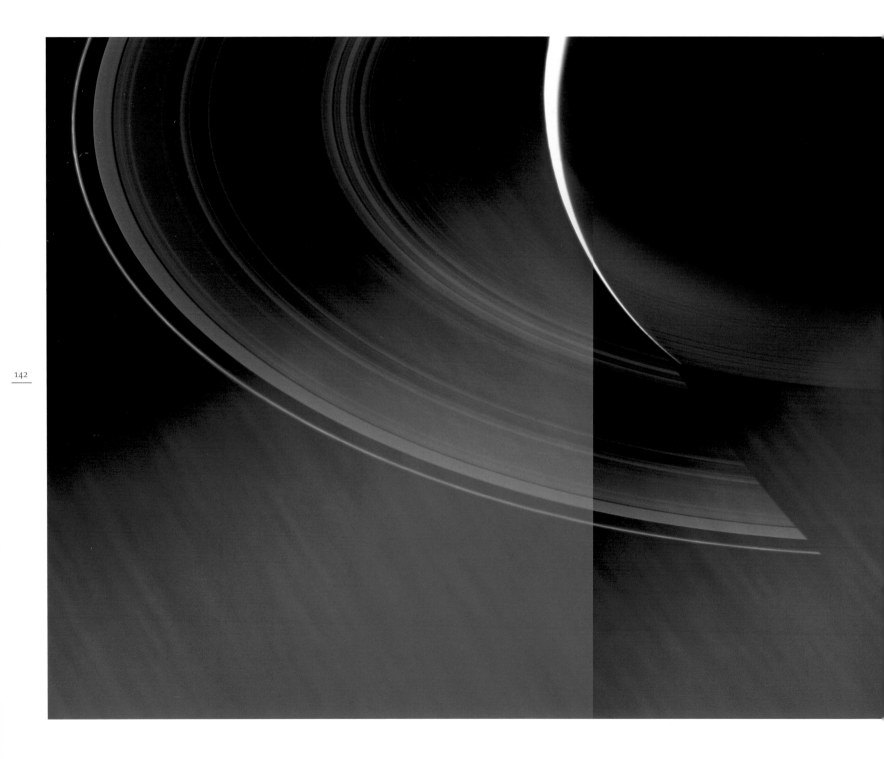

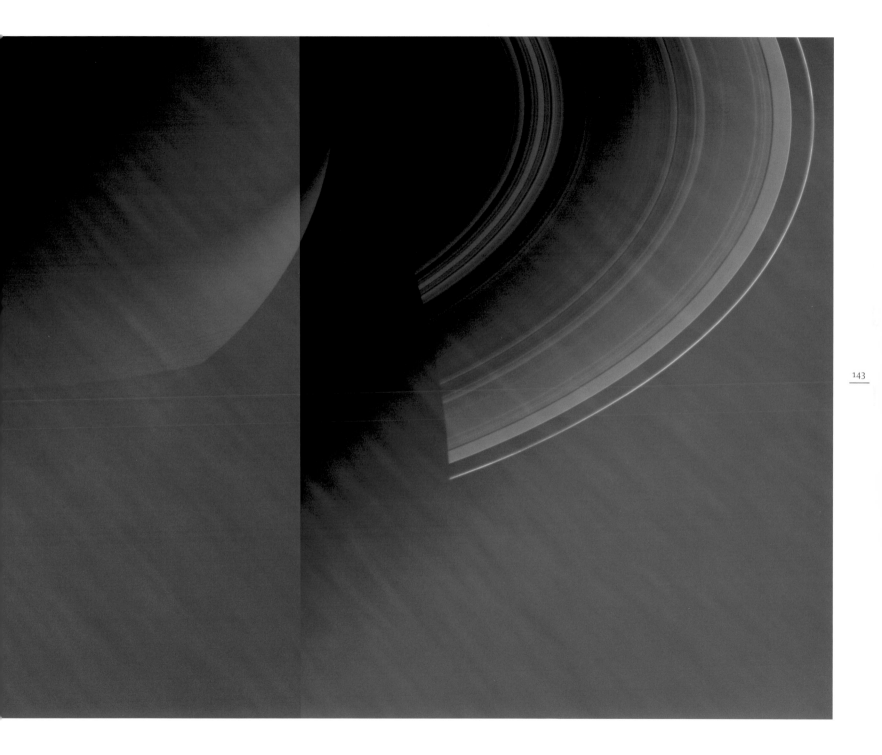

Atmosphere of Titan

East is up in this view of the north
pole of Saturn's moon Titan,
revealing complex atmospheric
layers. Methane molecules in
the upper atmosphere scatter
sunlight, producing a blue colour.
Deeper layers of the predominant-
ly nitrogen atmosphere full of
organic molecules appear smoggy
brown. Titan is Saturn's largest
satellite and the only moon in
the solar system with a dense
atmosphere.

Mosaic composite photograph.
Cassini, 31 March, 2005

**View across Rhea at Dione
and Saturn's rings**

In this view across the south pole
of Saturn's second largest moon,
Rhea, the planet's rings are seen
nearly edge-on. Rhea's sister-
moon Dione, Saturn's fourth
largest, is on their far side. Dione's
bright, seemingly wispy features
are actually ice cliffs – both moons
are largely made of water ice.

*Mosaic composite photograph.
Cassini, 11 January, 2011*

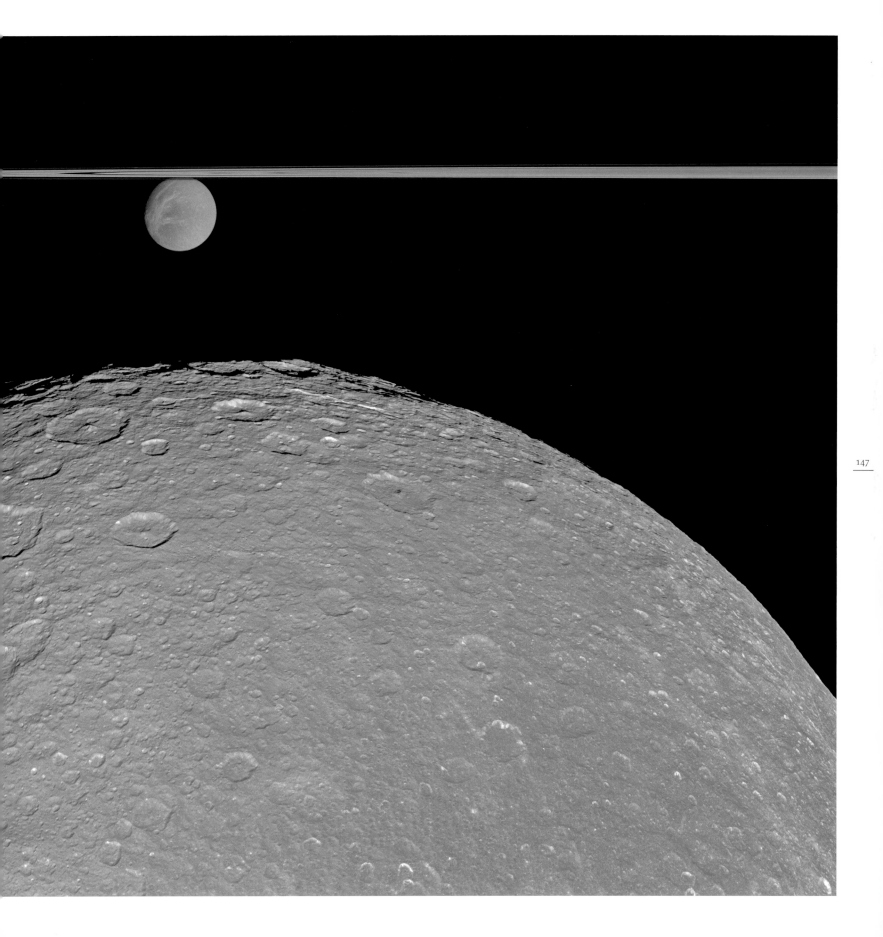

Enceladus Vents Water into Space

Enceladus, Saturn's sixth largest
moon, erupts a vast spray of
water into space from its southern
polar region. The water immedi-
ately freezes even as it rises to
feed into Saturn's nebulous outer
E ring. The moon is lit by the Sun
on the left, and backlit by the
reflecting surface of its parent
planet to the right (not visible in
this photograph).

Mosaic composite photograph.
Cassini, 25 December, 2009

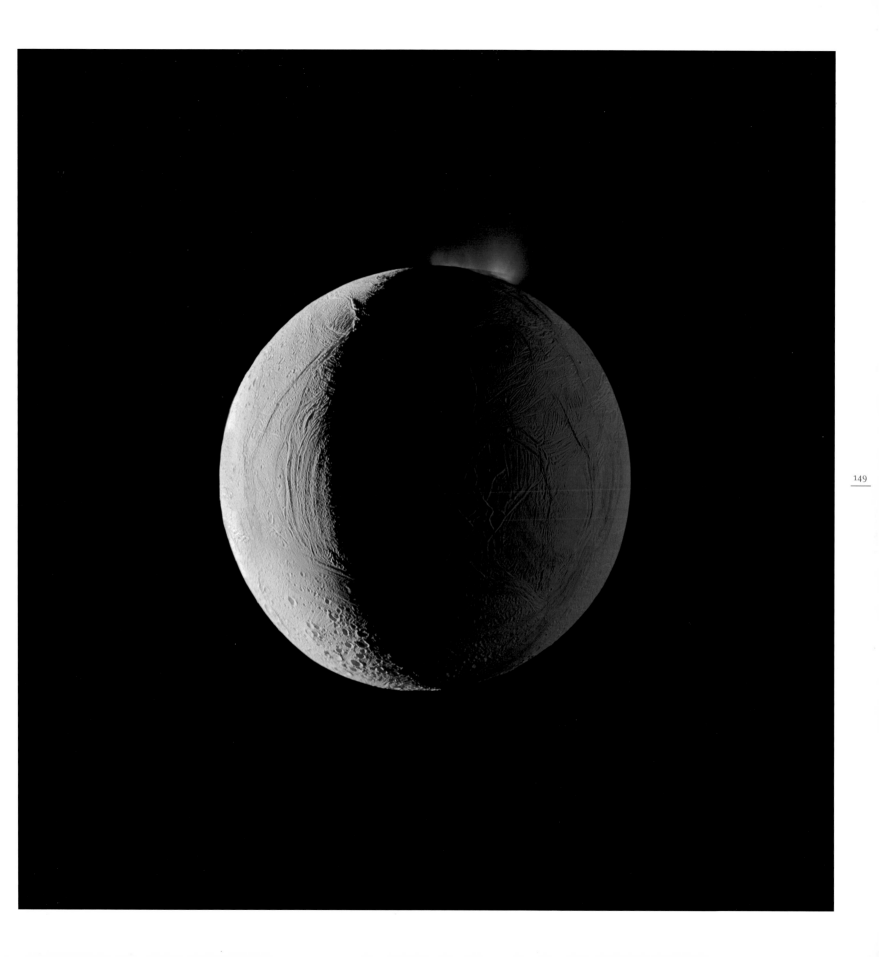

The Outermost Worlds

On the remote outskirts of the solar system lie the great aquamarine planets of Uranus and Neptune, sometimes called the ice giants. More than 19 times further away from the Sun than Earth is, Uranus is unique among the planets because it's tipped on its side, with one of its poles always pointing towards the Sun. Even further away, 2.8 billion miles (4.5 billion kilometres) from the Sun, submarine-blue Neptune patrols the planetary system's edge. From here, the Sun appears merely as a bright point of light in a sky swarming with other stars. Neptune is extremely cold, but its atmosphere teems with activity, including vast spinning storms.

And then there's Pluto, the innermost object of the mysterious Kuiper Belt. Considered a fully-fledged planet from its discovery by American astronomer Clyde Tombauch in 1930 all the way to 2006, Pluto was demoted to 'dwarf planet' status following a controversial decision by the International Astronomical Union in that year. Pluto's highly elliptical, 248-year-long orbit occasionally brings it slightly closer to the Sun than Neptune.

The third-largest planet, Uranus, has its equator roughly aligned with its terminator, the boundary between the day and night hemispheres of the planet.

facing page

Uranus and its Rings

The rings of Uranus weren't discovered until 1977. Extremely dark, they may be made of countless fragments of water ice containing radiation-altered organic material. The third largest planet, Uranus was discovered in 1781 by William Herschel using a telescope of his own design and construction.

Mosaic composite photograph. Voyager 2, 24 January, 1986

This off-kilter position, unique for a planet, is thought to have resulted from a collision with another large planet-sized body at an early stage of its development. Look for evidence of Uranus's idiosyncrasy, however, in the only available spacecraft pictures of it, and you will be disappointed: this sphere of hydrogen and helium was almost absolutely blank on January 24, 1986, when Voyager 2 whipped past at a speed of almost 50,000 miles (80,000 kilometres) per hour — featureless to the point where the eye skated frictionlessly over its cool blue-green surface (a colour resulting from small quantities of upper-atmosphere methane, which absorbs red light). At least during that encounter, Uranus had the quality of a purely abstract shape, something perhaps from a work by Russian Suprematist painter Kazimir Malevich. It seemed to exist only to define its own shape, and to differentiate itself from the blackness in which it hangs, despite being such a huge object (it's four times the diameter of the Earth). Since then, however, images from the Hubble Space Telescope have revealed storms in the Uranian atmosphere.

Although, like Venus, Uranus is frequently described as rotating in retrograde — meaning east to west, backwards compared to most of the Solar System's planets — in fact there is some dispute about which

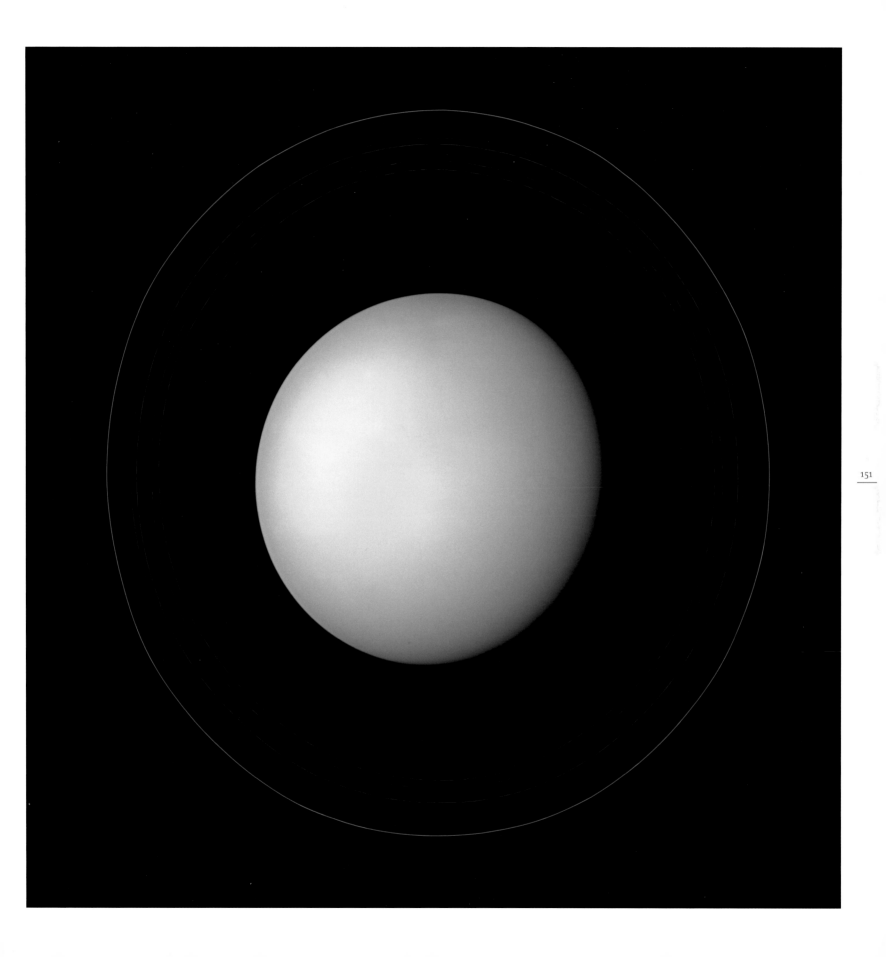

facing page

Neptune and Triton

This crescent view of
the outermost planet
in the Solar System
and its moon, Triton, is
one of the last images
recorded by Voyager 2 as
it sped onward toward
interstellar space, having
surveyed all the gas
giant worlds of the outer
Solar System. Launched
almost 40 years ago,
we continue to receive
transmissions from both
Voyager spacecraft.

*Composite photograph.
Voyager 2,
31 August, 1989*

152

Overleaf

A Plutonian Haze

When NASA's New
Horizon's spacecraft flew
by Pluto in July 2015, a
sense of astonishment
was experienced by the
mission's scientists.
Pluto contained a far
more variegated surface
than anyone had dared to
hope for. And soon after
the closest approach, it
became clear that when
back-lit by the Sun, the
dwarf planet's tenuous
atmosphere was as blue
as the skies of Earth.

*Mosiac composite photo-
graph. New Horizons,
14 July, 2015*

pole is the illuminated one and which is pointing end-lessly out towards interstellar space. It's possible that Uranus's inclination is over 90°, which would make its rotation nominally the same as most of the rest of the planets. Alternatively, if it's less than 90°, it's officially in retrograde. In any case, this debate shares some of the strangely slippery conceptual qualities of Uranus's visual perfection during the Voyager encounter. Is there really any way to decide which is the north and which the south pole of a planet that's pointing one of them perpetually at the Sun? And how does one choose, without knowing which pole was 'up' when the planet was knocked askance, billions of years ago?

As for Neptune, this mesmerisingly submarine-blue planet is half again as far away from the Sun as its cousin Uranus — so distant that by the time Voyager 2 arrived there in August 1989, its computers were 17 years old and most of its designers had retired; so removed that one would think that like Uranus it would be subdued into soporific featurelessness by the intense cold. This outermost ice giant patrols the Solar System's outskirts at an appropriately glacial pace: Neptune revolves around the Sun once every 165 years.

But instead of an even more opaque and impene-trable version of Uranus, Voyager 2 found one of the most intriguing planets. Neptune confounded almost all expectations. To begin with, from a distance it looks eerily like a doppelganger of the Earth although, despite its name, this oceanic colouration isn't the re-sult of water but of an upper atmosphere that absorbs red light. Unlike Uranus, but similarly to its gas giant relatives Saturn and Jupiter, Neptune radiates more energy than it receives from the Sun and therefore has some mysterious inner heat source. And Neptune is far more interesting visually than Uranus was during the Voyager encounter. Viewed up close, it loses its earthly appearance somewhat and starts to exhibit a repertoire of features similar in some respects to those of Jupiter

and Saturn, but also very distinct and in keeping with its overall cool tone. Most notable in 1989 was a vast bruise of a storm quickly called the Great Dark Spot, an oblong disturbance adrift in a position on the planet similar to Jupiter's Great Red Spot.

Voyager 2's encounter with Neptune concluded with a kinetic series of pictures in which its moon Triton could be seen moving up the planet's deep blue cres-cent even as the pair rapidly receded in the frame. Then this intricate machine, which had travelled 4.5 billion miles (7.2 billion kilometres) in the 12 years since its launch, shot headlong into the inky expanse of noth-ingness beyond the edge of the Solar System. Its tour of the outer planets concluded, the spacecraft was soon ordered to shut its cameras down. Voyager's astonish-ing flood of interplanetary visions had finally ceased.

It took over a quarter century before another mission vaulted to the Solar System's outer limits. Another way to look at NASA's New Horizon's spacecraft, however, is as the first attempt to explore the enigmatic Kuiper Belt — a vast region of exceedingly distant snowballs composed mostly of frozen volatiles such as methane, nitrogen, ammonia and water. Dwarf planet Pluto, the innermost, proved to be an extraordinarily variegated world when New Horizons whipped by on July 14, 2015, with craggy mountains rising at least as high as 3,500 metres (11,000 feet) above the frigid surface of this icy body. A vast frozen plain seemingly made of poured concrete, informally named Sputnik Planum in honour of the first satellite, dominated the sunlit side during the encounter.

Only an hour or so after New Horizons flew by Pluto at a distance of 7,800 miles (12,500 kilometres), the spacecraft's cameras recorded a surprising feature. With the Sun now on the far side of the planet, Pluto's ten-uous, back-lit atmosphere proved to be as blue as the skies of distant Earth at dusk. Then like the twin Voyag-ers, New Horizons sped onwards into the unknown.

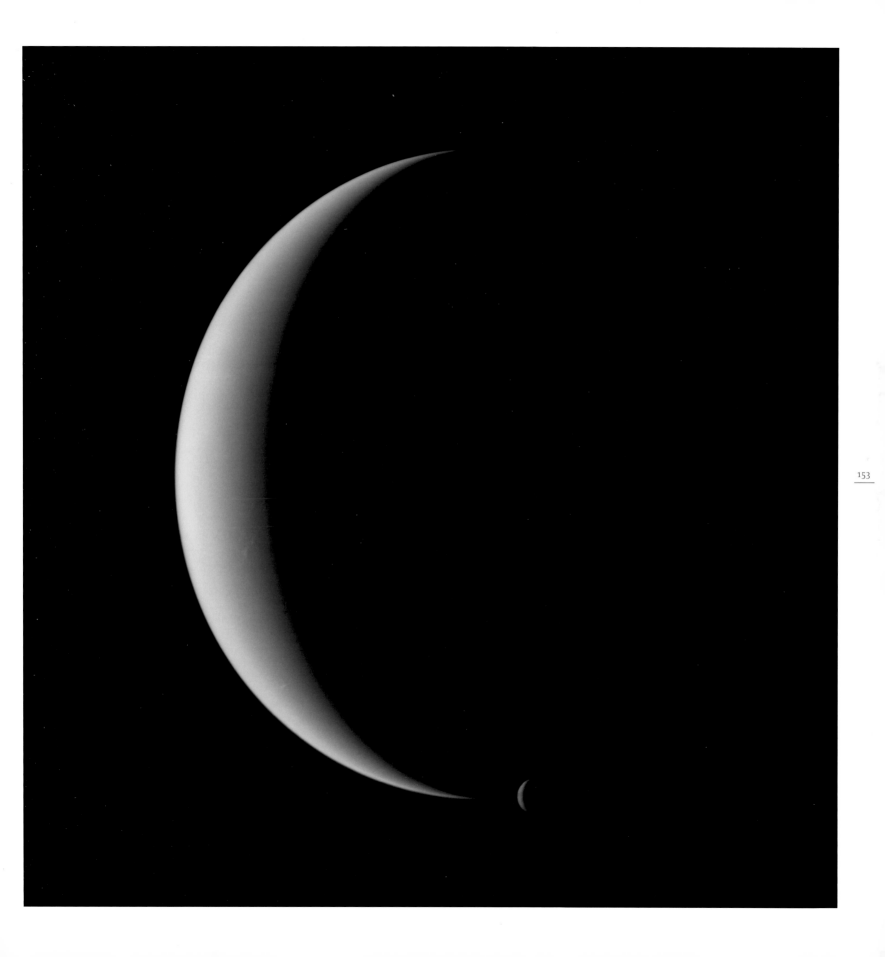

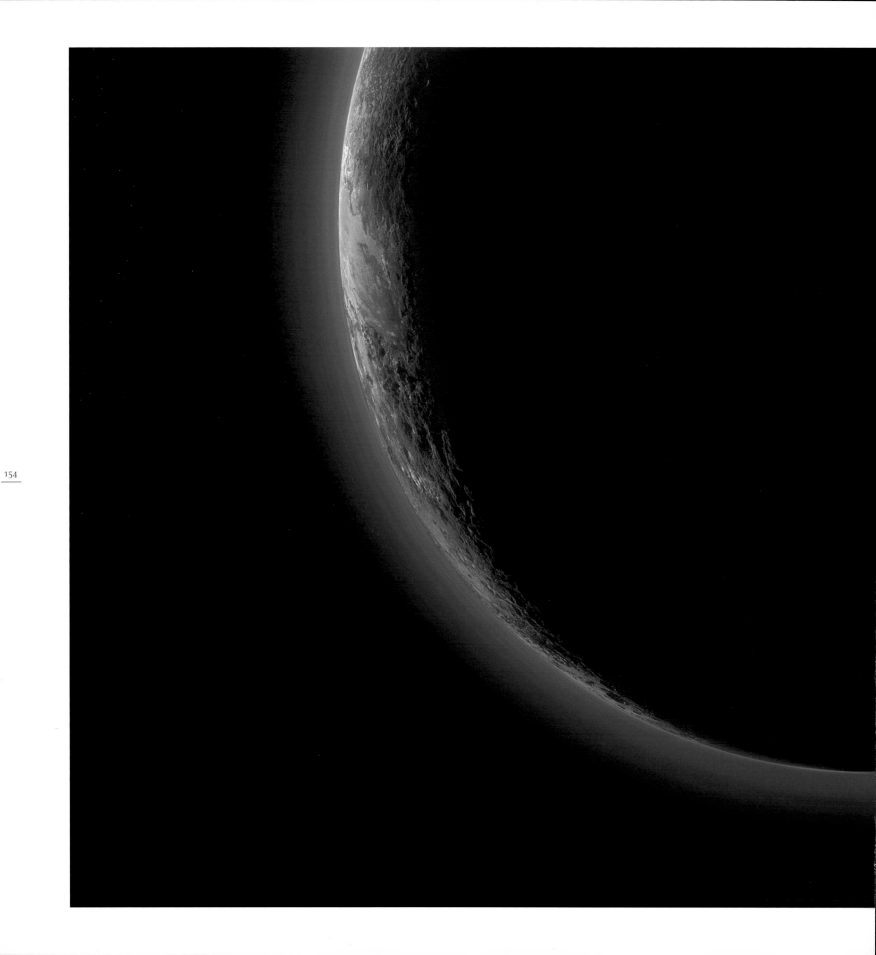

About the Images

Michael Benson

The process of creating full-colour images from the black-and-white raw frames sent to Earth by interplanetary spacecraft — and then mosaic composites in which many such images are stitched together — can be complicated. For a full-colour image to be composited, the spacecraft needs to have taken at least two, but preferably three, photographs of the same area of a given subject, with each such image exposed through a different filter. Ideally, those filters are red, green and blue, matching the frequencies to which the human eye is sensitive. In that case a composite colour image can usually be created. But in practice, such spacecraft as the Cassini Orbiter or the New Horizons Pluto mission have many different filters. They use these to record wavelengths of light well outside of the relatively narrow red, green and blue (RGB) zone of the electromagnetic spectrum that human eyes can see.

In some cases, for example, a given extraterrestrial scene will have been covered with a red and green filter, but instead of blue, an ultraviolet filter may have been used. Or alternatively, a blue might be available but only an infrared at the other end. Sometimes a red and a blue image of the same area was exposed, but not a green. As a result, if the aim is to create true colour composites, a kind of game of visual musical chairs can ensue. Colour landscape photography, after all, isn't a high priority of these missions, which have scientific research as their goal. So when the music stops, one

can only hope that data sufficient to achieve results compatible with fine-art photographic prints has been acquired and can be welded together to good effect.

More often than not, however, various different solutions must be found to try to achieve an image that can be read as being close to what the human eye might see, if we could only go to these extraordinarily distant locations ourselves. If shots taken through a red and a blue filter are available, for example, but green is not, then a synthetic green image can be created by mixing the other two colours. Depending on how far from the visible parts of the electromagnetic spectrum they are, infrared or ultraviolet images can also be mixed with visible light ones to create a passable analogue of a red or blue frame — one that can then be combined with other images to make an RGB composite.

With the exception of the radar and black and white images, all of the pictures presented in *Otherworlds* are as close to their true colours as possible using the data available. From there what used to be called darkroom techniques are used to optimize these photographs. Many outside sources of information are deployed to try to confirm the essential veracity of these planetary colours. In particular I'd like to acknowledge the virtuoso Croatian planetary image processor Gordan Ugarkovic, who has done a lot of fine work in this regard.

Another issue with images created using data from interplanetary spacecraft is the relatively limited

resolution of the individual images. The Cassini orbiter, for example, was launched in 1997, took seven years to get to Saturn, and has now been in orbit for 12 years. The CCDs used by its cameras are thus 19 years old; as a result, a single Cassini frame is only 1,024 pixels across. (By contrast, my iPhone 6 camera produces shots 3,264 pixels across.)

One way to compensate for this, while also producing a more expansive view, is to mosaic many individual images together. Most of the Mars, Jupiter and Saturn photographs reproduced here are such mosaic composites. And if they're in colour, since each individual colour frame requires two or three black-and-white frames shot through different filters, this can mean that it takes many dozens or even hundreds of raw frames to make such composites. Occasionally, as on pages 94-95, the final composite photographs are presented uncropped; in those cases, their jagged edges give the viewer a sense of how individual frames can be assembled to make such photographs.

If the spacecraft that takes the individual frames comprising a mosaic is stationary, as when the Curiosity Rover is conducting a multiframe survey of a given slice of Gale Crater on Mars, these views can fall together without significant complications — though it can still be a time-consuming process to get it right. But if the individual images that make up a final mosaic were taken by a spacecraft vaulting through space at an extremely high rate of speed, as with most of the images in *Otherworlds*, various arcane complications can ensue. For example, the view of the transit of Jupiter's volcanic moon Io across the face of its giant parent planet reproduced on pages 111–113 was composed of six narrow-angle camera pointings totalling 18 individual frames. They were exposed across over an hour as the Cassini Orbiter flew by Jupiter on its way to Saturn on January 1, 2001. Despite the staggering size of a planet eleven times the diameter of Earth, a Jovian day is under ten hours, and so the gas giant's spin already creates problems in matching images taken over so many minutes. And to further complicate, Cassini was travelling at more than 40,000 miles (64,000 kilometres) per hour.

As a result, when assembling the pictures that make up that composite mosaic, Jupiter's cloud formations didn't fit together readily, and the final composite required some jigsaw work. Luckily, the spacecraft's wide-angle camera captured global views of Jupiter at the same time, allowing for comparisons to be made as the mosaic emerged. The final result possesses a kind of aggregate accuracy, one capturing the moment when the satellite crosses Jupiter's limb (even if the image is actually comprised of pictures taken during the entire span of Io's transit). In this way the old convention that a photograph represents a mere moment in time is entirely supplanted by such images.

Acknowledgements

Michael Benson

None of the photographs in *Otherworlds: Visions of Our Solar System* would have been possible without the extraordinary pioneering work of the scientists and engineers who made a succession of missions to the Sun's far-flung worlds feasible. From the Lunar Orbiters of the 1960s to the Curiosity Mars Rover, comet-chasing Rosetta spacecraft, Cassini Orbiter and New Horizons Pluto mission, an unprecedented chapter in the history of our interaction with the natural world has been written. As a retrospective look at the visual legacy of this story, the museum exhibition and book *Otherworlds* pays tribute to this achievement, and would have been inconceivable without it.

Although I have shown planetary images in museums under different titles before, the new and expanded *Otherworlds* was agreed to and enabled by London's Natural History Museum, and I am in debt to the extraordinarily dedicated and good humoured band of professionals populating that terracotta-clad cathedral. It was a real pleasure to collaborate with this hard-working team for many months in 2015 and 2016 — scientists, designers, graphic artists, managers, filmmakers and media professionals. Needless to say this is practically the 'Ur' museum, and certainly so when it comes to the world's natural history museums. It was a great privilege to be permitted inside, and I very much hope to find new ways of collaborating in the future. This book was made possible by Head of Publishing at the NHM, Colin Ziegler, who handled with equanimity a certain brinksmanship concerning deadlines that Abrams Books has been well aware of for years, but the Natural History Museum's publishing arm might have had issues with. He didn't — and if you're reading these words, it all worked out in the end.

The list of those to who I owe special thanks in connection with this show is long. It starts with Exhibition Programme Manager Alex Fairhead and Programme Manager Beca Jones, who made the choreographing of the complex pathway to the final show look easy. With enviable reserves of tolerance, they did so in ways comparable to how olympic-level figure skaters or ski jumpers can make their hyperkinetic itineraries seem deceptively straightforward. Don't try this at home!

No less important were Interpretation Developer Poppy Cooper, Exhibition Design Manager Eleonora Rosatone and planetary geologist Dr. Joseph Michalski — a kind of benevolent triumvirate overseeing the nuts-and-bolts (and walls and lights) production of *Otherworlds*. Poppy did a superb job marshalling the text content and presentation and threading it, like old-school celluloid, through the projector wheels of the NHM's sign-off mechanism. Eleonora and her excellent collaborators Simon Caslaw and Marc Desmeules, in charge of 3D exhibit design and graphic design respectively, engaged with me in a meaningful and enjoyable collaboration across many NY-London Skype

calls as we sought to fuse the content and design of the show to produce a coherent message — one echoing a trajectory through the Solar System. For his part, while in charge of conveying science content, Joe immediately grasped that the show was all about foregrounding the photography. He succeeded in conveying that content in absolute synchronicity with this spirit, with his excellent Foreword to this book no exception.

Meanwhile, intrepid documentarian Sally Weale brought her crew to Iceland, not to mention various no less exotic subterranean corners of the NHM, to film a documentary linking the Museum's work to the more aesthetic concerns of the show.

My London-based representative Jernej Gregoric originally approached the NHM, and apart from his many productive communications with the Museum has since continued seeking other worthy venues for my work internationally; I owe him big thanks. And *Otherworlds* never would have come to the NHM in the first place without the good offices of Peronel Craddock and Emily Smith, the Heads of Content and Audience Development respectively.

There are many other museum professionals who spent long hours ensuring that *Otherworlds* came to London in good order and with a communicative disposition. They include Lisa Anderson, Tracey Bates, Vanessa Eley, Amy Freeborn, Katy Glazer, Steve Hopkinson, Hannah Jones, Chloe Kembery, Murray MacKay, Craig Manley, Catarina Nuñes, Jenny Palmer, Lee Quinn, Adam Richardson, Sameh Sharif, Camilla Tham, Jonathan Tyzack and Emily Williamson. Failure to enumerate their respective roles should not be taken as a diminishment of their critical importance to the successful presentation of *Otherworlds*.

Here in Brooklyn, the local centre of the universe, digital topographies maestro Markley Boyer went out of his way to help devise believable Earth atmosphere effects for the images presented on pages 13-19.

And Boris Balant, my indefatigable Ljubljana-based collaborator on four books and counting, pulled off this one with great panache as usual — and on extremely tight deadlines. I'd also like to thank Carter Emmart and Jon Parker for consultation on Earth atmospheres. And as always, Ren Weschler, for much.

I'd also like to thank the dedicated staff of London's Flowers Gallery, starting with Matthew and Emily Flowers, and saluting Chris Littlewood, Victoria Mendrzyk, Hannah Hughes and Alexandra Peake. I'm honoured to be represented among this gallery's excellent artists (and I thank the great Robert Polidori for his role in that, as well as the thought-provoking conversations we've shared).

Chatting with Matt in NY Chelsea's Cookshop in the summer of 2015, it became clear that before his career as one of the international art scene's leading gallerists, the man played keyboards in the Highgate New Wave band Sore Throat. Sensing an opening, I asked him if he just might happen to know Brian Eno (whose music I've listened to keenly for three decades and counting). He did, and soon set up the meeting which led to the extraordinary honour of Brian's agreeing to create an original ambient composition for the show.

I'm immensely grateful to Brian for loaning his talent to my project, and to Matt for arranging that meeting. Apart from creating a perfect sonic counterpoint to the images on display in *Otherworlds: Visions of Our Solar System* — one which, via ever-changing variations, echoes the infinite shifting grace of the spheres — it allows me to quote the Acknowledgements in my first volume of planetary landscapes, *Beyond: Visions of the Interplanetary Probes* (2003):

> Finally, if it hadn't been for the complex striations and abstract topographies of Brian Eno's music, this book would probably look and feel quite different. One day, no doubt, we'll find another green world.

Image Credits

Jacket front: NASA/JPL/Michael Benson, Kinetikon Pictures (hereinafter, MB/KP); **Case front**: NASA/JPL/PIRL/University of Arizona/MB/KP; **Case back**: NASA/JPL//MB/KP; **Title page**: NASA/SDO, AIA/MB/KP; **Earth and Moon**: Pg. 13: NOAA-NASA-GOES/MB/KP; Pg. 15-17: NOAA-NASA-GOES/MB/KP; Pg. 19-21 NOAA-NASA-GOES/MB/KP; Pg. 23-26: Jeff Schmaltz, Lucian Plesea, MODIS LRRT/NASA GSFC/MB/KP; Pg. 28-29: NASA JSC/MB/KP; Pg. 31: Jeff Schmaltz, Lucian Plesea, MODIS Land Rapid Response team/NASA GSFC/MB/KP; Pg 32-33: NASA JSC/; Pg 34-37: NASA LOIRP/Austin Epps/MB/KP; Pg. 38-41: NASA GSFC/Arizona State University/MB/KP; Pg. 42-43: NASA/GSFC/Arizona State University/MB/KP; **Venus**: Pg. 45: NASA/Calvin Hamilton/MB/KP; Pg. 47-53: NASA/JPL/USGS/MB/KP; **The Sun**: Pg. 55-59: NASA SDO/NASA GSFC/MB/KP; Pg. 60-61: TRACE, Stanford-Lockheed Institute for Space Research/MB/KP; Pg. 62-63: NASA STEREO Project/MB/KP; **Mercury**: Pg. 65-67: NASA/SDO, AIA/MB/KP; Pg. 68-71: NASA/ Mark S Robinson/Mariner 10 Image Project/MB/KP; Pg. 72-73: NASA/Johns Hopkins University Applied Physics Laboratory/Carnegie Institution of Washington/MB/KP; **Mars**: Pg. 75-79: ESA/Rosetta/; Pg. 81-83: NASA/JPL/Dr Paul Geissler/MB/KP; Pg. 84-85: ESA/DLR/FU Berlin/MB/KP; Pg 86-87: NASA/JPL/Dr Paul Geissler/MB/KP; Pg. 88: NASA/JPL/; Pg. 89: NASA/JPL/Dr Paul Geissler/MB/KP; Pg. 90-91: NASA/JPL/MB/KP; Pg. 92-101: NASA/JPL/MB/KP; **Asteroids**: Pg. 203-205: NASA/JPL/MB/KP; Pg. 106-108: NASA/Mark S Robinson/Northwestern University/MB/KP; ESA/Rosetta/NAVCAM–CC BY-SA IGO 3.0/MB/KP; **Jupiter**: Pg. 111-115: NASA/JPL/MB/KP; Pg. 116: NASA/JPL/PIRL/University of Arizona/MB/KP; Pg. 118-119: NASA/JPL/Dr Paul Geissler/MB/KP; Pg 121-127: NASA/JPL/MB/KP; **Saturn**: Pg. 128-149: NASA/JPL/MB/KP; **Outer Worlds**: Pg 150-153: NASA/JPL/MB/KP; Pg. 154-155: NASA/Johns Hopkins University Applied Physics Laboratory/Southwest Research Institute/MB/KP; **Above and Endpapers**: Mars Rovers by Nick Sotiriades.